DOGS

HISTORY ◆ MYTH ◆ ART

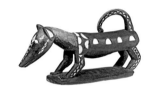

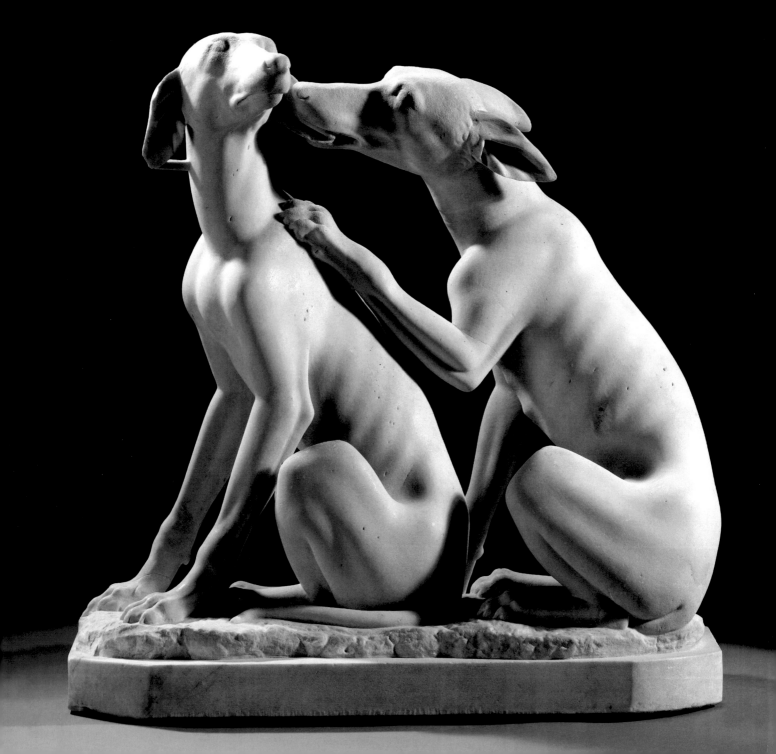

DOGS

HISTORY · MYTH · ART

CATHERINE JOHNS

THE BRITISH MUSEUM PRESS

In memory of Theo (1964–76)

First published in 2008 by The British Museum Press
A division of The British Museum Company Ltd
38 Russell Square, London WC1B 3QQ

www.britishmuseum.org

Catherine Johns has asserted the right to be identified
as the author of this work

ISBN: 978-0-7141-5067-3

A catalogue record for this book is available from
the British Library

Designed and typeset in Berkeley Oldstyle,
Calligraphic and ScalaSans by Price Watkins

Printed in Hong Kong by Printing Express Limited

HALF-TITLE
Life-size wooden figure with mother-of-pearl inlay,
from Ulawa, Solomon Islands. Early 20th century.

FRONTISPIECE
The Townley Greyhounds. Roman, 1st–2nd century AD
(see page 121).

OPPOSITE
Stoneware figure from Sawankhalok, Thailand,
14th–16th century AD.

CONTENTS

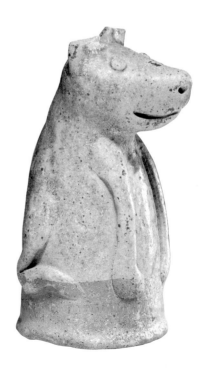

PREFACE AND ACKNOWLEDGEMENTS

THIS book employs the same approach as *Horses, History, Myth, Art* (2006). It is designed to be a visual celebration of the ancient relationship between humans and dogs, rather than a systematic chronological and thematic survey.

The introductory essay *Dogs and People* is a brief summary of the domestication of dogs, as far as we are able to trace it back into the early prehistoric period, and of the manifold roles, practical and symbolic, that dogs and other canine animals have played in human society. The second part of the book is a picture section in which art and artefacts depicting dogs are juxtaposed, described and explained for comparison under very general headings. Each picture-opening is self-contained, so that whereas the introductory essay should be read from beginning to end, the picture pages may be read and dipped into in any order. The illustrations are of domestic dogs and related wild species, wolves, foxes and jackals, as they have been portrayed in the art and the functional and decorative objects of many periods and places. Nearly all the illustrations are of items in the extensive collections of the British Museum, and to facilitate direct comparisons of images, they are reproduced at widely varying scales, some greatly reduced and others greatly enlarged.

Although I have attempted to achieve a judicious balance of artefacts from different periods of history, countries and regions, and of varying materials and functions, I may not always have succeeded. My choice of material inevitably reflects both personal bias and the objects available to me in the collections. My familiarity with the world of Graeco-Roman antiquity is probably responsible for the large number of objects from that era pictured here, but the large number of European prints and drawings from the last 400 hundred years or so simply reflects the sheer richness of choice available. The relative paucity of material from cultures in which dogs are regarded as unclean is inevitable, but it has still been possible to find a few beautiful objects from them. Some readers may be disappointed to find that a type of dog which is of special interest to them is not included in the 'types and breeds' section, but the selection has been circumscribed by what is available.

I am, as always, more grateful than I can say to my colleagues in the British Museum and to the other friends who have generously given me their help and advice, and who have taken time from their own busy schedules to assist me. In writing a book of this kind, the author encounters a dauntingly wide range of subjects, many of them highly specialized. This, paradoxically, is why the bibliography at the end of the book is so brief, and lists only works on dogs as a species and on the history of their relationship with humankind. If I were to include even the most general introductory books on the art, history, archaeology and religion of all the human cultures represented here, the bibliography would be longer than the text.

My husband, Donald Bailey, has given me the benefit of his unrivalled knowledge of the museum's Greek and Roman collections, and Juliet Clutton-Brock has been generous enough to read the introductory essay from her perspective as an authority in the field of zoology and the history of animal domestication: palaeozoology is a very active field of research, and new theories and discoveries are emerging all the time. Guy de la Bédoyère and R.C.A. Carey provided the translation of Margarita's tombstone (p.198), and Saxon Vylentz suggested some useful references on canine behaviour. Of my colleagues in the British Museum, the following have been kind enough to answer my many questions and to give me valuable information based on their expert knowledge: Richard Abdy, Richard Blurton, Rosina Buckland, Sheila Canby, Sally Fletcher, Antony Griffiths, Ralph Jackson, Ian Jenkins, Jonathan King, Marcel Marée, Sonja Marzinzik, Carol Michaelson, Mavis Pilbeam, James Robinson, Judy Rudoe, Robert Storrie, David Thompson and Dyfri Williams. Any errors in the text are my own. I am also indebted to other members of the British Museum staff, especially the photographers, and to the institutions that have allowed photographs of their objects to be used in the book, namely Tate Britain, The Potteries Museum and Art Gallery, Stoke-on-Trent, the Musées de Bordeaux and the Walker Art Gallery, Liverpool. I am also greatly indebted to the designer, Ray Watkins, and to my patient colleagues in the British Museum Press.

Catherine Johns

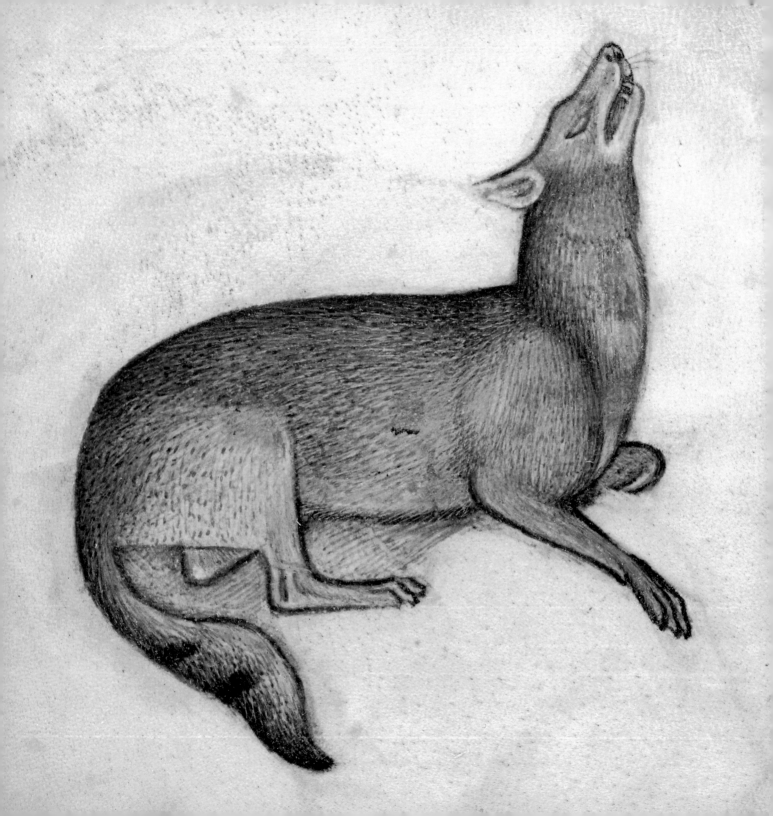

DOGS AND PEOPLE

DOGS are our oldest friends in the animal kingdom, and they occupy a very special place in our affections – as we doubtless do in theirs. The relationship between dogs and human beings goes back so far into prehistory that nobody yet knows for certain exactly when, where, why or even how often human communities and canine ones first entered into that two-way social contract we call 'domestication'. Perhaps we shall never know. Like us, dogs are highly intelligent, adaptable and opportunistic creatures, and the range of roles they fulfil in our society still continues to grow and evolve.

Evolution and domestication

Though the evolution and domestication of the dog have long been studied, the story is by no means fully understood as yet. There are currently more than thirty species of *Canidae*, the dog-like animals which include wolves and coyotes, jackals and foxes, but the Grey Wolf, *Canis lupus*, is the domestic dog's sole wild ancestor and cousin, and it still exists. Some modern breeds of dog retain many wolf-like characteristics of behaviour and appearance to this day, and the two species remain genetically close enough to be able to interbreed easily. Although the use of DNA evidence may lead eventually to greater clarity, the precise classification of fossil remains from remote periods of prehistory can be uncertain when dealing with such very closely related species. There would undoubtedly have been many contacts, hostile, neutral and occasionally friendly, between individual wolves or proto-dogs and human communities even in the earliest phases of human evolution, and it is also highly probable that canine domestication was not a single event, occurring at one time and location in prehistory, but was rather a series of parallel episodes taking place over a wide span of space and time, and involving separate regional populations of wild wolves and dogs.

The earliest known archaeological indications that suggest true domestic dogs, animals living alongside humans and apart from wild canid populations, date from around 12,000 BC, the end of the Ice Age and, in human cultural terms, the phase that is known as the Upper Palaeolithic. Recent though this may be in geological and evolutionary time, it is still an exceptionally early date in the context of animal domestication. Close human-dog relationships may very well have occurred far earlier than that, but without leaving evidence that we have yet found and can classify. People still lived as bands of hunter-gatherers, and several more millennia

OPPOSITE
Wolf
Painting on vellum
Italian (Lombard), *c.* 1400 AD
(see page 94)

were to pass before some of them began to keep livestock such as sheep, cattle and horses in captivity, for their meat and as providers of many other useful products and services. In the wild those creatures had all been food-animals hunted by humans, so the association between man and wolf (or dog), both of them normally on the 'predator' side of the predator-prey equation, may always have been a little different. This fact does not, however, preclude the probability that wolves themselves were sometimes hunted for their meat and skins. There is no doubt that the attachment between humans and canids was, by a very long way, the first foray into the close inter-species relationship that may be defined as 'domestication'.

It used to be firmly believed that human beings were fundamentally different from the rest of the animal creation, and that 'man' had simply selected certain species, which had been placed on the planet for his exclusive use and convenience, and proceeded to impose servitude upon them. The truth is more subtle and complex, and considerably more interesting. Humans and all other animals have far more in common biologically than anyone used to imagine even a century or two ago. It is simply not possible for people to domesticate any and every species according to their choice and whim, and domestication of a species is not the same thing as the taming of an individual animal: in fact, relatively few species have thrown in their lot with humankind to become truly domesticated, and, though those that have done so have sometimes been harshly oppressed, the wider biological and evolutionary view suggests that they have also benefited in some ways from the relationship and have evolved along different lines from their wild progenitors and counterparts. Humans have undoubtedly exploited their domesticated animals over the ages, but they have also protected them.

One of the key factors that brought dogs and humans together in the first place was a pattern of mutual benefit. This helped to forge a bond that has remained strong through all the changing developments of human culture: the birth and death of languages; discoveries and inventions from farming and writing to the building of cities; wars and folk-wanderings; the rise and fall of empires. At the most basic and practical level, dogs acquired a more reliable and varied source of food and easier access to the physical comforts of warmth and shelter than if they had been living independently, while humans acquired highly efficient collaborators in the vital tasks of hunting and – later – herding, an early-warning system for any human or animal approach to their settlements, and effective, self-directed weapons against external aggressors.

At a biological and species level, rather than on a conscious, individual one, domestic animals are complicit in the long and subtle process of domestication, unconsciously

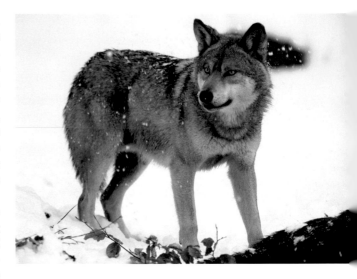

The Grey Wolf (*Canis Lupus*), the ancestor of the domestic dog.

responding to the advantages that an association with humans can confer, and willingly reciprocating: in the case of dogs, with their natural lively intelligence and curiosity, we may seriously wonder whether it was invariably *Homo*, rather than *Canis*, who made the first approaches. The idea that dogs might initially have domesticated *us* is a little uncomfortable, but it ought to be borne in mind as a possibility, as with another predatory, carnivorous species, the domestic cat, *Felis catus* – a much later entrant into human society, and one that is still quite able to take us or leave us. Dogs know all about the many ways of obtaining rewards and favours by ingratiating themselves with those in power, and it is not hard to envisage proto-dogs, especially juvenile ones, shamelessly manipulating our Palaeolithic ancestors into offering edible treats in return for friendly, submissive or even amusing behaviour. Trying to step outside our strictly anthropocentric view, and even attempting to imagine a cynocentric one, may help our understanding of the two-way processes involved.

A significant factor in the ancient canine-human association is that dogs and people organize and structure their social communities in broadly similar ways. Dogs are gregarious creatures that like to live in groups of both sexes and all ages; their communities have a clear and strong social stratification, and they respect the authority of high-status individuals in the group. Their communication skills, based on body-language and vocalization, are complex and highly developed, and they can express every shade of anger, aggression, friendliness, pleasure, fear, submission and ingratiation in ways that other dogs read and respond to in a predictable manner. But though they accept as a fact that some individuals are more powerful, more important, than others, their social system is not rigid and immutable; dogs are competitive and devious, and can move up or down their social scale; every dog is always watching for an opportunity to improve his or her own standing in the hierarchy, and to acquire more power and respect. Predators rather than prey, dogs are intelligent, inquisitive and highly adaptable, able to deal with new, unknown situations as well as familiar ones, and, in spite of their social structure, they will readily act cooperatively and even unselfishly to achieve ends that benefit the whole group. Unlike wild wolves, they retain many juvenile characteristics throughout their adult lives, for example, curiosity and playfulness, and they are capable of feeling deep and lasting affection towards their friends and companions.

Now re-read the paragraph above, substituting 'human' for 'dog'. No wonder people and dogs understand each other.

The process of domestication in all animals leads to some physical and behavioural changes, even before humans attempt to control breeding deliberately. Certain characteristics that might

Egyptian faience (glazed composition) figure of a spotted dog with a curled tail. Probably of Middle Kingdom date, perhaps *c*. 2000–1700 BC.

11

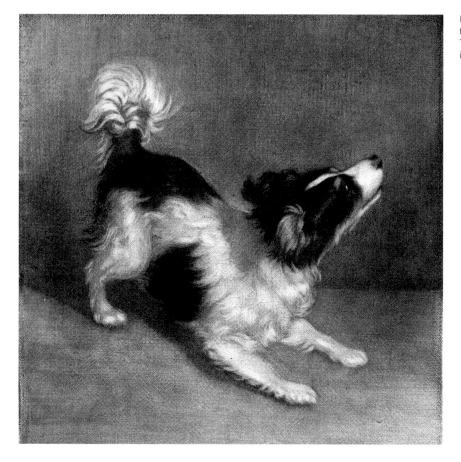

Mezzotint of a small spaniel, attributed to the Dutch artist Johannes Verkolje (1650–93). The pose, known as the 'play-bow' position, is characteristic of a playing dog.

be unnecessary or even dangerous in the wild – most obviously, a willingness to tolerate human presence and even to approach humans – are highly valued by people, so the animals that possess them will be protected and encouraged, rewarded with food and other comforts, and will survive to breed, while fiercely aggressive and untameable individuals will be excluded or killed. Unusual colours, coat-patterns and other 'different' physical traits that make an animal recognizable or visually attractive will become more common through human preferences, and will be established in the limited gene pool of any given local community of tame, people-friendly individuals. Eventually, this leads to the establishment of recognizable sub-populations of a species that we now usually call 'breeds', even though the concepts of modern pedigree breeding were unknown in antiquity.

Neoteny, the retention of juvenile characteristics, both physical and mental, into adulthood, is typical of domesticates, and will separate the human-friendly population yet further from its wild cousins, making dogs more puppy-like, more playful, inquisitive and willing to learn new skills, and more disposed to specialize in limited aspects of their full range of wolfish behavioural potential. Many of the new skills and specializations will be based as much on human as on canine needs; for example, a readiness to chase other animals is an innate canine trait, but to desist from catching, attacking and killing the prey is a major adaptation of instinctive behaviour. The driving, containing and directing of a herd of hoofed animals, while refraining from harming them and indeed, protecting them from other predators, is something that herding dogs have done for millennia, but it is quite foreign to the basic instincts of a true wolf.

Types and breeds

The many roles that dogs have played, and continue to play, in human society have led to a bewildering variety of canine physical appearance and temperament. Adult dogs may range in weight from as little as 2 pounds (1 kg) to as much as 200 (90 kg); they can look very like the ancestral wolf, or can appear so utterly different as to suggest another species altogether. Some of the earliest works of art depicting domestic dogs show animals that had already been selected or bred for specialized human purposes, such as the elegant greyhounds of some Early

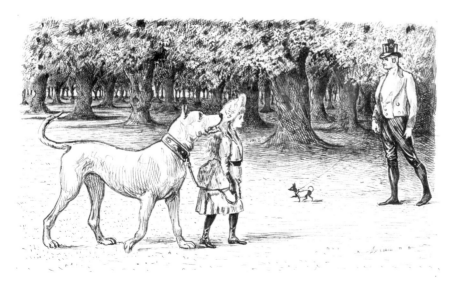

This drawing by George du Maurier (1834–96), captioned 'Under control', was published in Punch magazine in 1886, and depends for its effect on extremes of size. The young girl walks a gigantic hound, probably a Great Dane with cropped ears, while the liveried manservant is accompanied by a minuscule animal, probably an English Toy Terrier. The setting is Kensington Gardens in London.

Dynastic Egyptian paintings, and the powerful mastiffs of the Ancient Near East. I use generic words such as *greyhound* and *mastiff* to refer to the general physical appearance and likely behaviour of ancient dogs, not as formal breed-names. The word *breed* itself will be used here with the greatest caution, and, in particular, I shall avoid the common tendency to claim a direct, pure line of descent of any modern breed from dogs of similar appearance depicted 1,000 years ago or more. The basic genetic diversity of canids is such that similar types can be created and recreated at different times and places, and dogs with characteristics suitable for certain uses will often look similar: those that chase deer or hares must be swift, those that hunt savage prey such as wild swine must be strong, and those that are destined to be affectionate companions to the idle rich will frequently be small and fluffy.

Some of the physical changes that human intervention has imposed upon dogs since early times have slightly altered their ability to communicate clearly with each other. Long floppy ears and abbreviated or tightly curled tails are both common characteristics amongst domesticated dogs, and these appendages cannot convey with absolute precision the complex social messages that wolves and wolf-like dogs are able to exchange with their large, pricked and mobile ears and long waving tails. However, such modifications may already be seen in the very earliest depictions of dogs, and have existed so long in *Canis familiaris* that the animals have accommodated to them, and can still communicate adequately amongst themselves.

A large, barking dog in green-glazed earthenware was a tomb-guardian in Han Dynasty China (1st–2nd century AD). He has half-bent ears, a tightly coiled tail, and wears a harness rather than a collar.

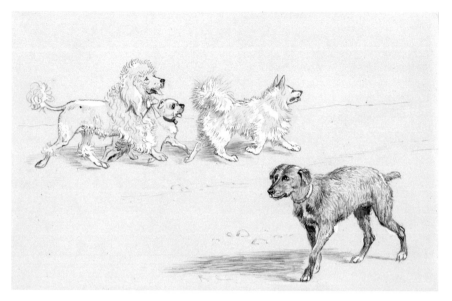

This pen-and-ink drawing by Randolph Caldecott (1846–86) is an illustration to Robert Louis Stevenson's essay *The Character of Dogs*. The humble mongrel is cut dead by three pedigree dogs, a poodle, a pug and a white German spitz, in a parable of Victorian human society.

It is sensible for a potential dog-owner to look for a puppy that he knows will grow up to possess the size, general appearance, temperament and abilities best suited to its future tasks, and people have achieved this goal for millennia simply by selecting the offspring of parents that both possess the desired qualities. If you want a large, tranquil, smooth-coated black dog, you would be wise to avoid a puppy whose dam and sire are both small, excitable long-haired yellow animals: so much is pure common sense. It was in the period of the Enlightenment in Europe that serious attempts were first made to place this kind of empirical approach on a more scientific basis. We still have much to learn about the intricacies of genetics, but its microscopic mysteries were completely unknown in the eighteenth century. Nevertheless, practical experiment, and the careful observation and recording of the results of controlled breeding, led to an increase in knowledge and to real improvements in certain traditional breeds of many domestic animals, as well as the creation of new breeds. The passion for standardization of type continued during the nineteenth and twentieth centuries, to an extent where many people now actually despise the generic dog, the no-breed mongrel.

In some quarters, there is an obsessive concern with so-called 'pure' bloodlines, and with the ruthless manipulation of physical appearance to match breed standards which are based chiefly on an arbitrary visual aesthetic. The 'correct' look is usually achieved by means of a degree of inbreeding that, in our own species, we should unhesitatingly label 'incestuous'. In certain dog breeds, immoderately

large or small size, severely flattened faces, dwarfishly shortened legs, heavily wrinkled and folded skin, or excessively heavy, long coats have become 'required' over the last century or 150 years, and it is not surprising that some of these unnatural extremes have brought inherited health problems in their wake. Put simply, too great a limitation of the gene pool is going to accentuate 'bad' and 'good' traits impartially. Furthermore, we should reflect that an exaggerated admiration for pure-bred, pedigree animals, and a corresponding contempt towards mongrels and cross-breds, is fundamentally the same ideological position as the conviction that members of the nobility and aristocracy are finer creatures in every way than ordinary, randomly bred human beings, and that some whole *races* of humans are intrinsically superior to others. It is no accident that the creation, development and refinement of numerous new dog breeds, and the draconian stud-book rules of many breed societies, emerged fully in the nineteenth century, when views about human eugenics and race that most of us now regard as both flawed and distasteful were widely held and seldom questioned.

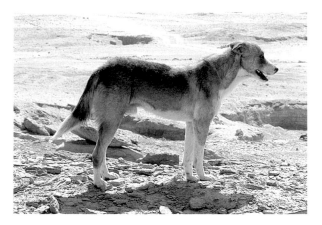

A village dog at Edfu, Egypt, 2007.

Many breed- or type-names already occur in written sources from the ancient world, and are found in even greater profusion in the Middle Ages, but interpreting exactly what the designations meant (including how precise they may have been, and how stable over time) and, above all, confidently matching up depictions in art with descriptions in literature, is fraught with uncertainty. Some of the dogs shown in the objects described in the second part of this book would undoubtedly have been given a specific breed-name by their original owners; some even look very like dogs with a modern breed-name; but the identification of these distinctive canine races, past or present, is not the purpose of the book. The common theme is the appeal of generic Dog, *Canis familiaris*, to humans throughout the ages.

Practical roles in human society

The list of tasks in which dogs assist their human companions is a long one, and it continues to grow. Hunting, guarding persons and property, and the herding and protection of livestock, all go back into the mists of prehistory. The human passion for sports and competition has led to the exploitation of canine instincts and propensities in many ritualized forms of hunting, attack and slaughter, performed as competitive entertainment for the enjoyment of human audiences. But the keen senses of dogs and their willingness to carry out tasks assigned to them by their human pack-leaders have also been employed for more worthy ends. Dogs now play a significant part in many aspects of law enforcement, in dangerous and

delicate rescue operations and as reliable, astonishingly effective helpers to people who suffer from various disabilities. No other species has quite the combination of qualities needed for all these tasks.

Hunting

Hunting is an innate skill in canine animals, as it is in other carnivorous predators. Their lives depend upon it. The earliest interactions of man and dog over the hunting of prey animals were probably competitive. Bands of humans who came across a pack of wolves dismembering a carcase might well have tried to disperse them and steal the meat for themselves. The wolves would probably have behaved in much the same way if the deer or goat had been brought down by human hunters. But as people became accustomed to the presence of packs of wild wolves on the fringes of their own settlements, there must have been more and more occasions when human and canine hunters formed a loose alliance to track, chase and kill some hapless creature and then to share the spoils. All canine animals can track and chase game far better than humans can ever hope to do, and the earliest weapons used by men would not have been as effective as fast-running and savage hounds.

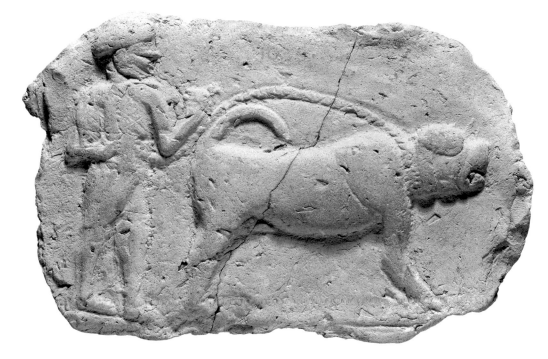

A large, mastiff-like hound and his handler, on an Old Babylonian clay plaque dating from about 2000–1700 BC.

17

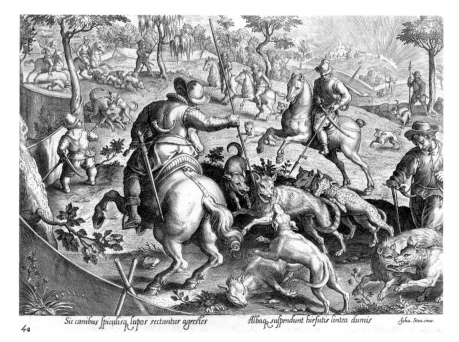

Sic canibus ſpiculiſq, lupos ſectantur agreſtes *Albaq, ſuſpendunt hirſutis lintea dumis* *Joha. Stra. inue.*

4a

No Stone Age hunter could have left us an account of the first time he and his companions set out on a hunt accompanied by the scruffy pack of bony, half-wild proto-dogs who lived nearby and who no longer feared or attacked their human neighbours. By the time we have written and pictorial evidence from the great ancient civilizations of the Near East and Egypt, those earliest phases of human/canine accommodation were long past, and we can never recreate them except in imagination. The hunting hounds we see on Egyptian tomb-paintings or Assyrian reliefs are not wolfish wild animals, cautiously and perhaps only temporarily in league with men and women: they are wholly and visibly domesticated; sleek, well-fed, collared and leashed, and already divided into markedly different physical types, the distinct strains suited to hunting different quarry, from hares to lions.

Throughout all the succeeding ages, countless different kinds of hunt have been depicted in art and described in literature, and hounds are nearly always part of the picture. Although initially hunting was part of the survival strategy of humans, who could use not only the edible meat and fat of the animals they killed, but also materials such as bones, skin, hair, sinews and horns, once people lived in settled communities, grew crops and raised livestock, hunting remained a ritual activity that fulfilled a psychological need, even if the slain deer or boar was no

longer essential food. In due course, many forms of hunting became associated with the elite, the leisured classes who had free time to fill and who could display their wealth in the form of fine clothes, handsome horses and well-trained, courageous hounds. In antiquity, the Middle Ages and up to the present day, and all over the world, hunting and killing other animals has been part of human behaviour, and in most cases, humans have used dogs to help them.

The Greek cavalry commander Xenophon wrote a treatise on hunting in the fourth century BC, and by the Middle Ages there were many works of reference on the subject. Prehistoric men and women would already have observed that specific types of dog excelled at hunting different species of prey. Sight-hounds hunt by keeping their rapidly fleeing quarry in view and by running down and catching it; scent-hounds identify the scent-trail of the prey, follow it, and may ultimately trap or hold the victim until the human huntsmen arrive to despatch it. Naturally, all dogs use all their senses when hunting, but it is clear that these broad distinctions have very ancient origins. There have been countless different styles, methods and fashions of hunting, and whatever traditions were being followed, there were hounds expressly bred and trained to carry them out. In post-medieval times, many breeds have been developed that possess special skills for working with men who are hunting with guns.

Guarding and protection

The element of guarding and protection must also have emerged as part of the human/canine symbiosis in very early times. The hearing of dogs is greatly superior to that of humans, and their territorial instincts lead them to challenge the approach of strangers. Like hunting co-operation, this instinctive behaviour would have proved useful to people, and the half-wild packs of dogs that still live on the fringes of human settlements in so many countries today continue to provide that service, often barking during the night and resting in the heat of the day. Personal protection provided by a dog can only follow the major development of allowing dogs to live as individuals within a human settlement rather than in a canine pack on the outskirts, but once that had been achieved, any dog that had come to accept one or more humans as high-ranking pack-members would certainly be ready to defend them, and their territory, to the best of his ability. The small guard-dog amulets from Nineveh, dating from the seventh century BC, (p.48) exemplify the status of dogs as guards and protectors in that society:

Three Egyptian guard-dogs rest during the day after a hard night's barking, at the ancient temple of Karnak, 1990.

their individual names or invocations, and their uniformly heavy jowls and curled tails, show that they are a chosen type of guard-dog, probably specifically bred and trained for that purpose.

The role of guard-dog implies more than merely giving warning and issuing canine threats with raised hackles, growls and snarls. If the human or other interloper is not intimidated, then the dog must be prepared to attack. The elaborate hierarchy and system of communication within a wolf-pack is designed to avert actual fighting as far as possible. When dominant wolves threaten, their subordinates usually accept their authority, behave submissively, and are therefore not harmed. The hierarchy of the pack is thus not only preserved, but reinforced. Human antagonists tend to display body-language that appears aggressive to a dog, even when that is not their intention; alternatively, the potential human victim may show fear by running away, an action that will certainly arouse the dog's chasing instincts. Recognized canine submission tactics, such as turning the gaze away, lying supine on the floor and whimpering, do not come naturally to a human being confronting a snarling carnivore with slavering jaws and very large, sharp teeth. So, guard-dogs sometimes did, and do, attack when defied by a human trespasser.

Fighting

Fighting dogs of many kinds have a long history, whether bred to fight one another, to bait larger animals or to slaughter smaller animals, such as rodents. Many of the terrier breeds developed in the nineteenth century were bred chiefly for ratting, and were sometimes made to take part in organized rat-killing competitions. Baiting animals such as bulls and bears by taunting and harassing them was the original task of some breeds (such as the English Bull Terrier and the Bulldog) that have since adapted to play a more peaceful part in human society. Dogs bred and trained chiefly to fight each other, to provide so-called entertainment for humans, undoubtedly have a long history, and they still exist, in spite of the fact that dog-fighting as a sport is now illegal in civilized countries.

The question of 'war-dogs' must be addressed here. There is a strong popular belief that large dogs were used as organized fighting troops in some ancient armies. Ancient documentary sources and art can all too easily be misunderstood by those who are not fully familiar with the social context. There are certainly some allusions in Latin literature to fighting dogs in foreign armies, but these are colourful tales of the exotic customs of distant lands rather than the factual first-hand reporting that a modern reader is conditioned to expect. We know enough about the Roman army itself, from extensive written, visual and material evidence, to be certain that there were no regular Roman 'canine soldiers'. War-dogs of another kind have existed in modern times, however; not attack dogs, but animals trained to carry out a wide

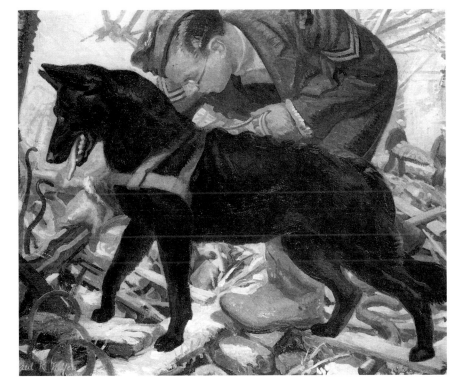

Jet of Iada, an Alsatian (German Shepherd Dog), was a very successful search-and-rescue dog during the bombing of English cities during the Second World War. He is credited with saving some 50 human lives. The painting is by Alfred K. Wiffen (1896–1968).

range of tasks in combat zones, such as searching for the wounded and carrying supplies. These functions come under the heading of 'assistance' rather than fighting.

Herding

The highly skilled and specialized function of a modern working sheepdog or cattle-dog is to control the flock or herd, to move the animals in the directions required by the shepherd, and to pick out and isolate individuals as required. In the past, however, herding dogs were usually fierce guard-dogs; they had to protect their owner's livestock from the attacks of wolves and other predators, or from the depredations of human thieves. The Roman author Columella, writing of farming and country life in the first century AD, recommends that a shepherd dog should be white, 'because it is unlike a wild beast, and sometimes, when driving off wolves in the dimness of early morning or dusk a means of distinction is required, lest one strike a dog instead of a wild animal'. This image does not have much in common with the picture of today's Border Collies competing in the sheepdog trials.

Other roles

Draught

Today, we seldom think of transport and haulage in connection with dogs, although everyone knows of the Arctic sled-dogs – wolf-like Siberian Huskies and Alaskan Malamutes – whose skills are still fostered for both practical and sporting purposes in their region. But a few generations ago, small dog-drawn commercial vehicles were a fairly familiar sight even in urban settings in certain countries. Some of the larger and more powerful breeds, such as Rottweilers, Newfoundlands, Swiss Mountain Dogs and, in China, Chow Chows, were quite commonly trained for such work. Today, like the use of horses for transport in first-world countries, draught dogs have generally moved into the realm of hobby and competition rather than everyday work. The use of dogs as draught animals was banned by law in Britain in the 1850s.

Assistance

Dogs now work with human handlers in a wide range of highly specialized and demanding tasks in law enforcement and in search and rescue. Their ability to detect and locate specific targets, from explosives and illegal drugs to injured human victims of natural and man-made disasters, goes far beyond any invention of modern technology.

Dogs undoubtedly helped to guide blind or partially sighted humans long before this skill had been formally honed and developed, but suitably trained and experienced dogs can also carry out an impressive range of everyday tasks for those who are unable to hear, walk or reach. It has been discovered that contact with friendly pets, especially dogs, can convey substantial psychological benefit to humans who may, for a variety of reasons, have difficulty in connecting emotionally with other people, and recent research has touched on the possible abilities of dogs as diagnosticians: it appears that some dogs are capable of detecting cancerous growths by scent alone. It is likely that we have not yet identified all the ways in which dogs are willing and able to work with us and help us.

Entertainment

There are many contexts in which dogs perform in public, often in competitions related to some aspect of canine work and skills. While circuses now seldom use dogs as performers in the way that was quite common even fifty years ago, greyhound racing, sheepdog trials, agility displays and similar events all fulfil both the competitive urge of humans and the pleasure many take in simply watching animals. The beauty-contest dog-shows of the kind we now regard as traditional (even though they were not established until the late nineteenth century) also require the

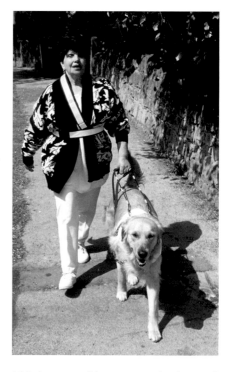

A blind woman safely accompanied and assisted by her trained guide-dog.

competitors to perform, by displaying themselves in the manner favoured by the judge. In general, the canine contestants enjoy these activities. They like to please their human associates, and quickly learn what to do to garner praise and approval.

Exploitation
Though this is not the place to dwell on cruelty and exploitation, it should be noted that dogs, in spite of their own carnivorous diet, have not been exempt from being eaten by humans. Although nobody in the contemporary Western world would readily eat dog-meat, it is still available in some countries, and other canine products, such as pelts, are probably more widely used.

In the West, the continuing use of dogs as experimental subjects in scientific research, including medical research, is a matter that gives rise to intense concern. The first living creature to orbit the Earth in a space-craft was a pretty mongrel bitch from Moscow, known as Laika: she was launched into space in Sputnik II on 3 November 1957 and her image became recognizable all over the world. Yet this little animal was never intended to survive the space mission, but was quite cynically and deliberately sent to her death (now thought to have occurred within hours of the launch). There was controversy about the project even at the time, though not

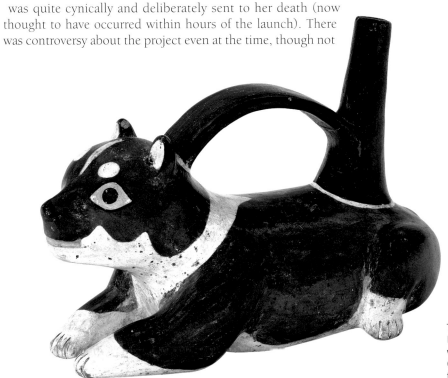

This ceramic vessel, a stirrup-jar, was made in Peru. Vases in the forms of animals or plants were common in the Nasca Culture (200 BC–AD 600), and were painted and burnished with great technical and artistic skill.

23

in the Soviet Union: some forty years later, it is said, one of the Russian scientists involved in the project admitted that the scientific information gleaned from Sputnik II was not enough to justify the death of the dog.

Dogs as friends and companions

It is unnecessary to emphasize that a great many of the dogs kept today are owned solely as pets – animals whose company gives pleasure and comfort to their human associates – and that many working dogs which have 'real jobs' as guards, herders and hunting hounds are also personal friends to their humans. It is, however, important to stress that this emotional attachment to dogs is not a recent phenomenon arising from Victorian sentimentality, as some people apparently imagine. It goes back far into antiquity. Dogs were regularly given personal names in ancient Egypt, and the bestowal of a name has deep meaning in human language, for it differentiates one individual from another: it confers a degree of personhood. We know of ancient Egyptian dogs buried in decorated sarcophagi, an expensive honour that would not be afforded a mere possession, which could easily be replaced, but only a person, whose individual loss was mourned. From both Greek and Roman sources, we have lists of names that were considered suitable for dogs, and there is ample evidence in Classical literature of the deep affection and devotion felt between many owners and their dogs. I need only refer the reader to the Roman tombstone of the white bitch Margarita (pp.198–9): the hound who 'lay on her master's and her mistress's laps', and who merited an expensive marble memorial with a long epitaph, was as fully a member of her human family as any beloved pet today.

Religion, myth and symbolism

It is characteristic of humans to apply many layers of meaning to all aspects of the natural world around them, and dogs, as such ancient associates of humanity, feature in myth and symbolism all over the world.

Dogs, death and the Underworld

Dogs live with us, enjoy our company, and understand and communicate freely with us; they are 'almost human'. Yet they are also sharp-fanged, hairy carnivorous quadrupeds, and can sometimes behave in wolfish ways that shock their human friends. They are valued members of our human families, yet they observe their own independent, canine, hierarchy outside our homes. They can be affectionate, playful, and obedient to our rules of conduct and cleanliness, yet they are scavengers, casual corpse-eaters and enthusiastic connoisseurs of disgusting

The Golden Jackal (*Canis aureus*)

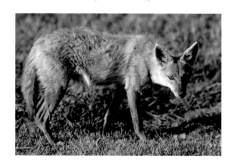

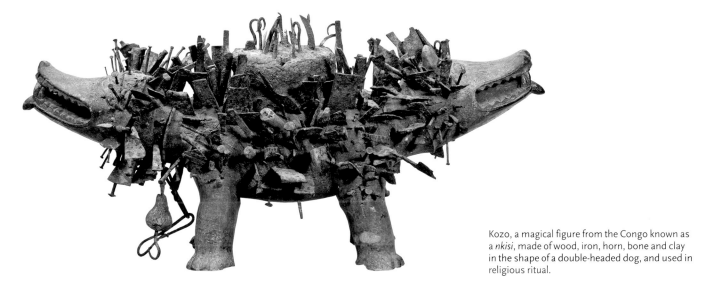

Kozo, a magical figure from the Congo known as a *nkisi*, made of wood, iron, horn, bone and clay in the shape of a double-headed dog, and used in religious ritual.

and decaying ordure. Their sensory abilities make them keenly aware of things that we cannot hear or see or smell, and they may appear even to intuit distant or future events. Dogs straddle the worlds of mankind and of wild nature like no other species, and this is probably why they have been widely regarded as inhabitants, not only of both the human and the animal worlds, but also of the different planes of existence of life and death, this world and the Underworld. Dogs and dog-like animals have been perceived in many cultures as mediators between the living and the dead, guardians of the thresholds between our world and beyond, and guides of human souls passing from this world into the next.

In ancient Egyptian religion, the god Anubis, depicted as a black jackal or jackal-headed man, played a pivotal role in funerary rites: embalming of the corpse, judgement of the soul, and the safe transition to the next plane of existence. Another Egyptian god, Wepwawet, whose identity eventually virtually merged with that of Anubis, was originally more wolf-like, but both were always represented as canine creatures. Far from ancient Egypt, the Aztec lightning- and fire-deity Xolotl, often depicted as a dog-headed man, was also a psychopomp (soul-guide), while guardians of the portals of the Underworld have been wolves or dogs in numerous belief-systems. Cerberus, the Classical guardian of Hades, with his three (or sometimes more) heads had a close counterpart in very early Indian mythology, the three-headed Cerbura, while the Hindu Lord of Death, Yama, was accompanied by a pair of four-eyed watchdogs, Syama and Sabala. They were the offspring of Lord Indra's bitch Sarama. The Greek goddess of night, ghostly spirits and necromancy, Hecate, also had a dog as one of her animal attributes, a black

bitch who may have been a transformed human; though Hecate was sometimes depicted as a hunter, her associations with Hades indicate that her dog was more than just a hunter's hound. Garm, one of the sinister supernatural wolves of Norse legend, was the guardian of Hel, the land of the dead.

In northern European folklore, supernatural dogs from the ghostly realms were inclined to put in unwelcome appearances in this world, and there are many fabled packs of hunting hounds and of individual, often gigantic, glowing-eyed, spectral Black Dogs which portend no good at all to the man or woman who sees or hears them. The Gabriel Hounds and the *Cŵn Annwn* (Dogs of Annwn) are just two of the hunting packs from the Underworld whose appearance or baying may signal a forthcoming death; the hounds of Annwn are not black, but white with red ears, a coloration regularly associated with supernatural status in Welsh myth. Throughout, and beyond, the British Isles such myths connect monstrous dogs with messages from the life beyond this one.

Dogs, deities, saints

Yet in spite of these sometimes menacing associations between ghostly dogs and the realms of death, dogs also have a strong and very ancient symbolic connection with healing. It may have been their habit of licking their own wounds and those of others that gave humans the idea that their saliva had healing properties, though we should not lightly dismiss the psychological element: a very sick person may be greatly comforted and encouraged by the constant devotion of a concerned dog, to the extent of finding the strength to fight his or her own illness. The healing sky-goddess Gula in ancient Mesopotamia was represented with a large dog seated alongside her throne, and in Graeco-Roman mythology, while the principal attribute of the physician deity Asclepius was a snake, he was also accompanied by a dog. At Asclepian shrines, devotees who came to worship and to be cured of their ills by means of the rite of incubation (sleeping within the sacred precincts and receiving the god's assistance and instructions in a dream-vision), might encounter both sacred snakes and dogs as chosen emissaries of the divine healer. Even in a remote corner of the Roman Empire, in the province of Britannia, a local deity, Nodens, revealed his credentials as a healing god through votives depicting dogs.

The dog-star, Sirius, in the constellation of *Canis Maior*, had widespread importance in the ancient world. The Egyptian calendar was based upon the rising of this brightest of stars, known there as Sopdet or Sothis in Greek, an event that took place in summer just before the annual inundation upon which the fertility of the Nile Valley depended. Because of the cosmic connection with the whole basis of the Egyptian economy, Sothis was also directly associated with the universal mother-goddess, Isis. The Sothic dog, long-haired and prick-eared, was represented in art,

A little gold amulet, only 1.4 cm (1/2 in) high, with a ring for suspension: it was probably worn to ensure the protection of the healing goddess Gula. It is from Kish, Iraq, and dates from about 700 – 500 BC.

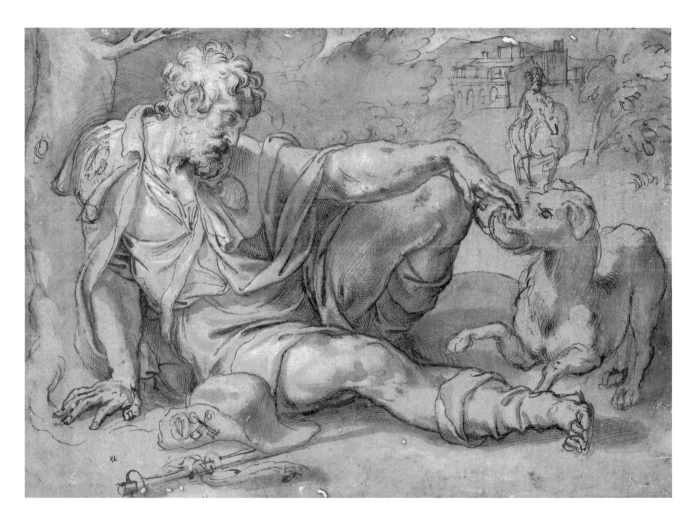

St Roch in the desert, receiving bread from a dog. This chalk, ink and wash study is by the Italian (Veronese) artist Paolo Farinati (1539–1606).

and sometimes Isis even rode upon his back. Sirius was identified in Graeco-Roman myth with various other mythical and legendary hounds, including Orthros, the brother of Cerberus, and Laelaps. Laelaps, originally given to Europa by Zeus, was a magical hound who always caught his prey: a later owner set him to hunt the Teumessian Fox, a gigantic animal that was too swift ever to be caught, and Zeus, faced with the paradox of a fox that could not be caught and a hound that could not be escaped, was obliged to turn both animals into stone – or, according to some versions of the myth, to set them in the heavens as a constellation of stars.

Some pagan deities, such as the great Graeco-Roman goddess Artemis/Diana, or

the minor Roman deity Silvanus, were accompanied by dogs or hunting hounds for prosaic and obvious reasons, simply because they presided over that universal obsession, hunting. One of the myths connected with Diana was the gruesome story of Actaeon, a young huntsman who, having accidentally glimpsed the goddess while she was bathing, was transformed into a stag and torn apart by his own hounds.

Dogs were not very common as attributes of Christian saints. St Roch, a thirteenth-century native of the south of France, though born into wealth, chose to minister to the victims of the plague and eventually became infected himself. He withdrew into the wilderness, where he was kept alive by the daily visits of a hound who brought him bread. More remarkable within Christendom was another medieval French saint of the same period, Guinefort. This saint was not a person at all, but a greyhound. The story of Guinefort parallels that of other legendary faithful hounds, such as Gelert, who were left guarding their master's infant heir and saved the baby from a marauding wild animal (in Guinefort's case a serpent; in Gelert's, a wolf). The returning lord, seeing an overturned cradle, no sign of the child, and a bloody-jawed hound, instantly kills the dog, only to discover the baby safe beneath the crib, and the corpse of the attacker. The grave of the unjustly slaughtered Guinefort became a shrine, and the canine martyr – canonized, needless to say, by popular belief rather than official Church sanction – was credited with miraculous healings of sick children.

There were, and still are, cultures and religions that regard dogs as unclean creatures to be spurned, yet, even within these, exceptions are often made for hunting hounds, herding dogs and watchdogs. And even where custom or belief decree that dogs should be avoided, there are always people who, quite simply, like the animals too much to despise or ill-treat them.

Dog-like monsters

While many mythical and supernatural horses are winged, horned, half-human or half-fish, most dog- and wolf-monsters took less imaginative forms; winged dogs are not a standard type in art and myth as the winged horse Pegasus is. However, the *senmurw* or *simurgh*, the phoenix-like creature of ancient Persian legend, does have the head of a dog, along with the paws of a lion, and the body, tail and wings of a bird. It is a kindly

The monster Scylla depicted in mould-made relief on a pottery flask, made in Italy in the 4th–3rd century BC.

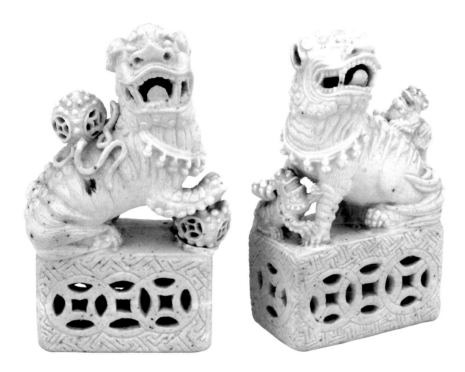

A pair of porcelain Dogs of Fo, made in Qing Dynasty China around AD 1700. The male has two globes, and the female two cubs.

and beneficent creature, and is so ancient that it has already seen the destruction of this world three times. The head of the Greek sea-monster, the *ketos*, looks more like that of a wolf than any other natural animal, but it would be stretching the evidence to call it a sea-wolf. Another Greek sea-monster, Scylla, had a human body, but wolves or savage dogs grew from her torso, their jaws ready to rend passing boats.

The noble Chinese Dogs of Fo belong in the 'monster' category only because they are a complex amalgam of dog and lion. Represented in pairs, the male with a carved globe and the female with a cub, they are ubiquitous in Chinese art, and are perceived as guardians and protectors.

Werewolves and other mythical shape-shifters are perhaps beyond the scope of this brief summary, except in so far as tales about them underline the fascination that men and women still feel for wolves as symbols of wildness, epitomizing both fierceness and beauty. A recent preoccupation with werewolves in popular fantasy fiction, including erotic novels, underlines the fact that these mythological stereotypes are still powerful.

Wolves, coyotes and foxes all play important parts in the legends and superstitions of the peoples who are familiar with them as wild animals. In European cultural tradition, the fox, endowed with a characteristically cunning intelligence,

has appeared as a regular figure in animal fables since the days of Aesop, and foxes are also highly significant in Japanese folklore, both as benevolent spirits and as mischievous and even dangerous tricksters. Supernatural Japanese *kitsune* (foxes) may have as many as nine tails, and some are adept shape-shifters, though their human form may sometimes waver if they relax their concentration.

Dogs in art

Dogs have played, and continue to play, a major and very special part in human culture, and for thousands of years men and women have represented the things that matter to them in their art. From individual studies and portraits by distinguished artists to personal and domestic adornments, and from symbolic objects with inner meanings to the most prosaic of everyday utensils, dogs have been depicted in our material culture. Wolves, jackals and foxes, the wild relatives of our domestic dogs, have also occupied an unwavering place in human consciousness. The second part of this book draws on pictures of a wide range of objects made from early prehistory to the present day to convey an impression of how we have perceived dogs, and how we feel about them.

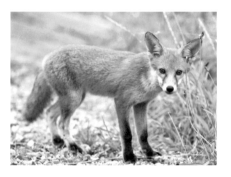

The Red Fox (*Vulpes vulpes*) is a very widespread species, and its appearance can vary quite considerably in different regions of the world. This picture shows a young fox in Britain.

A pair of ornamental hounds in *blanc de Chine*, glazed white porcelain made in the 18th century at Dehua, Fujian province, China.

DOGS DEPICTED

HUNTING DOGS

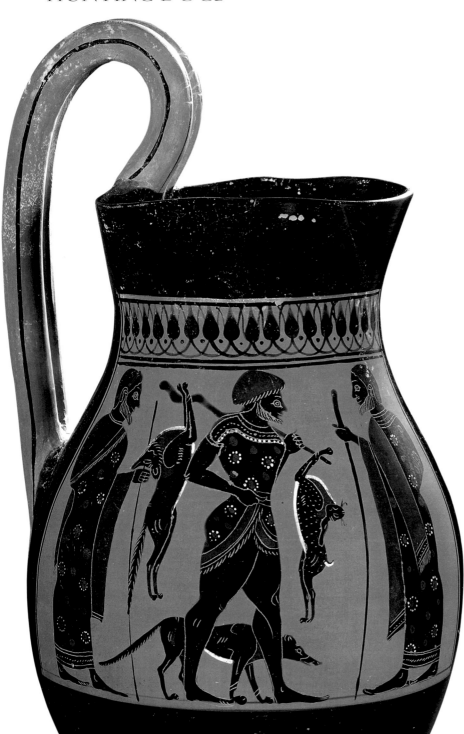

THE solitary hunter returning home with his dog and the day's kill is an age-old image, even though the human, the dog and the prey may vary a good deal in appearance.

The Greek black-figure jug was painted with the scene of the returning hunter in Athens around the middle of the sixth century BC. It is the work of an outstanding artist known to us as the 'Amasis painter'; we do not know his own name, but his distinctive style has been noted on several vessels signed by the potter Amasis. His huntsman is richly dressed in a short, lavishly patterned tunic with a fringe at the hem, and he carries over his shoulder a staff from which hang two very dead animals, a fox and a large hare. A sleek, long-tailed hound walks beside him, looking tired. The basic visual effect

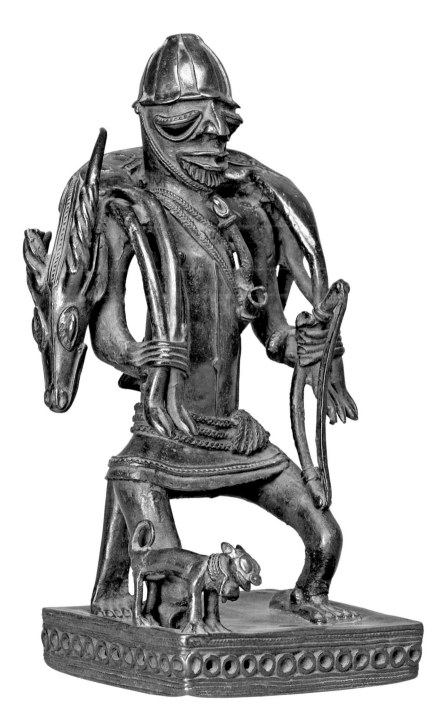

of the black figures on the light terracotta ground is heightened and given additional detail and impact through the use of applied dark red and white ceramic colours.

The other hunter boasts a much larger kill and a much smaller dog. The bronze statuette dates from some time between the sixteenth and eighteenth centuries AD, and is a product of the sophisticated Nigerian bronze-casting industries of the early modern period. Our African hunter has bagged an antelope, which he carries over his shoulders while also grasping his bow in his left hand. His little dog scarcely looks like a fierce, swift hound that helped bring down the prey, but appearances may be deceptive. The dog has a curly tail, and seems to wear a double collar, one part of which carries a large, flat pendant.

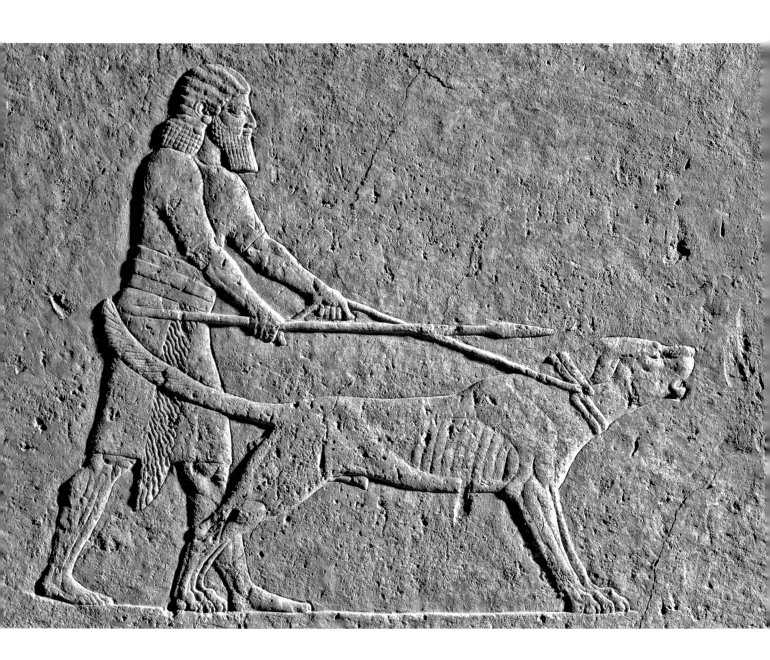

A HUNTSMAN and his hound could hardly appear more different than they do in these two works of art, yet a common thread unites them; the social implications of hunting, and the equally ancient and central role played in that pastime by hounds.

The stone wall-relief is part of a lion-hunt scene from the palace of Ashurbanipal (r. 669–631 BC) at Nineveh. The handler of this dog was one of the many who had the task of trying to prevent the escape of any lion from the enclosed area where the king was displaying his royal strength and prowess by killing them. The type of dog is very familiar from other Mesopotamian art of this and earlier periods. He is a very large and powerful, deep-jawed animal that we can easily believe had the courage and tenacity to confront even the most dangerous of prey. Every line of his lean but heavily muscled frame expresses concentration and ferocity.

The crisply moulded white stoneware figure seems somewhat frivolous by comparison. An English gentleman of the late seventeenth century, elaborately dressed and with beautifully coiffed hair, returns from the hunt with a dead hare slung over his shoulder, doubtless staining his elegant coat with its blood. The small hound looks up expectantly at his master, probably hoping to enjoy his share of the kill in due course. This figure epitomises the outstanding technical and artistic achievement embodied in the products of the Fulham Pottery, founded by the scholarly entrepreneur John Dwight (?1635–1703) in 1672. Dwight brought his analytical and scientific mind to bear on the challenges of producing new hard-fired ceramic materials and types of decoration. The products of the Fulham Pottery range from everyday utensils to extremely high-quality portrait sculpture.

OPPOSITE
Alabaster wall-relief of a huntsman
and his hound.
Neo-Assyrian, 645–635 BC.
Nineveh, Iraq.
THIS PAGE
Figure of a hunter in salt-glazed stoneware.
English (Fulham, London), c. 1680.

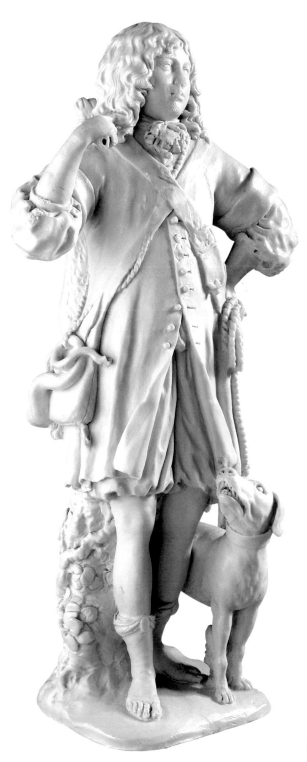

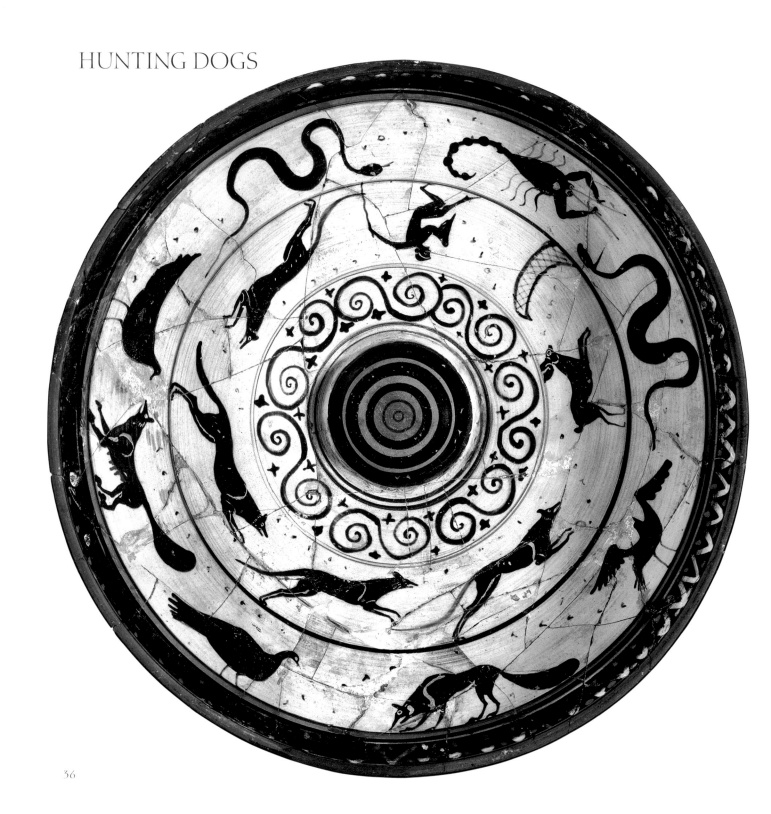

REPRESENTATIONS of hunting hounds and their prey have been such a fundamental part of the decorative repertoire in many societies that they have been used in contexts that had no apparent connection with hunting.

The shallow dish, made in Greece in the early fifth century BC, is painted in the black-figure technique on a white background onto a shape known as a *phiale*, a vessel used for pouring libations in religious ritual. The bowl can easily be held in one hand, for wine to be swirled around in it and then poured out as a religious offering. The central zone of decoration depicts the hare-hunt so dear to the ancient Greeks. Four hounds pursue a hare into a net where a man waits on the other side. The outer frieze includes a variety of animals: birds, snakes, a scorpion and two bushy-tailed foxes, are all drawn with the greatest elegance and panache. In nature, animals are either predator or prey, and often both: this inexorable pattern did not distress our ancestors as it so often distresses us.

The other artefact, a pop-eyed little dog made of clay, grasping an amorphous hare in his jaws, is considerably less sophisticated in style. It is also Greek, but was made about a century earlier than the *phiale*. It could very well have been used as a toy, but it was found in a tomb and should therefore be regarded as a ritual or religious object, perhaps intended to evoke the pleasures of the hunt for the deceased, or even to provide him with a dog as a guide for his soul's onward journey.

OPPOSITE
A hare-hunt on a pottery libation dish (*phiale*) in black-figure technique on a white ground.
Greek (Athenian), c. 500–470 BC.
Capua, Italy.
THIS PAGE
Terracotta figurine of a hunting dog.
Greek (Boeotian), 600–580 BC.
Thebes, Greece.

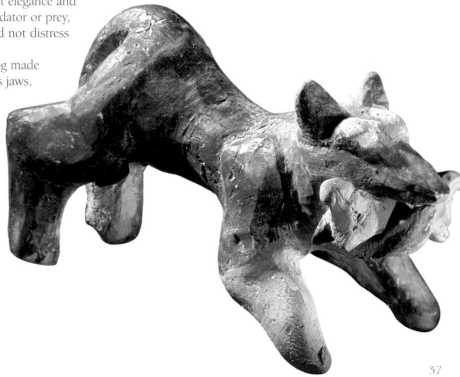

HUNTING DOGS

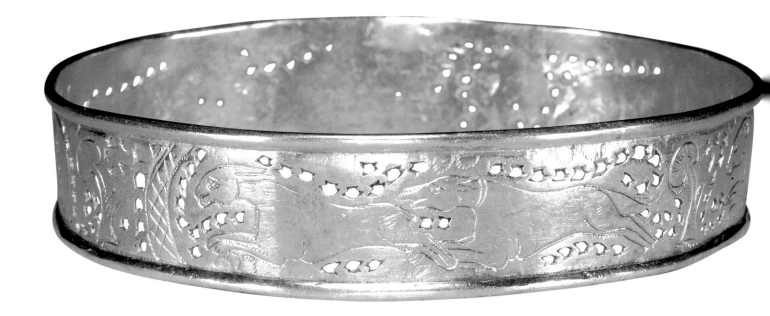

THE rules that have governed hunting as a sport of the wealthy have always been complicated, but they have varied a good deal at different times and places. Assyrian kings and medieval European aristocrats thought nothing of hunting large game that had already been captured and confined within fenced parks and was therefore almost bound to be caught and killed, while ancient Greek and Roman hunters regarded it as normal to drive their quarry into nets. Hunting often posed real danger to the predators, human and canine, as well as the prey, but the notion that the chase as entertainment (rather than as a means of catching dinner) might perhaps give the prey a sporting chance of escape was not widespread.

The late Roman bracelet is from a large hoard of coins, gold jewellery and silver tableware buried at Hoxne

(Suffolk, eastern England) in the early years of the fifth century AD. The bangle would have been worn by a woman of taste and means, and the scene it depicts would have been familiar to her. A hound and hare are rushing towards a barrier in the form of two curved lines with cross-hatching between them. Though very stylized, this indicates the net in which the hapless hare will be ensnared if the hound does not seize it first.

The Romano-British pot also shows hounds pursuing hares, carried out in a difficult technique in which figures are piped onto the surface of the vessel using clay of a flowing consistency. Hounds would have chased hares, both on their own account and in the service of humans, long before Britain became a province of Rome, but the graceful ceramic jar and its lively decoration express a fusion of Classical and native culture.

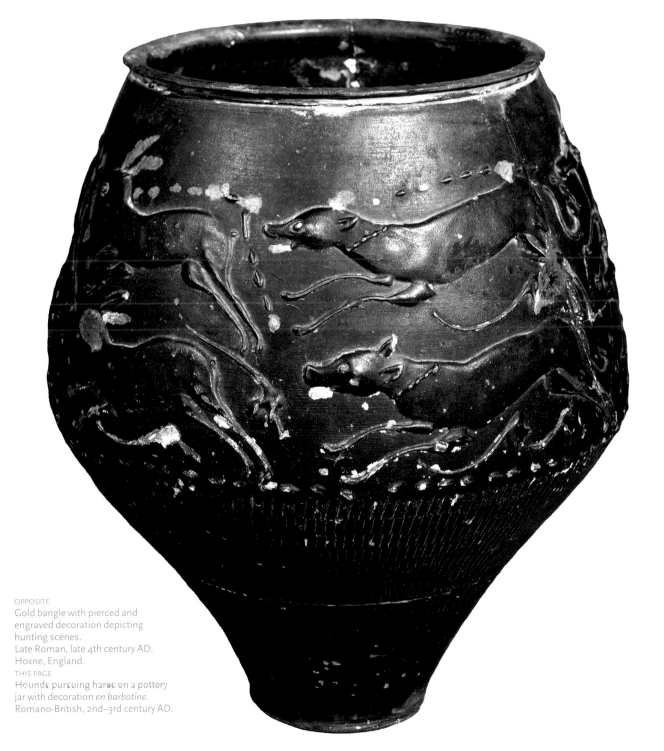

OPPOSITE
Gold bangle with pierced and
engraved decoration depicting
hunting scenes.
Late Roman, late 4th century AD.
Hoxne, England.
THIS PAGE
Hounds pursuing hares on a pottery
jar with decoration *en barbotine*.
Romano-British, 2nd–3rd century AD.

HUNTING DOGS

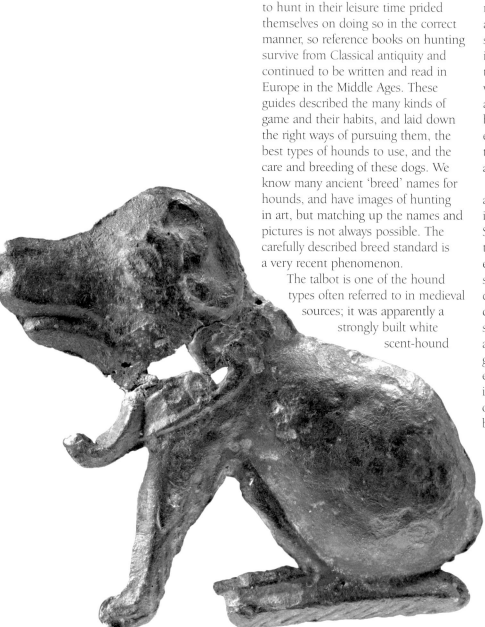

THOSE who had the wealth and status to hunt in their leisure time prided themselves on doing so in the correct manner, so reference books on hunting survive from Classical antiquity and continued to be written and read in Europe in the Middle Ages. These guides described the many kinds of game and their habits, and laid down the right ways of pursuing them, the best types of hounds to use, and the care and breeding of these dogs. We know many ancient 'breed' names for hounds, and have images of hunting in art, but matching up the names and pictures is not always possible. The carefully described breed standard is a very recent phenomenon.

The talbot is one of the hound types often referred to in medieval sources; it was apparently a strongly built white scent-hound with a curly tail and hanging ears. It regularly appears in heraldic contexts, and the charmingly Thurberesque little seated animal made of cast lead alloy is a good example. The dog's collar has the two letters 'ta' inscribed upon it, so we know that it is intended to represent a talbot. The figure is a medieval livery badge, worn by a person who was employed in the household of one of the Talbot families in whose coat of arms the animal appears.

Some of the numerous dogs that appear on the complex, beautiful and iconic medieval object known as the Savernake Horn are also undoubtedly talbots. The hunting horn is of exotic elephant ivory, adorned with enamelled silver mounts; those near the mouth date from the middle of the fourteenth century and show a variety of hunting scenes, including the hunting of lions and the mythical unicorn. Slender greyhounds and the more robust floppy-eared talbots both appear, delicately incised on silver and standing out clearly against the vivid enamelled background.

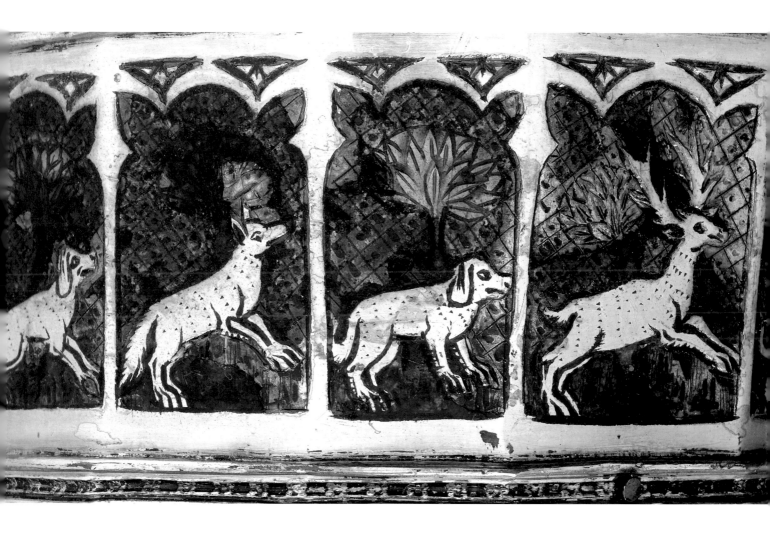

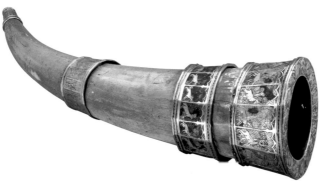

OPPOSITE
Lead-alloy livery badge in the shape
of a talbot.
English, medieval.
Bristol, England.
THIS PAGE
Ivory hunting horn with enamelled
silver mounts.
English and Scottish, medieval
(14th century and later).
Savernake Forest, Wiltshire, England.

HUNTING DOGS

IT is not surprising that scenes showing a hound chasing and catching a hare tend to look rather similar whether they were designed in remote antiquity or in more recent times. The two small objects shown here have almost identical motifs, though one is from twelfth-century Germany and the other from late Roman Britain, about 800 years earlier. Both are functional as well as decorative, and exemplify the wealthy and luxurious lives of their owners.

The large ivory gaming piece belongs to a set in which all the pieces are carved with lively and vivid images of different animals. This one shows a hound seizing a hare by the ear. The dog is somewhat oddly proportioned, but its head and folded ears suggest a greyhound-like animal.

The function of the exquisite hollow silver statuette, with its gilded details, was practical. Only

THIS PAGE
Carved walrus-ivory draughts-piece.
German, 12th century, probably from Cologne.
OPPOSITE
Parcel-gilt silver pepper-castor in the form of
a hound catching a hare.
Late Roman, 4th–5th century AD.
Hoxne, England.

4 centimetres (about 1½ in.) high, it was designed as an item of luxury tableware, a container for ground pepper or some other spice, with a base-plate which could be turned to open or close the holes through which the contents could be sprinkled onto food. It forms part of the Hoxne treasure, a large collection of gold and silver coins, jewellery and tableware that was buried in Suffolk, in eastern England, early in the fifth century AD. The Hoxne hound is very small – scarcely bigger than his prey – and apart from a band of gilding indicating a collar around his neck, his smooth coat is left ungilded, contrasting with the golden surface of the hare and the leafy ground on which the animals are set. Both creatures have eyes inset with clear glass, and the hound, like that on the medieval gaming piece, grasps his victim by the ear.

HUNTING DOGS

THE ownership of well-bred hunting hounds has been associated with privilege in Islamic societies as well as in Europe. The greyhound type, hunting by sight, and able, with its lean, powerfully muscled body and long legs, to run down the fleetest quarry, has existed in many sizes and variants.

The lively hunting scene painted in India in the seventeenth or eighteenth century depicts the Mughal emperor Akbar the Great (r.1556–1605)

THIS PAGE
Akbar the Great hunting.
Painting on paper.
Mughal India, c. 1650–1750.
OPPOSITE
George Vernon Stokes (1873–1954):
Studies of a Saluki.
Charcoal and chalk, 20th century.

hunting blackbuck (*Antilope cervicapra*). It was painted well after Akbar's own time, but this wise and powerful ruler, a man of outstanding personal qualities as well as impressive military and political achievements, had attained an almost legendary status. He is shown leaning forward over the shoulder of his galloping horse and snaring the male blackbuck with his bow, an extraordinary and obviously very dangerous feat. In the foreground, three blackbuck does are chased by a large hound held on a short leash by a running attendant; above a border of flowers, a little fox rushes past in the opposite direction, obviously fairly safe, since the hunters are concentrating on worthier prey. The emperor's hound is not quite like the greyhounds that we would see in contemporary European art: the proportions and the long, silky ears immediately indicate the saluki, the beautiful, swift hound of the Middle East.

The drawing by George Vernon Stokes (1873–1954) depicts a twentieth-century Saluki: in one study, the dog is simply stretched out, relaxing, but in the other we see him advancing and delicately stepping into water. Though Stokes may be remembered more as a popular illustrator than as a significant artist, his drawings of dogs and other animals not only form a valuable record, but convey to us the deep pleasure he took in the beauty of living creatures.

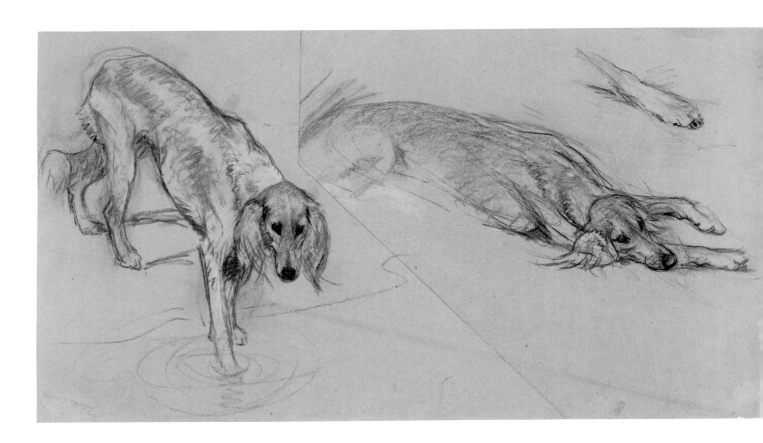

HUNTING DOGS

THE conventions of hunting various types of prey have differed widely over time and space. Here are two very dissimilar representations of foxhunting, both dating from the eighteenth century.

The drawing by the fine English artist Sawrey Gilpin (1733–1807) is an image that calls to mind one aspect of the lives of the wealthier classes in post-medieval England. Countless paintings and prints were made from the eighteenth century onwards, by artists ranging from the celebrated to the incompetent, showing riders galloping after packs of foxhounds as they pursued a fox across country, sailing over hedges and fences, and occasionally failing to clear them and finishing up in muddy ditches. Gilpin's drawing depicts part of a meet, before the hunt itself gets under way. From his seemingly casual and freely drawn lines the colourful scene

springs to life, with the hounds eagerly milling about, sniffing the ground and waving their tails aloft.

The picture of a single female hunter was painted by a Mughal artist in India, probably at around the same time as Gilpin was drawing his complacent English squires. The sumptuously dressed and bejewelled lady has gone out hawking. Her falcon is on her wrist, and with the most nonchalant skill she is riding a striking piebald horse whose legs and tail are dyed red with henna. In the foreground are her two hounds, which appear to have seized an unfortunate fox more or less in passing; certainly the rider is paying no attention to them. The lady may well represent Chand Bibi (1550–99), a legendary Indian female ruler and military leader of the sixteenth century. Her notable skills as a horsewoman and hunter are shown here as being equal to her other formidable qualities as a politician, warrior, scholar and artist.

WORKING DOGS

WHEN looking at dogs in ancient art, it can be difficult to say from appearance alone whether a given dog was a guard-dog, a hunting hound or a shepherd dog: all these roles might require powerful animals capable of fighting off wolves and other dangerous predators.

The five talismanic dogs are guard-dogs, with the magical purpose of keeping evil and misfortune at bay. Model dogs of this kind, inscribed with names, were deposited in sets of ten to protect thresholds, and this half-set, made of painted terracotta, was found in a doorway niche in the North Palace at Nineveh, the ancient Assyrian capital. Each bears a magical inscription in cuneiform script: 'Expeller of evil'; 'Catcher of the enemy'; 'Don't think, bite!'; 'Biter of his foe'; 'Loud is his bark'. They look similar to the hunting hounds represented in Assyrian art of the same period, the seventh century BC, though their tightly curled tails are distinctive.

The imposing seated marble dog is also probably a guard-dog, with powerful jaws and a muscular body. He is of Roman date, a marble copy of a Hellenistic bronze statue, and has generally been regarded as a visual representation of the admired 'Molossian hound' of Classical antiquity. This traditional identification, like so many other attempts to bring together visual and written evidence, must be treated with caution. Other versions of the statue are known. This example was acquired in Rome in the 1750s, when many English gentlemen were adorning their homes with Classical art, by the collector Henry Constantine Jennings, and became known as 'Jennings' Dog'. Jennings had to sell the statue in 1816 to help pay his gambling debts, but his comment records that he acquired it with real delight: 'A fine dog it was, and a lucky dog was I to purchase it.'

THIS PAGE
A group of moulded, inscribed and painted terracotta figures. Neo-Assyrian, *c.* 645 BC. Nineveh, Iraq.
OPPOSITE
'Jennings' Dog'. Marble. Roman, *c.* 2nd century AD.

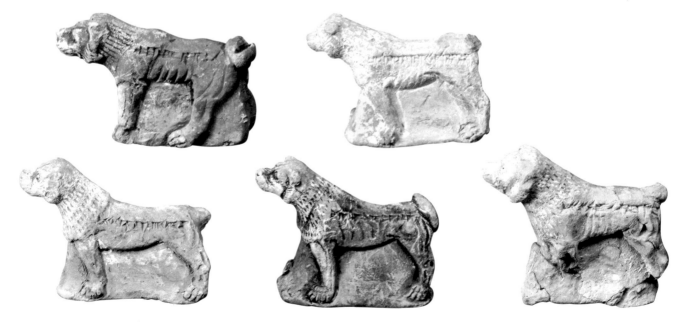

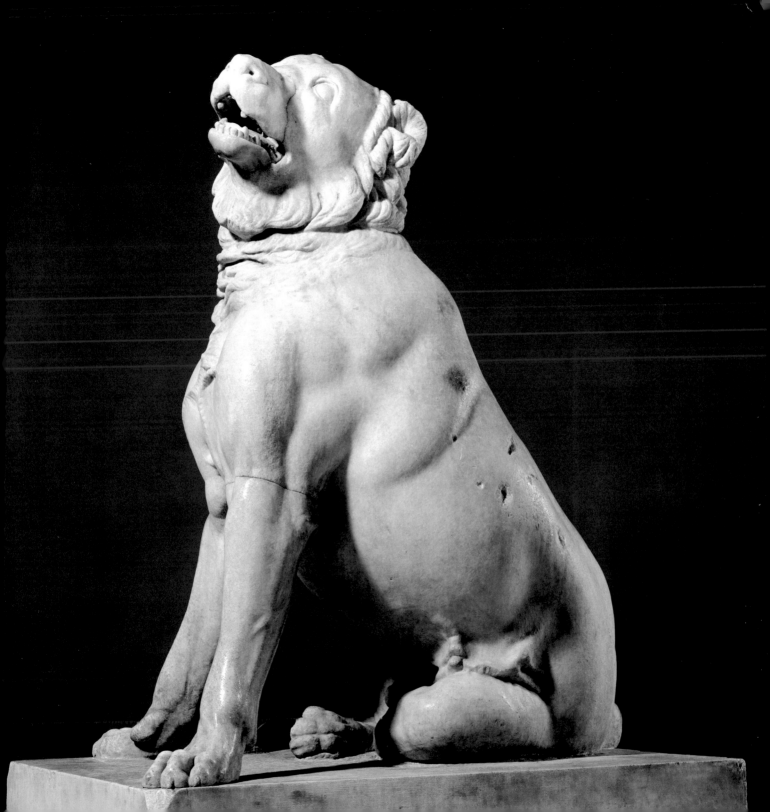

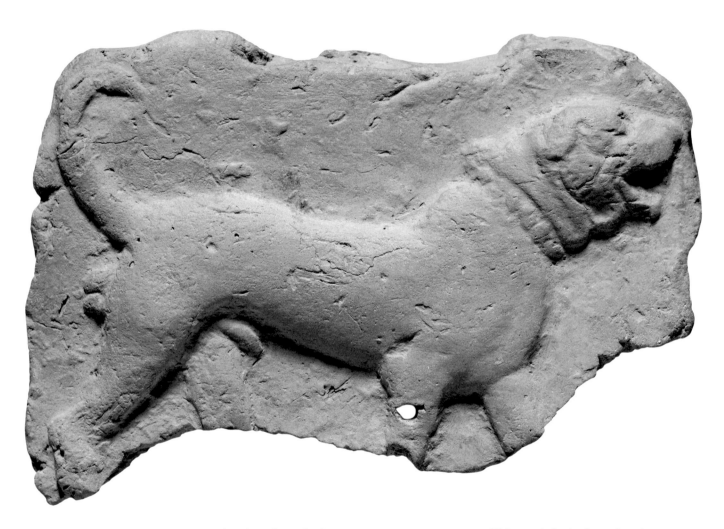

NOTWITHSTANDING precise modern breed standards, words such as 'greyhound', 'terrier' and 'mastiff' can be used in general terms and are widely understood. We think of large, muscular, heavily built dogs with large heads and powerful jaws as being of mastiff type, and tend to assume that they have always been valued chiefly as guard-dogs, though some were certainly hounds used for hunting large and dangerous quarry.

Many of the dogs represented in the art of ancient Mesopotamia are mastiff-like, and the barking dog shown in relief on a small moulded terracotta plaque from Ur, in present-day Iraq, is a fine example. Smooth-coated, he has a curved tail, short pendant ears and a strong, square muzzle. His powerful neck is encircled with a collar that may be made of heavy rope, and though he does not have the many deep skin-folds around the face and neck that we see in some modern breeds, there is certainly loose skin around the neck and a slight dewlap. His testicles are placed as though

he were a lion rather than a dog, perhaps because those species were thought to be related in ancient Mesopotamia. This handsome creature was modelled more than 3,500 years ago, between 1900 and 1600 BC.

The chalk drawing of a seventeenth-century dog has much in common with the ancient dog from Ur, with a head, ears and neck of very similar conformation. Drawn by Abraham Hondius (?1625–91), he is shown as though starting up suddenly from a reclining position and turning to growl or snarl at whatever has disturbed him. The artist, who was noted as a painter of animals, was no doubt displaying his expertise at depicting a difficult, twisted pose and conveying the impression of movement.

OPPOSITE
Moulded terracotta plaque depicting a mastiff.
Mesopotamian, 1900–1600 BC.
Ur, Iraq.
THIS PAGE
Abraham Hondius (1625?–91):
A mastiff.
Black chalk, 17th century.

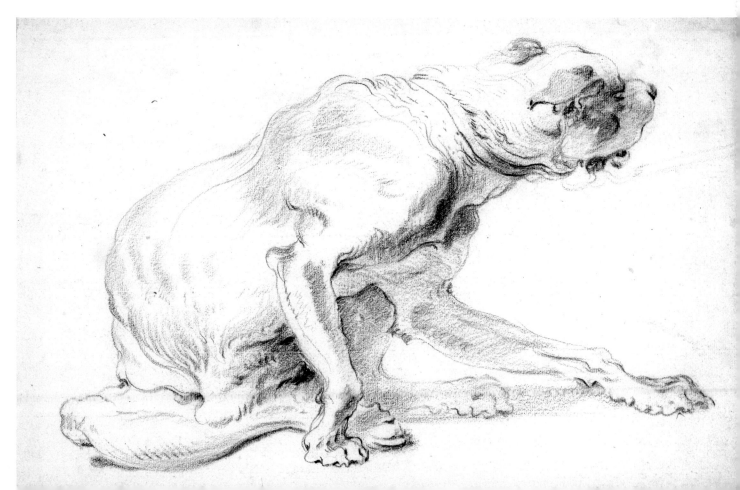

WORKING DOGS

DOGS undoubtedly assisted humans with the management and protection of domestic livestock, particularly cattle and sheep, from very early times. Adept as they may have been in carrying out their duties, however, these would not always have borne much resemblance to the activities that we associate with herding today. For example, one of the tasks of sheepdogs mentioned by writers in the Roman period was to defend the flocks from wolves bent on stealing lambs. By the same token, it is not usually possible to recognize representations of herding dogs in ancient sources: they may be visually

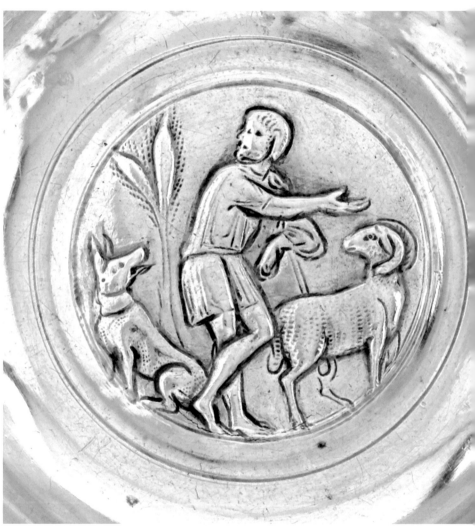

THIS PAGE
Silver bowl with chased ornament in relief.
Late Roman, 4th–5th century AD.
Carthage, Tunisia.
OPPOSITE
Gold brooch with engraved and painted rock-crystal setting.
Belgian, c. 1880.

indistinguishable from contemporary hunting hounds or guard-dogs.

The fine late Roman silver bowl makes the point well. Many wealthy Romans in the fourth and fifth centuries AD owned beautiful silver tableware which they used to impress their guests. Pastoral themes, which were traditionally associated with the iconography of the god Bacchus, were popular in the decoration of such silverware. Here the rim of the bowl bears a series of vignettes of goats and sheep with dogs and shepherds, and the central

decoration has a shepherd standing between his dog and a ram. The sheepdog, smooth-coated and prick-eared, looks much the same as the hunting hounds we see in elsewhere in Roman art.

By the nineteenth century, many of the sheepdog types of northern Europe

had become visually fairly distinctive, and the example portrayed on the late Victorian brooch is readily recognizable as a red-and-white collie. The setting featuring the dog portrait is a 'reverse intaglio', cut in the flat underside of a carefully shaped and polished rock-crystal, painted, and then backed with glass before mounting in gold. It is a product of a Brussels manufacturer, Vandenhove & Fils; such settings were used in jewellery made by internationally famous houses such as Cartier and Tiffany.

WORKING DOGS

THOUGH it is only in recent times that we have started systematically to explore the remarkable abilities of dogs to assist disadvantaged humans, the reality of the dog competently leading his blind or partially sighted owner, or faithfully accompanying a human friend who lives outside society as a mendicant, must go back millennia. Two nineteenth-century images form an interesting counterpoint: the specific scene imagined by a famous artist, and the more general and universal one observed by a minor one.

The work of Sir Edwin Landseer (1802–73) is as unfashionable today as it was admired in his own time, because his anthropomorphic perception of animals seems to us to exemplify the worst aspects of Victorian sentimentality and hypocrisy. Our first reaction to the 1831 print reproduced here, of two 'Alpine

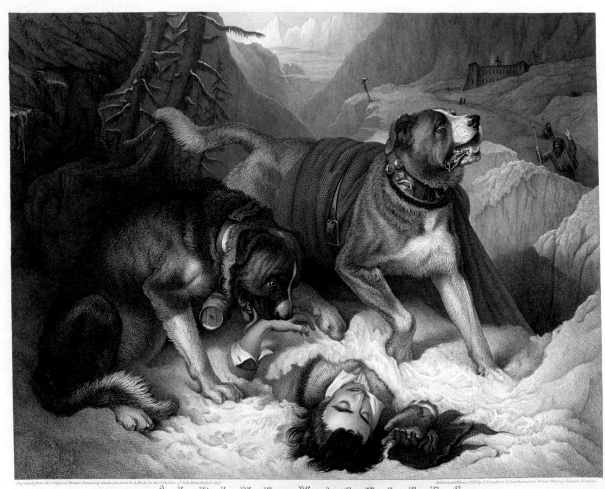

Engraved from the Original Picture Painted by Edwin Landseer R.A.Elect, in the Collection of Wells Watts-Russell, Esq. Published 28th June 1831 by J.J.Landseer 6 Southampton Street, Fitzroy Square London.

ALPINE MASTIFFS.

Inscribed with profound respect to The Right Honble Charles Earl Grey, First Lord of the Treasury, &c&c&c by John & Edwin Landseer

mastiffs reanimating a Traveller' is to roll our eyes. But this is an interesting picture. The 'alpine mastiffs' are early examples of the splendid breed we now call the St Bernard, and the dramatic circumstances not only establish the specific and traditional role of these dogs, but also underline the fact that dogs of many breeds are trained today in the unromantic but life-saving techniques of what we now call 'search and rescue'.

The watercolour stands for all the beggars, in so many times and places, who have relied upon the constant companionship of their dogs. This blind London beggar with his jaunty little terrier was immortalized by Paul Musurus in 1860. Musurus (1840–1927) was the son of a Turkish ambassador to Britain, a member of a cultivated Greek Orthodox family of considerable literary attainments. Later, he found modest fame as a poet in the French language, but in this touching little vignette of a London scene of the mid-Victorian period we see that he was also a sensitive artist.

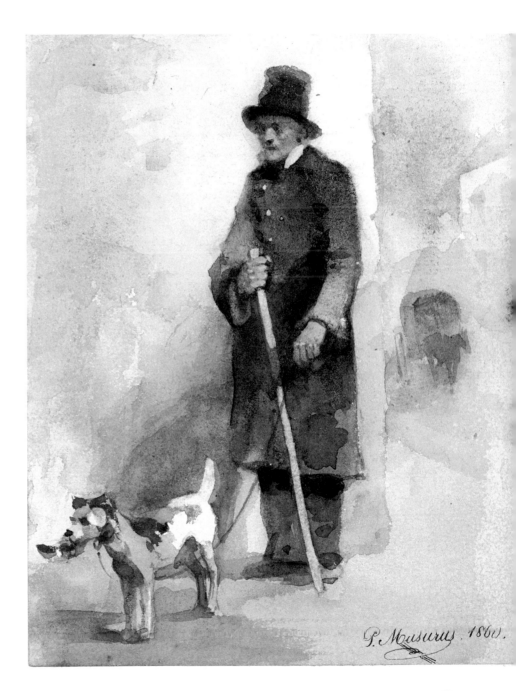

OPPOSITE
John and Thomas Landseer, after a painting by Edwin Landseer (1802–73): *Alpine mastiffs reanimating a Traveller.*
Engraving, 1831.
THIS PAGE
Paul Musurus (1840–1927): A London beggar.
Watercolour, 1860.

DOGS AND GODS

IN many belief systems, dogs have been associated not only with death and the journey into the afterlife, but also with healing. Gula, who was also known by several other names, was an ancient Mesopotamian goddess and the patron of medicine and healing. She was accompanied by, and sometimes represented by, a large dog.

The sardonyx (quartz) cylinder seal was engraved in the eighth century BC with a scene showing Gula being approached by a male worshipper. The goddess wears a star in her headdress and there is a column of stars behind her, probably indicating her throne, while her dog is seated in front of her beneath the crescent moon. Behind the worshipper is a goat feeding from a tree. Cylinder seals were first developed around 3500 BC to impress clay sealings used for identification and security purposes,

but were also worn as jewellery and as magical, protective amulets. They are remarkable miniature works of art.

The stamp seal in blue chalcedony, also a variety of quartz, is a little later, of the seventh to sixth century BC, and has a similar scene, only Gula is seated on her star-studded throne and her dog reclines beside her, held on a lead. The approaching worshipper is a woman.

Compared with the sophisticated gem-engraving of ancient Iraq, the little steatite stamp-seal may appear somewhat crude. As it comes from Anatolia (Turkey), we cannot connect it directly with Gula, but it may well indicate a similar amuletic and symbolic function for the image of a dog at a far earlier date in prehistory, possibly as early as 4500–4000 BC.

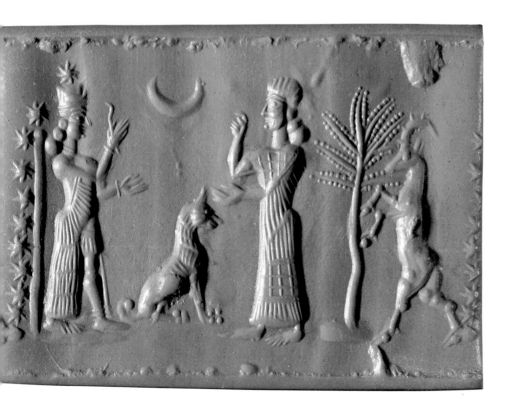
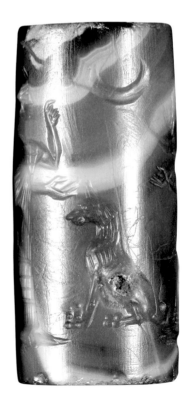

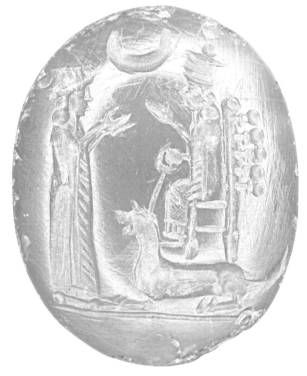

OPPOSITE
Engraved quartz (sardonyx)
cylinder seal showing Gula
and a worshipper.
Neo-Assyrian,
c. 8th century BC.
Nimrud, Iraq.
THIS PAGE, ABOVE
Gula and a worshipper, on
an engraved quartz
(chalcedony) stamp-seal.
Late Babylonian, 700–550 BC.
THIS PAGE, LEFT
Steatite stamp-seal.
Prehistoric, perhaps
Chalcolithic, *c*. 4500–4000 BC.
Mahsenli, Turkey.

DOGS AND GODS

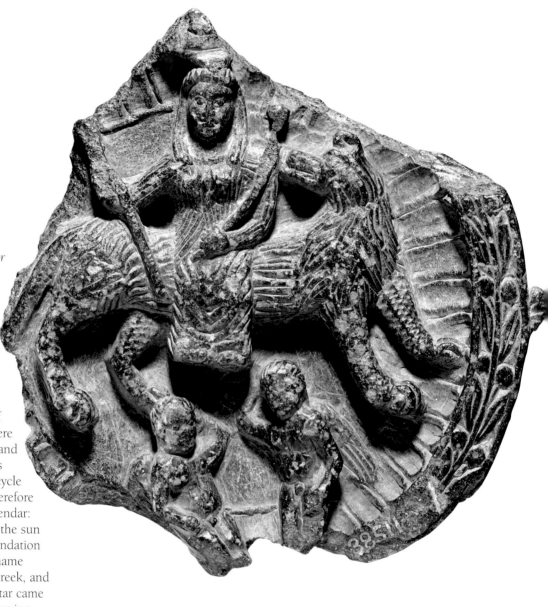

THE dog-star Sirius, in the constellation of *Canis Maior* (the greater dog), is the brightest star in the night sky. It features in myth and legend in many parts of the world. The Greeks saw the constellation as the hound of the hunter Orion or as other canine companions of deities and heroes. The hottest days of summer, the 'dog days', were associated with pestilence and epidemics, but the star was also central to the annual cycle of fertility in Egypt, and therefore formed the basis of the calendar: its midsummer rising with the sun marked the time of the inundation of the Nile. The Egyptian name Sopdet became Sothis in Greek, and the personification of the star came to be a dog, often accompanying the universal mother-goddess Isis.

The carved steatite bowl from

Roman Egypt shows a slightly naive scene of Isis-Sothis riding upon the great Sothic dog, a shaggy beast with a long tail, who turns his head back to look at his rider. Beneath are two winged cupids. The vessel, now damaged and missing much of its decorative rim, would have been used for religious purposes, as a votive gift.

A little more sophisticated is the rendering of the same scene on a base-metal coin, a *drachm*, issued at the mint of Alexandria in AD 157/8 under the emperor Antoninus Pius (r. 138–61). Here we can see more clearly that the goddess carries a cornucopia and a sceptre, symbols of fertility and power. Many of the small terracotta figures of shaggy dogs made in Roman Egypt and also further afield in the Roman world were probably intended to represent the celestial Sothic dog, 'the great Overdog / that romps through the dark'.*

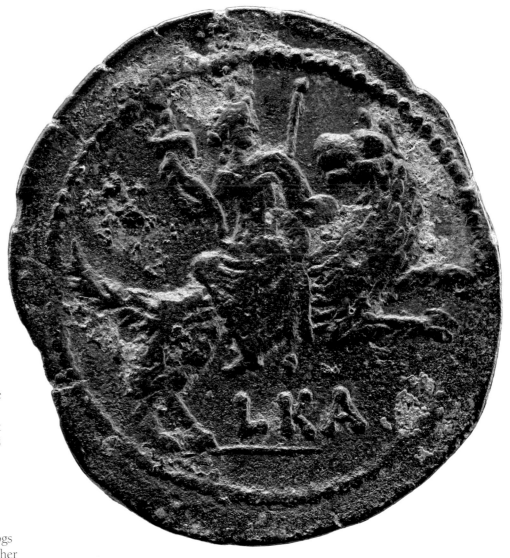

*From the poem *Canis Major*, by Robert Frost

59

DOGS AND GODS

IN contemplating ancient art, it is not always possible to tell whether a particular scene is to be taken literally, or whether it has some symbolic meaning. The carved tombstone of a young girl is from Alexandria: it dates from the Ptolemaic period and is purely Greek rather than Egyptian in style. The child is shown playing with a small dog, fluffy and curly-tailed, who jumps up to try to catch something, apparently a bird, with which she is teasing him. At first sight, this is simply a touching scene of a child, now prematurely dead, with her pet, and may be compared directly with the beautiful Roman tombstone from Bordeaux illustrated on page 182.

But the association of canine animals with the afterlife was not confined to the complex and important role of Anubis and other such gods in Egyptian religion. It may be that the presence of the dog

on the stela also had deeper meaning, because he would be an appropriate companion for the child's soul on its journey. This symbolism might well have been especially evident in Egypt, but in Greek mythology, too, canine animals had a special connection with the Underworld.

The goddess Hecate was one of the more mysterious Greek deities. Sometimes depicted in triple form, she was an Underworld goddess and a guide of souls in the afterlife. She was associated with witchcraft and necromancy, and guarded entrances, crossroads and other liminal places –

thresholds where travellers cross from one place, or one state of being, to another. Her chief animal companion was a large black bitch, and on the votive relief carving shown here, this animal stands behind her as she places a victory wreath on the head of a mare.

DOGS AND GODS

IN traditional Indian society, dogs are generally regarded as unclean scavengers and are therefore seldom represented in art, but they are sometimes seen, as in these two images, accompanying the god Shiva. Shiva is one of the chief deities of Hinduism: one of a triad, the Trimurti, with Brahma, the Creator and Vishnu, the Preserver. Shiva is the Destroyer, yet he is also 'the Auspicious One', with powers to promote the new life that arises from the destruction of the old. He has many paradoxical and apparently contradictory names and manifestations. In his fearsome guise as Bhairava, the graveyard dweller, he is a wandering ascetic living outside society, his hair matted, his skin covered with ashes, and bearing a cup made from a skull.

In the small bronze sculpture, made in Karnataka, southern India, around AD 950, Shiva appears as Bhairava. He is richly adorned with jewellery and holds symbolic objects: in his upper hands a trident and cobra-entwined drum, and, in his lower left (inauspicious) hand, a skull-cup and a severed human head, from which blood streams down. A very small dog leaps up to lap at the blood. The gruesomeness of the detail belies, and at the same time accentuates, the sophisticated elegance and balance of the composition.

The painting, dating from about 1820, is a simpler rendering of the god, this time with two major animal companions: the large brown dog with a curly tail that runs alongside him, and the colossal green parrot upon which he rides (an Indian ring-necked parakeet, *Psittacula krameri manillensis*). The dog wears a collar with a pendant, perhaps a bell. Shiva wears a tiger-skin and a long necklace of skulls, and carries weapons and his skull-cup in his hands. In the background is a beautiful park-like landscape with blossoming trees.

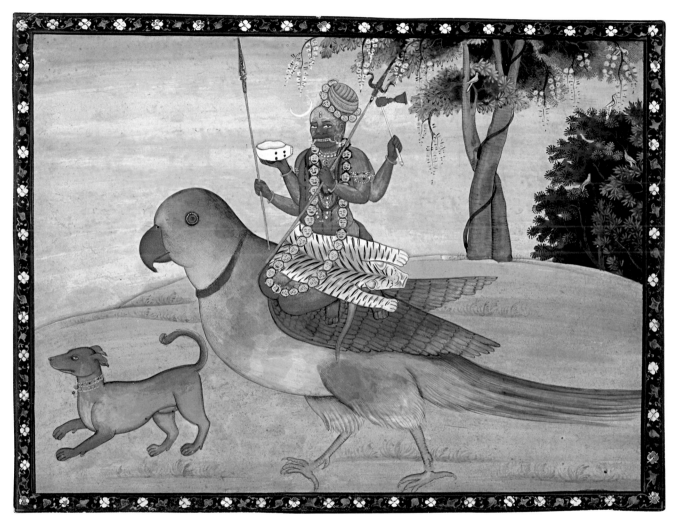

OPPOSITE
Cast bronze sculpture of the god Shiva.
Karnataka, Southern India, *c*. AD 950.
Deccan, India.
THIS PAGE
Shiva riding a parrot.
Painting on paper.
Indian, *c*. 1820.
Punjab Hills, India.

DOGS AND GODS

RELIGIOUS observances include all the rituals that people enact in order to obtain the help, favour and protection of their deities. The charming Japanese *maneki-neko* figures (brightly painted sitting cats beckoning with one raised paw) are well known outside their native country, but dogs, too, feature in certain contexts as amulets and magical talismans in modern Japan, and are sold at some religious shrines. Both objects shown here are modern, made at the beginning of the twenty-first century. The tiny clay dog standing on a green silk cushion is similar in style and decoration to many of the cat figurines; his rounded, simplified shape is cartoon-like, and his vivid colours are eye-catching. Eyes, nose, mouth and whiskers are painted in bright colours on the white background, and he has a spotted bib on his chest and a boldly stylized pink and red flower on each side of his rump. Little dog amulets of this kind are valued in particular for the protection of children. Some of these dogs are designed to be worn on a cord, but this one is intended to be placed on a flat surface.

The other objects are printed paper envelopes containing divination slips (*omikuji*), which may be purchased at the shrine of Kotohira-cho. These texts set out detailed personalized predictions after the manner of a horoscope: if the predictions are favourable, the purchaser keeps the

こんぴらぐ开運みくじ

slip; if they portend unlucky events, they are left at the shrine so that the misfortune is contained and not carried away. The dog symbolizes the site, and his name, Kotohira-inu (Kotohira Dog), is inscribed on the envelopes. Unlike the highly stylized little amuletic dog, this animal is a realistic representation of a dog of known type, the Japanese Akita, with his thick coat, wolf-like head and curled tail.

OPPOSITE
Amuletic figure in painted clay, with silk.
Japanese, 21st century (2000–2001).
Monju-do, Japan
THIS PAGE
Printed paper envelopes and divination slips.
Japanese, 21st century (2000–2001)
Kotohira-cho, Japan.

MYTHS AND MONSTERS

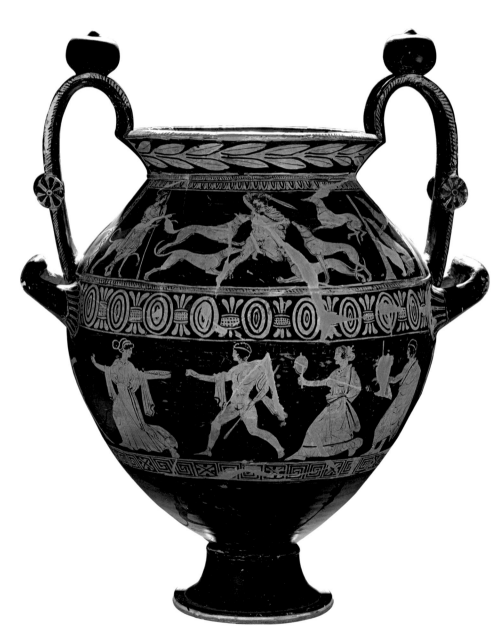

ONE of the Classical myths that continued to fascinate people in later ages was the story of Actaeon. Out hunting one day, this Theban prince inadvertently came upon the goddess Diana bathing in a pool. In some Greek versions of the legend, he spied upon the naked goddess for a while before he was discovered, but in the version that became most familiar to later ages, that of the early Roman poet Ovid in his *Metamorphoses*, Actaeon caught only a brief and fortuitous glimpse. Nevertheless, his punishment was extreme.

Artemis/Diana transformed him into a stag, and his own hounds turned on him and devoured him. In addition to the obvious sub-texts about guilt and divine wrath, the story may, more prosaically, reflect the fact that packs of hounds could, on occasion, become wild, uncontrollable and dangerous.

The death of Actaeon appears regularly in art, not only in antiquity,

THIS PAGE
Red-figure pottery *nestoris* (wine jar) with a scene showing the death of Actaeon, by the Dolon Painter.
South Italian Greek (Lucanian), 390–380 BC.
Basilicata, Italy.
OPPOSITE
The death of Actaeon.
Marble.
Roman, 2nd century AD.
Monte Cagnolo, Italy.

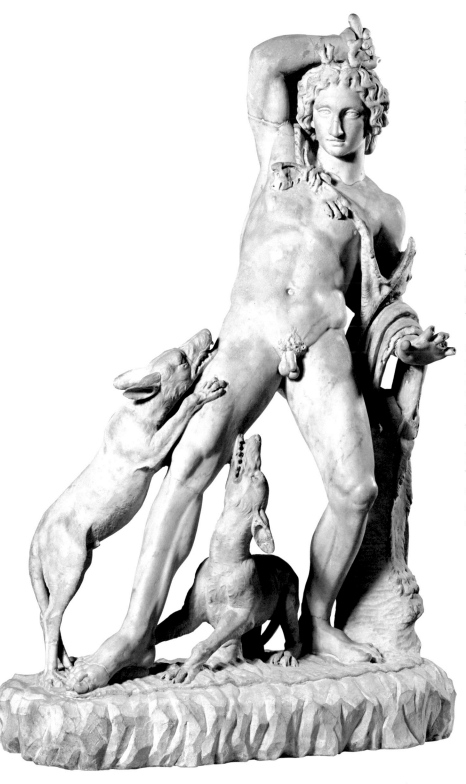

but also in the Renaissance and later. On the Italian *nestoris* (wine-jar) of the fourth century BC, we see Actaeon brandishing his sword as he tries to fend off four attacking hounds. The antlers sprouting from his head show that his transformation into a stag has begun. Three more dogs occupy the right of the scene, while the goddess stands to the left, accompanied by another. The animals are all very large and smooth-coated, with pricked ears and long, slightly curving tails. They wear collars.

The small marble statue belongs to the Roman period, and comes from the villa of the emperor Antoninus Pius (*r*. AD 138–61) at Monte Cagnolo. Actaeon's pose as he defends himself is close to that in the earlier vase-painting, though here there are only a token two hounds – not very large animals, though snarling savagely. The statue was once in the collection of Charles Townley, one of the major early nineteenth-century benefactors of the British Museum.

MYTHS AND MONSTERS

THE phrase 'between Scylla and Charybdis' is still used to describe a difficult course to be steered between two menaces. In Greek myth, Scylla and Charybdis were gruesome sea-monsters that lay in wait for craft passing through a very narrow strait, usually identified as the Straits of Messina, between Italy and Sicily. The vast maw of the whirlpool Charybdis could engulf and destroy whole ships, but, in avoiding her, at least some of the hapless sailors would come within reach of Scylla's savage fangs.

Written descriptions of Scylla are almost impossible to visualize, bizarrely combining canine heads and legs and one or more fish-tails, as well as elements of the nymph she had once been before the jealous sorceress Circe transformed her into a monster. The image on an Italian red-figure vase is much simplified: Scylla is simply a nymph to the waist and a fish beyond that point; instead of a ring of six snarling dog- or wolf-heads around her middle, there is just one, the head of a *ketos*, a wolf-like mythical sea-monster. She brandishes a steering-oar and a cuttlefish.

The scene on a Roman bronze dish is more detailed and dramatic, illustrating the moment when Scylla attacked six of Odysseus's sailors after they had successfully avoided Charybdis. She has two huge, coiled fish-tails, in which one of the sailors seems to be entwined, while three more are seized by the dogs that girdle the monster's hips. Scylla holds one man by his hair, and her other arm is raised to strike him. The eyes of the dogs and the drowning men are inlaid in silver, and the roundel is framed by an ornamental border.

MYTHS AND MONSTERS

THE Senmurw or Simurgh was an ancient and benevolent creature of Persian legend, which had the head of a dog, canine or leonine legs and claws, and the wings, body and large, feathery tail of a peacock-like bird. This dog-bird had lived so long that she had already witnessed the destruction of the world three times, and knew the wisdom of all the ages. The Senmurw's mythology was intertwined with that of the *Hom*, the Tree of Life. As well as being a mediator between earth and sky, she had powers to promote healing, fertility – especially the growth of plants, for the beating of her wings scattered seeds across the earth – and the legitimizing of earthly rulers. She played a pivotal role in the legend of the birth of the great Persian hero Rustam. The exact appearance of the celestial dog-bird evolved over the centuries, becoming gradually more dragon-like. She first appears in art as a motif on luxury textiles

THIS PAGE
Senmurw on a chased and parcel-gilt silver dish. Sasanian, *c.* 7th century AD.
OPPOSITE
Architectural ornament of moulded stucco (plaster). Umayyad, 7th– 8th century AD. Chal Tarkhan, Iran.

towards the end of the Sasanian period, which began in AD 224 and came to a gradual end in the middle of the seventh century AD with the invasions of Islamic Arab armies. The partially gilded silver plate was probably made in the seventh century, and represents the creature's strange, heraldic beauty, with a delicate pattern of feathers and a foliate tongue protruding from her canine mouth. Sasanian craftsmanship in precious metal was of the highest order,

and has some similarities with the contemporary work of the late Roman and Byzantine world.

Sasanian styles of art and architecture persisted well into the early Arab period, and the motif on the moulded stucco (plaster) architectural ornament from a seventh- or eighth-century building of the Ummayad dynasty remains very like the Senmurw on the silver plate, enclosed within a decorative roundel.

MYTHS AND MONSTERS

IN ancient Mesopotamia, dogs were thought to belong to the same group of animal species as lions, and the appearance and courage of the lion is also often mentioned in connection with the little Pekinese. The Chinese 'Dogs of Fo' are more leonine than canine, yet they cannot be omitted from any survey of mythical and monstrous dogs. Statues of these hybrid creatures have been used as guardians and protective spirits in China since the Han Dynasty (206 BC–AD 220), often flanking gateways and doorways into temples and other buildings of importance. They are usually represented in pairs, male and female, the male holding a ball under his paw, and the female a cub.

The two standing lion-dogs are porcelain miniatures made in the late seventeenth or early eighteenth century, and are coloured in vivid tones of yellow, green and purple. They incorporate tubes for incense-sticks at the back, and would therefore have scented the room in which they were placed as well as protecting it from evil forces. The male

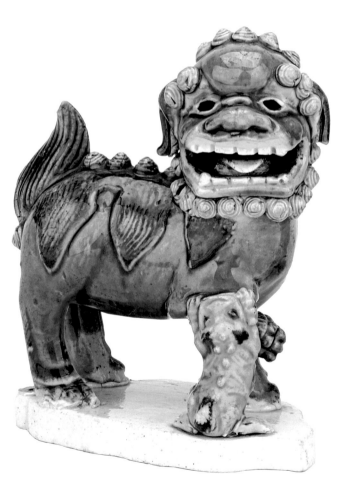
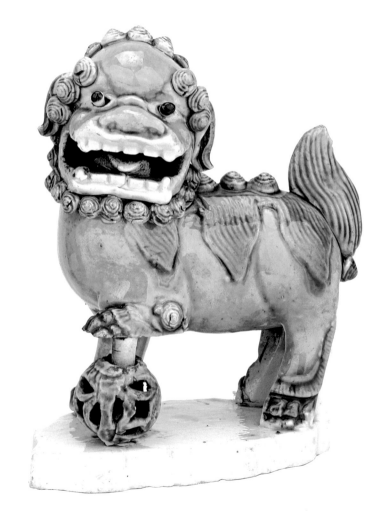

has a moveable ornamental globe beneath his paw, and a small cub reaches up against the female's leg. Exotic Chinese artefacts like these, in a style that was completely alien to Western artistic traditions, were popular in 18th-century Europe. A slightly more elaborate seated pair in white porcelain is illustrated on page 29.

The other beast, made of glazed stoneware, is not a typical lion-dog, though it was probably intended to depict one. It, too, is of seventeenth- to eighteenth-century date.

It seems to have a good deal more dog than lion in its ancestry. The treatment of the shaggy coat and the mouth makes one wonder whether, despite its appealingly grotesque face, a real dog of Pekinese type provided the artist's inspiration.

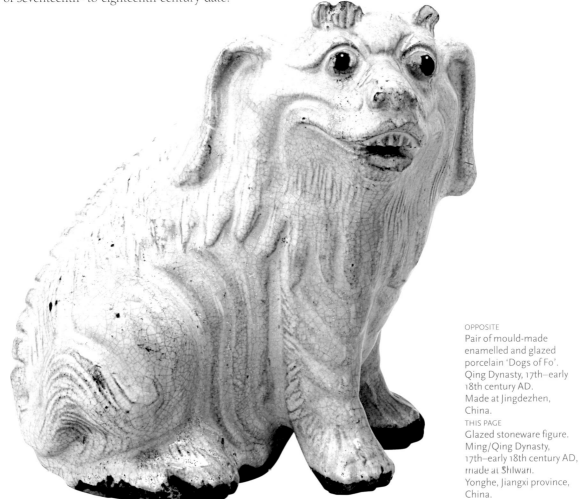

OPPOSITE
Pair of mould-made enamelled and glazed porcelain 'Dogs of Fo'. Qing Dynasty, 17th–early 18th century AD. Made at Jingdezhen, China.
THIS PAGE
Glazed stoneware figure. Ming/Qing Dynasty, 17th–early 18th century AD, made at Shiwan. Yonghe, Jiangxi province, China.

MYTHS AND MONSTERS

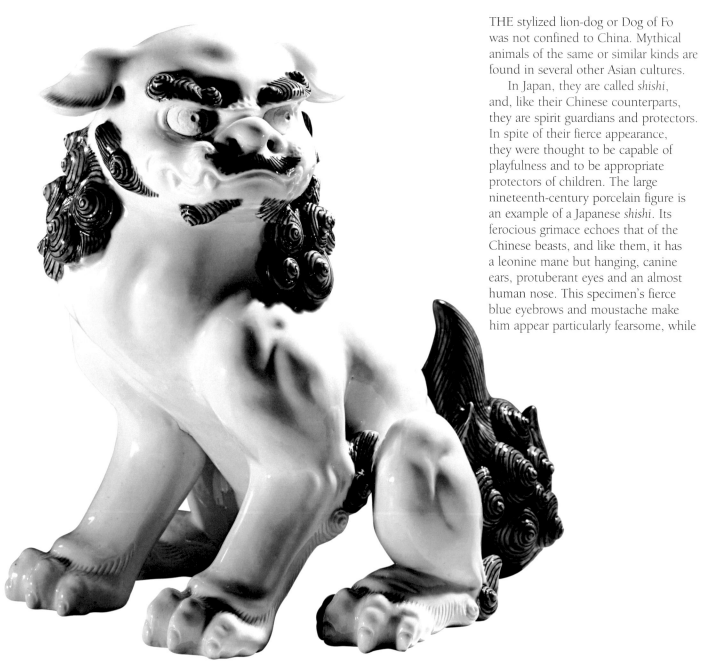

THE stylized lion-dog or Dog of Fo was not confined to China. Mythical animals of the same or similar kinds are found in several other Asian cultures.

In Japan, they are called *shishi*, and, like their Chinese counterparts, they are spirit guardians and protectors. In spite of their fierce appearance, they were thought to be capable of playfulness and to be appropriate protectors of children. The large nineteenth-century porcelain figure is an example of a Japanese *shishi*. Its ferocious grimace echoes that of the Chinese beasts, and like them, it has a leonine mane but hanging, canine ears, protuberant eyes and an almost human nose. This specimen's fierce blue eyebrows and moustache make him appear particularly fearsome, while

the exuberant curls of his blue mane and tail seem to have a life of their own, clouds and flames of blue erupting from the muscular white body.

The carved and painted head on the ivory hilt of an eighteenth-century dagger from Sri Lanka must be a cousin, for it is certainly not a natural dog of any breed. Its pop-eyed glare and savage, wide-mouthed snarl are those of the lion-dog, and as part of a weapon, its image must have been valued both as a defender of its owner and an aggressor against his enemies. The knife is a valuable, luxury object; the hilt below the head is intricately decorated, and the weapon has a steel blade and a velvet-covered, silver-mounted sheath.

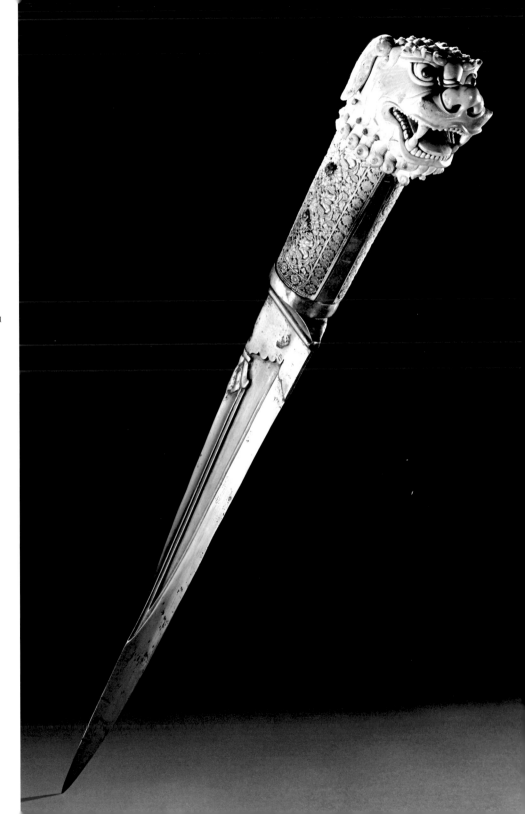

OPPOSITE
Porcelain *shishi* with underglaze blue colouring. Made at Mikawachi, Japan, 19th century.
THIS PAGE
Knife with carved and painted ivory hilt and steel blade. Sri Lanka, 18th century.

MYTHS AND MONSTERS

THE lion-dog or Dog of Fo was a being of good omen whether it appeared as a large statue guarding a gateway or as a small decorative or useful object on the desk of a scholar.

The seventeenth-century rock-crystal (clear colourless quartz) Chinese lion-dog is interesting for several reasons. It is a functional object, a seal, as well as a decorative and apotropaic one – that is, an amulet to avert ill fortune. Printed seals had been used for many centuries in China in place of signatures for a wide variety of official and personal purposes, so seals made from metal, stone and wood were common articles of use there. This example is carved in a fairly simple style with a standing animal that looks more naturalistically dog-like than most lion-dogs. It belonged to Sir Hans Sloane (1660–1753), who, like many cultured men of his time, was keenly interested in all the emerging areas of study and knowledge, from natural history and antiquities to the art and cultures of foreign lands, and collected objects pertaining to all those interests. Sloane's collection formed the basis of the British Museum.

The other seal is made of ivory, and depicts the Japanese lion-dog, the *shishi*. This eighteenth-century object was probably inspired by Chinese seals, but it also has another practical purpose, one specific to Japanese society, as it is also a *netsuke*, a toggle that formed a part of the costume.

MYTHS AND MONSTERS

CERBERUS (the 'demon of the pit') was the hound of Hades who guarded the gates of the Graeco-Roman Underworld and ensured that spirits could enter, but that none could return to the land of the living. He was a monstrous dog with a mane of serpents; some accounts credit him with as many as fifty heads, but only three are usually shown in art. The twelfth and final labour of Hercules was to capture this formidable beast without the use of weapons, and to lead him out of Hades. Unlike most of the creatures that did battle with Hercules, Cerberus was not killed, but merely subdued: he eventually returned to his task of guarding the portals of the Underworld.

The painting on the black-figure Athenian amphora from the fifth century BC shows the scene. Cerberus, depicted here with only two heads, is a lean and graceful animal, with a long, waving serpent-tail, and a mane of serpents extending along his back. Though Hercules has attached a short chain to one of his two collars, little effort seems to be needed to abduct Cerberus, who is walking obediently to heel. Mercury, in his role as the guide of souls, looks on with interest, as does Persephone. The whole image is one of somewhat mannered elegance.

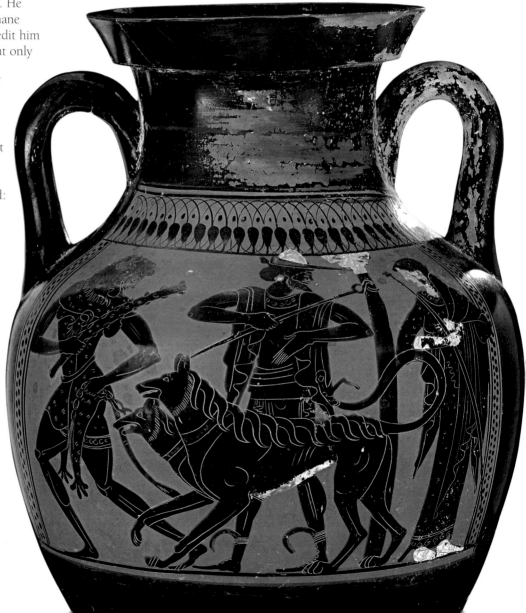

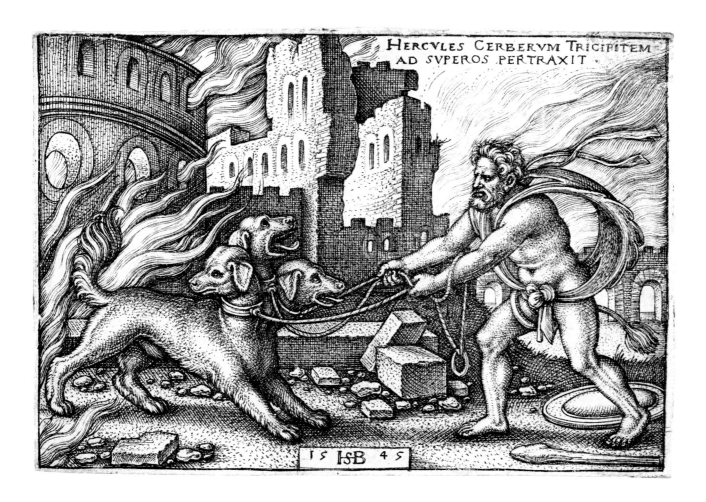

HERCVLES CERBERVM TRICIPITEM
AD SVPEROS PERTRAXIT .

IS IsB 45

The splendid German engraving of 1545 by Sebald Beham, shown here at an enlarged scale, depicts a chaotic and nightmarish vision of the same episode. Hercules, his powerful muscles rippling, drags at ropes attached to the hound's three collars against a non-Classical backdrop of the gates of hell – not the subterranean caves of antiquity, but a ruinous, windswept urban landscape of walls and towers engulfed in flames. Cerberus himself, though large, triple-headed and undoubtedly dangerously fierce, looks much like an earthly mongrel with his floppy ears and plumed tail. Sebald Beham and his brother Barthel were leading engravers in sixteenth-century Nuremberg, and their work shows strong Classical influence.

OPPOSITE
Black-figure pottery amphora with a scene of Cerberus and Hercules by the Eucharides Painter.
Greek (Athenian), c.490 BC.
Aegina, Greece.
THIS PAGE
Sebald Beham (1500–50): Engraving from *The Labours of Hercules*, 1545.

CERBERUS, the triple-headed canine guardian of Hades, prevented ordinary departed souls from returning to the world above, but there were several occasions on which he was outwitted and his vigilance undermined. Hercules led him out of Hades as one of his labours. Hermes, who, as a god, could move freely between the realms of the living and the dead, once lulled Cerberus to sleep with a drink of water from Lethe, one of the rivers of the Underworld. On another occasion Orpheus's enchanted music had a similar effect, while both the Cumaean Sybil and Psyche chose the prosaic method of feeding him honey-cakes containing a soporific drug. The Hound of Hades evidently had a sweet tooth.

The little Roman statuette of Cerberus represents him as a very ordinary-looking dog, apart from his two extra heads. There has been no attempt to evoke a creature of terrifying size and ferocity, and it is all too easy to imagine

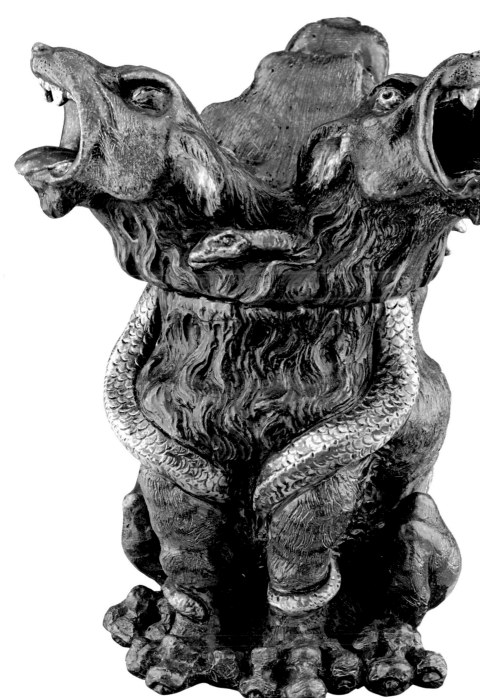

OPPOSITE
Cast bronze figure of
Cerberus.
Roman, 1st–2nd century AD.
Rhodes.
THIS PAGE
Salt-glazed stoneware lidded
jar in Martinware.
English, made at the Fulham
Pottery, London, 1870–1920.

him eagerly catching a casually tossed, drugged honey-cake in his jaws and barking for more.

The horrible, grotesque creature in the other illustration is a very different matter: it is Cerberus as envisaged by the four Martin brothers who established a studio pottery in Fulham, London, in the 1870s. Their distinctive products, known as Martinware, were made until the 1920s, and the lidded jar in salt-glazed stoneware is typical of their work: imaginative, bizarre and technically highly accomplished. Their late Victorian Cerberus owes more to the monstrous, misshapen gargoyles of medieval architecture than to any Classical tradition. The gaping jaws of his savage heads reveal sharp white fangs, and his bulky, muscular body is entwined with glistening blue-and-green snakes. It is hard to imagine anyone distracting this hellhound with honey-cakes, however delectable.

JACKALS

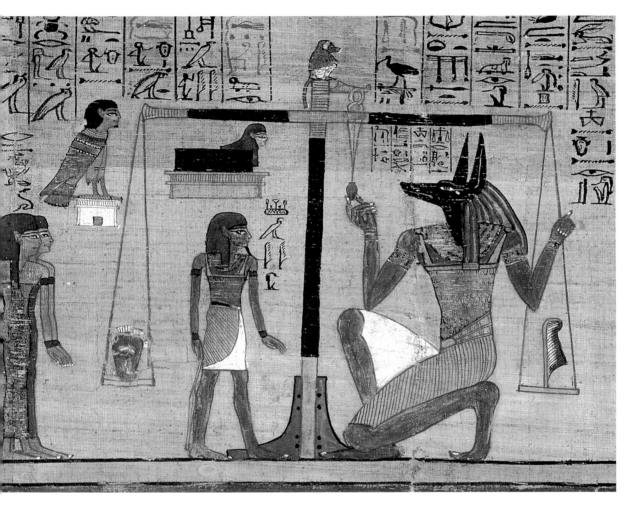

THIS PAGE
Scene from the Book
of the Dead of Any.
Egyptian papyrus, 19th
Dynasty, c. 1275 BC.
Thebes, Egypt.
OPPOSITE
Painted wooden figure
of Anubis.
Egyptian, Late Period
(c. 525–332 BC).

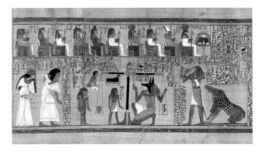

DOGS and other canine animals have been associated with the threshold between life and the afterlife in many human cultures, moving between the planes of existence as they move between the worlds of animals and humankind. The ancient Egyptian god Anubis was depicted in art as a black jackal, or a jackal-headed human figure, with a long, pointed muzzle and very large, narrow, upstanding ears. He fulfilled a number of vital roles in the Egyptian perception of death: it was he who weighed and judged the heart of the deceased person, who supervised the vital task of embalming the body, and who acted as the guide and protector of the departed soul.

The wonderful painting on papyrus is from a Book of the Dead, placed in the tomb of a man named Any who died at Thebes during the 19th Dynasty, around 1275 BC. Such documents, sometimes exquisitely illustrated like this, contained the correct spells for ensuring that a soul reached the afterlife safely. This scene shows one of the stages through which the soul must pass: Anubis weighs the heart of Any against the feather of Maat, representing order and justice, in the presence of several deities, including Osiris himself, the god of the Underworld. If the heart and the feather failed to balance, the heart would be consigned to the Devourer, a nightmarish creature combining crocodile, lion and hippopotamus which waits behind the ibis-headed god Thoth. Here, they balance, and the soul may continue its ordained journey.

The other illustration shows Anubis in his fully canine form, a black jackal that originally reclined on the lid of a box. This wooden object also had a funerary purpose, and would have been made for inclusion in the furnishings of a tomb.

JACKALS

IN the majority of cultures, amulets depicting or referring to gods were believed to have the power to protect those who wear or carry them. Both the small amulets shown here depict the jackal-headed god Anubis, the Egyptian deity of embalming and the guide and protector of souls, and both are made of faience, a glazed ceramic material which was used for both functional and decorative objects in Egypt.

The amuletic figure shows the god in his form as a man, wearing a kilt and with the head of a jackal. It is in the colour most often associated with faience, a vibrant turquoise, and is pierced at the back for suspension.

The plaque is made of yellow and blue faience, and shows Anubis in the form of a recumbent jackal. The winged *wedjat* eye of Horus above him represents resurrection, while the yellow colour refers to the sun, the regular rising of which is also linked

with the concept of rebirth. This decorative item was not intended as jewellery for everyday use by the living, but as a pectoral amulet forming part of a necklace that was laid on the chest of a mummy. Its protective power would therefore be focused on the soul of the deceased person, ensuring its safety and health in the afterlife. Originally used for royal mummies, by the time of the New Kingdom (1550–1070 BC) such necklaces were also placed on the bodies of people of the elite classes.

JACKALS

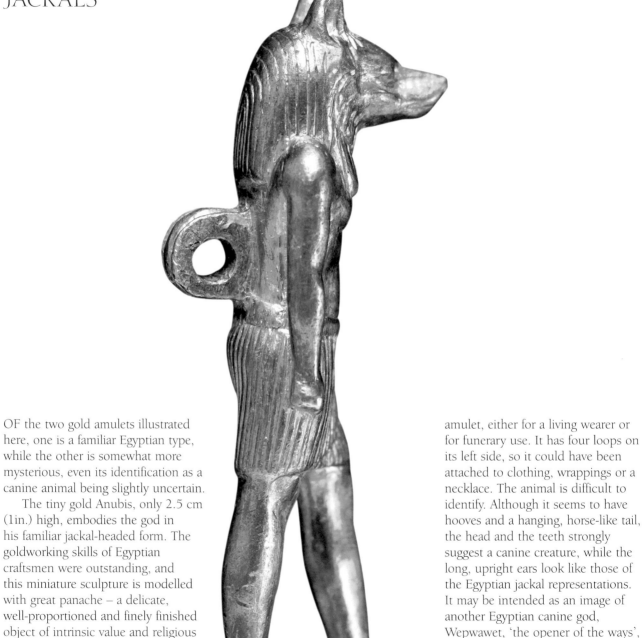

OF the two gold amulets illustrated here, one is a familiar Egyptian type, while the other is somewhat more mysterious, even its identification as a canine animal being slightly uncertain.

The tiny gold Anubis, only 2.5 cm (1in.) high, embodies the god in his familiar jackal-headed form. The goldworking skills of Egyptian craftsmen were outstanding, and this miniature sculpture is modelled with great panache – a delicate, well-proportioned and finely finished object of intrinsic value and religious power, created some 3,000 years ago, during the 21st or 22nd Dynasty.

The other gold figure was also an amulet, either for a living wearer or for funerary use. It has four loops on its left side, so it could have been attached to clothing, wrappings or a necklace. The animal is difficult to identify. Although it seems to have hooves and a hanging, horse-like tail, the head and the teeth strongly suggest a canine creature, while the long, upright ears look like those of the Egyptian jackal representations. It may be intended as an image of another Egyptian canine god, Wepwawet, 'the opener of the ways', who was perhaps a wolf, perhaps a jackal, and was sometimes conflated with Anubis himself as an

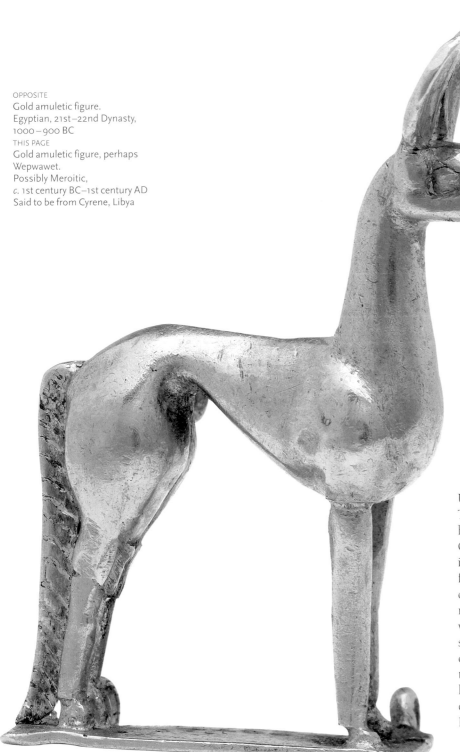

Underworld god and guide of souls. The little gold pendant is said to have been found at Cyrene, a major Greek city in modern Libya, and it is very similar to some gold figures from Meroe, the ancient centre of the Meroitic culture of Nubia, in modern Sudan. We do not know where it was made, or its full religious significance, but it is another example of an exquisite and precious ornament that is based on a canine form and had spiritual meaning. It probably dates from about the first centuries BC or AD.

JACKALS

NOT all jackal-headed gods from ancient Egypt represent Anubis, though all were connected with death and the afterlife. Wepwawet was also a canine god, and so was Duamutef, one of the Four Sons of Horus, who had a specific role in the mummification and burial process.

The Canopic jar is one of the set from the tomb of a woman named Neskhons, the wife of a High Priest of Amun. Neskhons died during the 21st Dynasty, between 1069 and 945 BC, and her name and titles are inscribed on the jar. When a corpse was embalmed, its liver, lungs, stomach and intestines were treated separately and were placed with the mummy, stored in sets of four jars protected by the Four Sons of Horus. These deities are represented in the superbly carved and painted lids of the jars. The human-headed god, Imsety, protected the liver; Hapy, with the head of a baboon, was responsible for the lungs; Duamutef, in jackal-headed form, and hawk-headed Qebehsenuef, presided over the preservation of stomach and intestines respectively.

Only a little later, this particular ritual was varied, and the deceased's viscera were returned to the body after embalming, but their protection by the Sons of Horus was still invoked by placing amulets depicting these gods on the body. The four large faience amulets, each around 14.5 centimetres (nearly 6 in.) high, are particularly fine examples. They are mould-made, and are provided with holes on the back to enable them to be sewn to the mummy wrappings. Details of the heads, and the wigs and broad collars which they wear, are boldly picked out on the white material in blue and black. Duamutef's jackal head is black, with a large, alert eye and sharply pricked ears.

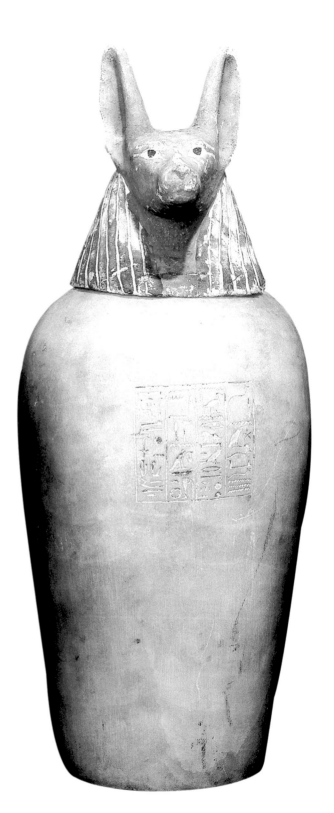

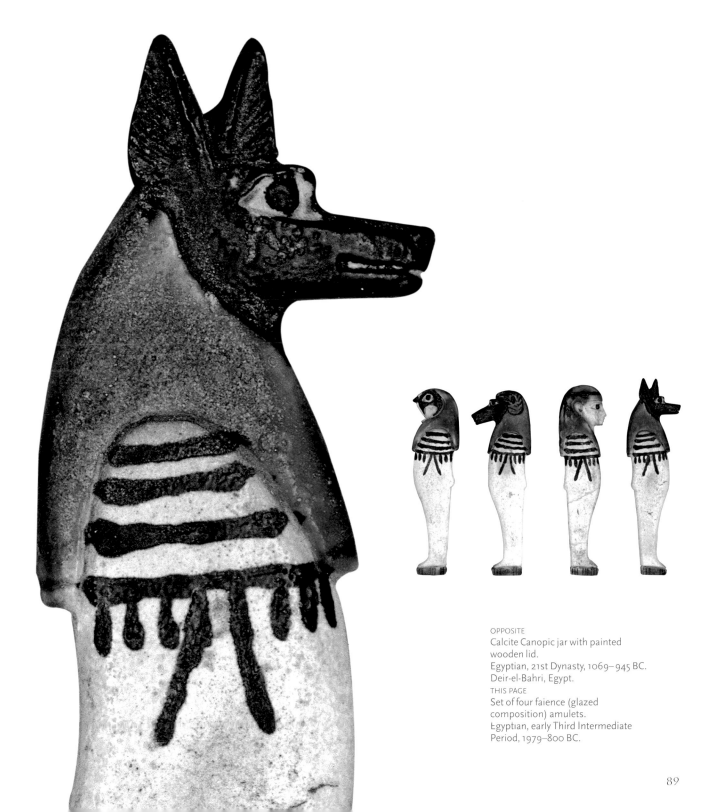

OPPOSITE
Calcite Canopic jar with painted
wooden lid.
Egyptian, 21st Dynasty, 1069–945 BC.
Deir-el-Bahri, Egypt.
THIS PAGE
Set of four faience (glazed
composition) amulets.
Egyptian, early Third Intermediate
Period, 1979–800 BC.

JACKALS

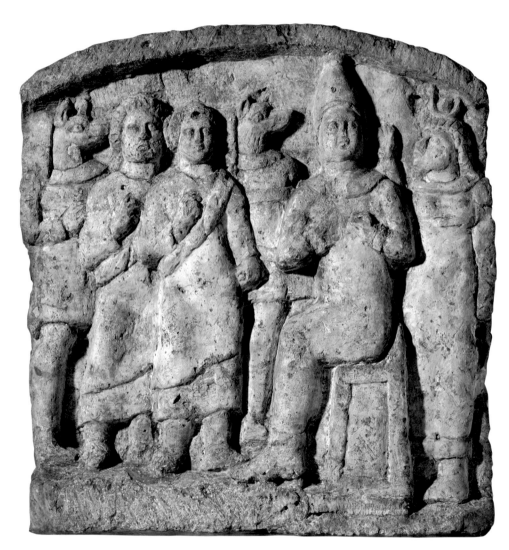

AFTER its long period of greatness as a unique culture, Egypt was influenced first by the Greeks, then by the Romans when it became a Roman province in 30 BC, and ultimately by the Arabs, who arrived in the seventh century AD. But cultural influences operate both ways, and the religion and art of ancient Egypt have had their own complex and lasting impact on all those from elsewhere who came to know the country.

The Egyptian grave stela illustrated is from the early Roman period, and it commemorates two departed souls, a man and a woman, probably husband and wife. They are shown being presented to Osiris and Isis as they embark on their journey into the next life, and each is accompanied by a jackal- or dog-headed god, Anubis, who acts as soul-guide and protector. The religious concept is wholly Egyptian, though the style of the carving is heavily influenced by

OPPOSITE
Limestone grave stela.
Romano-Egyptian, 1st–2nd century
AD.
Abydos, Egypt.
THIS PAGE
Mould-made
terracotta lamp.
Roman,
late 1st century AD.
Made in Campania, Italy.

Graeco-Roman traditions. Osiris, seated on a throne, wears a crown and turns to face the viewer; Isis wears her horned-disc headdress, and the two Anubis figures wear short tunics. Representations such as this, combining Egyptian and Classical imagery, probably had some input into later Christian mythologies of dog-headed saints.

The oil-lamp likewise bears classicized Egyptian imagery, but it was made in Italy and illustrates the spread of the worship of Isis far beyond Egypt itself. The goddess occupies the centre of the scene, flanked by Harpocrates and Hermanubis, the latter a canine-headed deity who was a conflation of the ancient Anubis with the Greek god Hermes, also a guide and protector of souls in the afterlife.

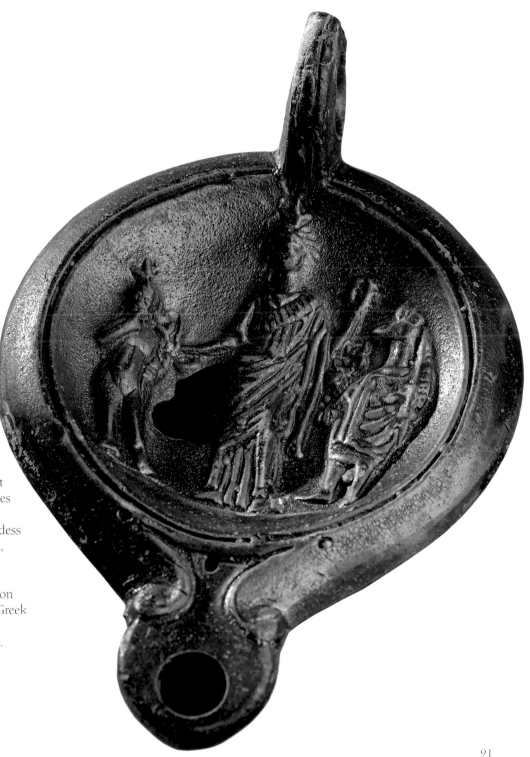

JACKALS

JACKALS played an important part in the mythology and art of ancient Egypt, but they were less significant, and therefore less commonly depicted, in other cultures. It can be difficult to distinguish a representation of a jackal from that of a dog or fox.

The mould-made figure of a seated canine animal, made of fine white pipeclay, was manufactured in the Roman period in the Allier Valley of central France. Small white terracotta figures of deities and other subjects, including a variety of animals, were produced there in large numbers in the first and second centuries AD; many were probably originally painted in bright colours. While some of these figures are undoubtedly dogs, those sitting in a noticeably upright and hunched posture like this one may be jackals; they have even been incorrectly described as cats. Because the worship of Isis became widespread in the Roman world, references to Egyptian deities were found far from Egypt, and this little creature could easily be a Gallo-Roman Anubis.

The page of beautiful medieval Persian painting and calligraphy has no connection with Egypt. It is from a book of animal fables, ultimately of Indian origin, recounting stories of the jackals Kalilah and Dimnah, who lived in the kingdom of the lion. Fables had a didactic purpose and conveyed advice in an attractive and entertaining form. Dimnah, a favourite of the king, is charged with finding the source of an annoying noise, and traces it to the bellowing of the ox Shanzabeh, whom he brings back to the lion's court. As a result, Dimnah eventually finds himself supplanted in the king's favour by Shanzabeh. The upper painted panel shows Dimnah confronting Shanzabeh, and the lower depicts the ox before the lion king. The rich colours, floral backgrounds and elegantly depicted animals express a characteristically Persian tradition in painting.

OPPOSITE
White terracotta figurine.
Gallo-Roman.
Made in the Allier Valley,
France, c. 2nd century AD.
THIS PAGE
Manuscript page from
the fable *Kalilah wa
Dimnah* of Nasr Allah.
Watercolour and ink
on paper.
Shiraz, Persia, AD 1333.

ابن شبر کفت ملک سباع شنزیه بترسید که ذکر شیرو سباع شنوذ دنده را کفت اکر بخو بی دل

که دلنی داز باس او ابن کنی با ته تیا بر دنه با او وثبق کرد و شرایط نا کید و احکام اندران

بجای آورد و هر دو درو ی بجانب شیر او ردند جون نزدیک شیر رسید دسم خدمت بجای آوردند

شبر کاو را کرم بر سید و کفت بذین نواجی کی آید و موجب امدن چه بوده است و قصه باز کفت

شیر کفت ایا مقام کن تا از سفت و اکرام و انعام ما نصیب یابی کا و دعا کنت و گرمتر

بطوح دعبت بسبب شیر او وانو بشتن نزدیک کردانبن و دراعناز و ملاطفت او اطناب و مبا لنت

موذ و روی تفحص حال و استکشاف کار او آورد و اداره رای و خرد و نجربت و امتحان او شا

بس از نامل و مشاورت وند تبروا سخارت او بار کان نقاده و مرم اسرا رخوش کردانبن

WOLVES

THIS PAGE
Two wolves.
Watercolour and
bodycolour drawing
on vellum.
Italian (Lombard),
c. 1400 AD.
OPPOSITE
Wolf.
Painting, with gilding.
Persian, Isfahan School,
c. 1675.

WOLVES seem very familiar to us, because they look so like many of the friendly and affectionate dogs we know well, and yet they are also remote and sinister – symbols of the wilderness and its impersonal power and imbued with ancient associations of myth and legend.

The medieval European painting shown here depicts two wolves with careful realism. The vellum sheet is thought to be from a sketch-book, perhaps a collection of visual references for artists, compiled in Lombardy, central north Italy, around AD 1400. Two domestic dogs, a greyhound and a mastiff, are painted on the other side of the leaf (see page 121). Both wolves have a satisfyingly solid and three-dimensional appearance, as well as a delicate precision of line.

The reclining wolf, with his head raised to howl, in many respects resembles the Persian wolf in the other illustration. This wolf dates from about 1675, a period in which there was a certain amount of European influence on Persian painting, and animal studies, portraits and flower compositions were all popular themes for inclusion in albums. Drawn, like his European ancestor, with elegant line and delicately sharp detail, the wolf is set within a panel and frame embellished with formal gilded patterns of leaves and flowers.

WOLVES

THE painstakingly accurate visual representation of a subject may be intended to analyse its appearance in a dispassionate, scientific way, but the same subject may also be used symbolically, to evoke emotional responses. The image of a wolf, far more than that of a domestic dog, can arouse many reactions in a viewer that hark back to atavistic fears and the memory of eerie folk-tales and legends.

The meticulous pen-and-ink study of a seated wolf by the Genoese artist Sinibaldo Scorza (1589–1631) is an example of objective artistic analysis. The wolf and the sensitively drawn dove on the same sheet exemplify the work of a person who was enchanted by the sheer beauty and harmony of nature and wished to record it in scrupulous detail. The sixteenth and seventeenth centuries in both southern and northern Europe saw a great surge of this kind of careful and objective artistic recording, and many artists became interested in observing animals and other aspects of nature with the same degree of attention that they paid to human subjects.

The other picture employs a totally different approach. The etching *Le Loup dans la Neige* ('The Wolf in the Snow') by the French artist Félix Bracquemond (1833-1914) was published in a series of modern French prints in 1864. The artist, also noted as a lithographer and a ceramic decorator, was interested

in the symbolic significance of the wolf, rather than the literal details of the animal's anatomy. His wintry landscape, with its bare trees and the solitary animal tracking across the snowy ground, is wholly emotional in its impact. We feel, as we are meant to feel, silence, deep chill and solitude. The wolf, usually a wild and potent image, is a mere speck on the landscape here, emphasizing the impersonal power of nature.

OPPOSITE
Sinibaldo Scorza (1589–1631):
Wolf.
Pen and ink, 1604–31.
THIS PAGE
Félix Bracquemond (1833–1914):
Le Loup dans la Neige.
Etching, 1864.

WOLVES

THE large bronze flagon (39.6 cm, about 15 1/2 in., high) is one of a matching pair known as the Basse-Yutz flagons and recognized as masterpieces of Celtic Iron Age art. They were found at Basse-Yutz, Lorraine, France, in 1927, and had probably been placed in the grave of a powerful local ruler around 400 BC. Because they were illegally excavated we know few details, but the set of wine-serving utensils, which also includes two Etruscan bronze vessels, expresses the sophistication of late prehistoric rulers in northern Europe and demonstrates their contacts with the Mediterranean world.

Though based on an Etruscan shape, the flagons were made in eastern France. The geometric coral inlays and the highly stylized wolves that form the handles and decorate the rims express the immensely confident and inventive art of the Iron Age Celts, which often transformed the more realistic representations of the Classical world into strange and abstract patterns. These wolves, their textured coats embellished with swirling lines, convey an other-worldly power.

The wolf seated on a tobacco pipe is likewise no mortal creature. Since wolves are important creatures in the lives and histories of the peoples of the North-West Coast of North America, they feature frequently in their art. This example, made of maple-wood with inlays of abalone shell, is a masterly sculptural composition: the snarling wolf, with his disturbingly anthropomorphized pose, is both part of the artefact and yet distinct from it, a wolf-spirit within the pipe coalescing into visible form. The smoker would have faced the intense glare of this fierce and vivid creature as he used the pipe.

WOLVES

THERE is a slight doubt about the identification of the 'wolves' on both the superb luxury objects illustrated here. We shall give them the benefit of the doubt.

The Braganza Brooch is a consummate masterpiece of gold jewellery, a product of the occasional convergence of Greek and 'barbarian' art and culture in the European Iron Age. The design of the jewel marks it as Iberian, and it was probably made in Spain or Portugal in the third century BC. But the impeccable craftsmanship appears to be that of a Greek goldsmith of the period, perhaps working to order

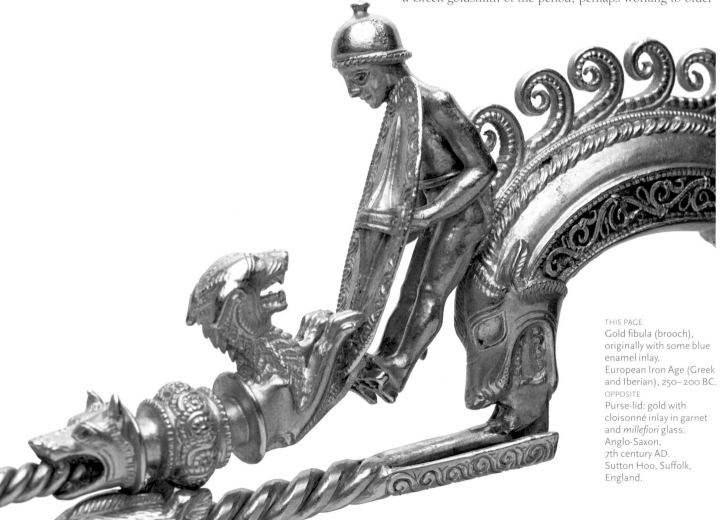

THIS PAGE
Gold fibula (brooch),
originally with some blue
enamel inlay.
European Iron Age (Greek
and Iberian), 250–200 BC.
OPPOSITE
Purse-lid: gold with
cloisonné inlay in garnet
and *millefiori* glass.
Anglo-Saxon,
7th century AD.
Sutton Hoo, Suffolk,
England.

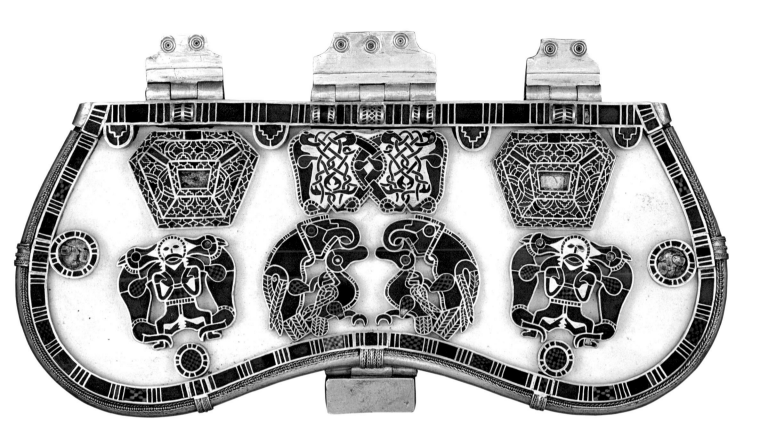

for a high-ranking local ruler. The naked warrior's shield and helmet are closely observed and are of distinctively Celtic types. The animal springing up before the warrior has been interpreted as his hunting hound, but might rather be an attacker, most likely a wolf. Two other wolf-like canine heads form the ends of the arched bow of the brooch, while the sliding catch for the pin is modelled as a boar's head.

Equally beautiful and mysterious is the purse-lid from the rich Anglo-Saxon burial at Sutton Hoo, Suffolk, in eastern England. The original lid, made to cover a leather coin-purse, was probably of whale-bone ivory, and its luxurious surviving fittings are made of gold, garnet and millefiori glass, matching other personal equipment from the burial. The two panels showing a hero between two rearing wild animals undoubtedly evoked legends unknown to us, and perhaps expressed totemic symbolism; though sometimes described as lions, the savage creatures look much more like the supernatural wolves that are so common in the myths and legends of northern Europe. The aristocracies of third-century BC Iberia and seventh-century AD England both displayed their wealth, power and status with exquisite goldwork, and with references to myths featuring wolves.

WOLVES

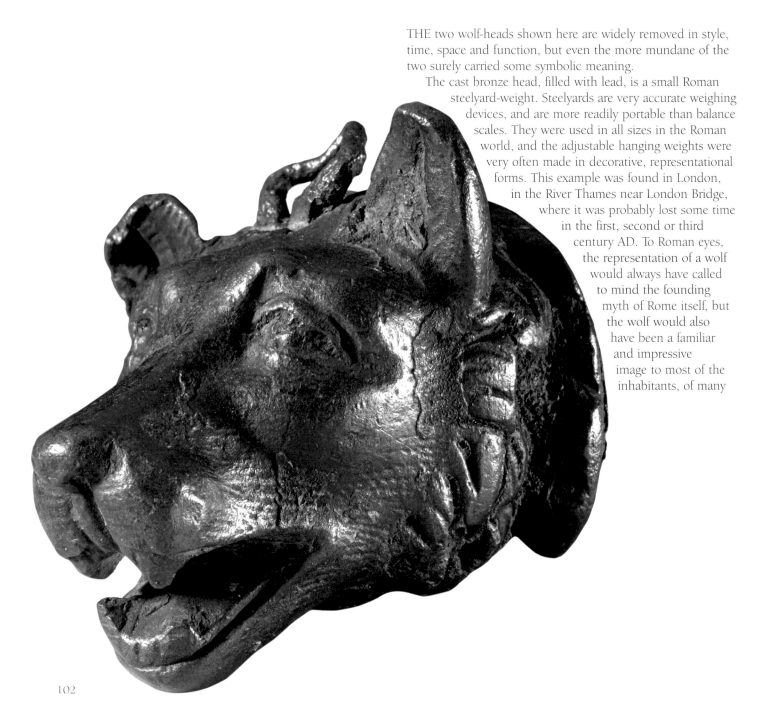

THE two wolf-heads shown here are widely removed in style, time, space and function, but even the more mundane of the two surely carried some symbolic meaning.

The cast bronze head, filled with lead, is a small Roman steelyard-weight. Steelyards are very accurate weighing devices, and are more readily portable than balance scales. They were used in all sizes in the Roman world, and the adjustable hanging weights were very often made in decorative, representational forms. This example was found in London, in the River Thames near London Bridge, where it was probably lost some time in the first, second or third century AD. To Roman eyes, the representation of a wolf would always have called to mind the founding myth of Rome itself, but the wolf would also have been a familiar and impressive image to most of the inhabitants, of many

different nationalities, who lived in Roman London.

The inlaid wooden wolf-head mask comes from a place and a people unknown to the Romans. Dating from the nineteenth century, it was a clan headdress probably worn during a potlatch, a ritual feast and ceremony of the native peoples of the Pacific North-West Coast of North America. Their powerful and sophisticated art is now recognized and admired far beyond modern Alaska and Canada, the lands where it originated, but an object like this was not made to delight the eyes of foreigners, but to help enact the rites of passage that are an important part of the community life of these northern nations. Wolves, along with ravens, salmon and bears, occupy a significant place in their culture.

WOLVES

A WOLF was central to the foundation-myth of ancient Rome. As with most myths and legends, the tale exists in several different versions, but all relate that the twins Romulus and Remus, sons of the god Mars and a royal priestess, Rhea Silvia, were at first deliberately abandoned, then assisted by various deities, nurtured and protected by a she-wolf, and finally rescued by a shepherd, who brought them up. Romulus was credited with founding the city of Rome in 753 BC. Remus died at that point, perhaps by his brother's hand. The visual imagery that refers to the legend is usually very simple and consistent: the standing she-wolf turns her head back towards the two human infants who sit beneath her, suckling at her teats.

THIS PAGE
Cast bronze statuette
of the wolf with Romulus
and Remus.
Roman, 1st–4th century AD.
OPPOSITE
Bronze disc with relief
ornament in *repoussé*
and chasing.
Romano-British, probably
1st–2nd century AD.
Moorfields, London, England.

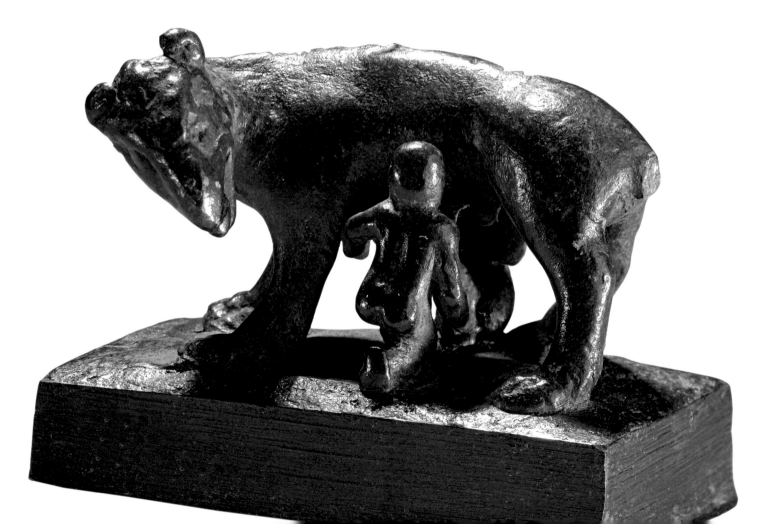

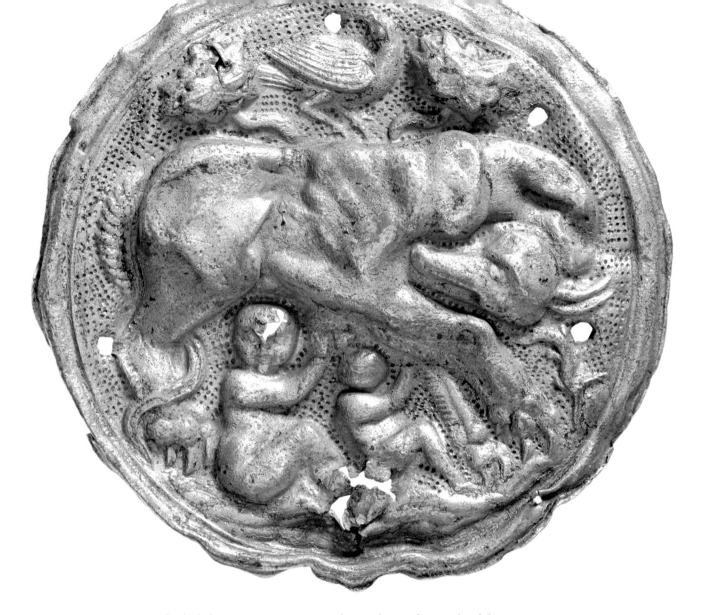

The little bronze statuette is a modest and typical example of this scene, one which is widespread in ancient Roman iconography and which still symbolizes the city of Rome today.

The somewhat damaged and battered bronze disc, found in London in the nineteenth century, is, by contrast, a more detailed representation of one version of the story. Intended as a decorative mount, perhaps for a piece of furniture, it depicts not only the wolf and the twins, but also a fig-tree and a bird. The fig-tree had caught and held the basket in which the infants had been floated onto the River Tiber; a woodpecker, sacred to Mars, assisted the wolf in feeding the children.

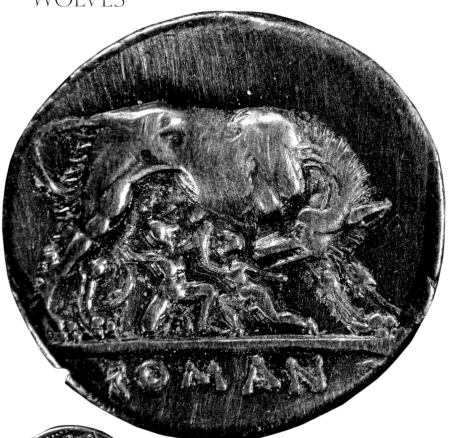

DESIGNS on coins helped to disseminate information and official propaganda in the ancient world. Portraits of rulers, news about important events, and pious invocations of divine protection were all part of the visual culture of the societies in which they were used. The iconic scene of the Wolf and Twins, referring to the founding of Rome, naturally appeared on some coins of the Roman Republic and the Roman Empire, but, more surprisingly, the image is not confined to Roman currency. Coins took on a status and authority of their own, and were sometimes imitated in societies that did not necessarily understand the full symbolism of their designs.

The beautiful silver *didrachm* of the Roman Republic, minted early in the third century BC, features the head of the hero Hercules on the obverse and a fine, detailed rendering of the Wolf and Twins on the reverse. The style is heavily influenced by Greek currencies, but the choice of reverse image is distinctively Italian, probably inspired by a statue that had been set up in Rome in 296 BC. Centuries later, the gold *aureus* of the emperor Maxentius (*r.* AD 306–12) foreshadows Byzantine practice in using a full-face image of the ruler on the obverse, but Romulus and Remus, with their lupine foster-mother, still grace the reverse, barely changed.

More remarkable is the third coin, a silver Anglo-Saxon penny of King Aethelberht II of East Anglia. Little is known about this minor king, though his death-date, AD 794, is recorded. Why did he, or his moneyer, select an ancient icon of the city of Rome for the reverse type of this coin? Probably because even in the late eighth century AD, the appearance of Roman coins was still familiar and still stood for legitimate power and authority.

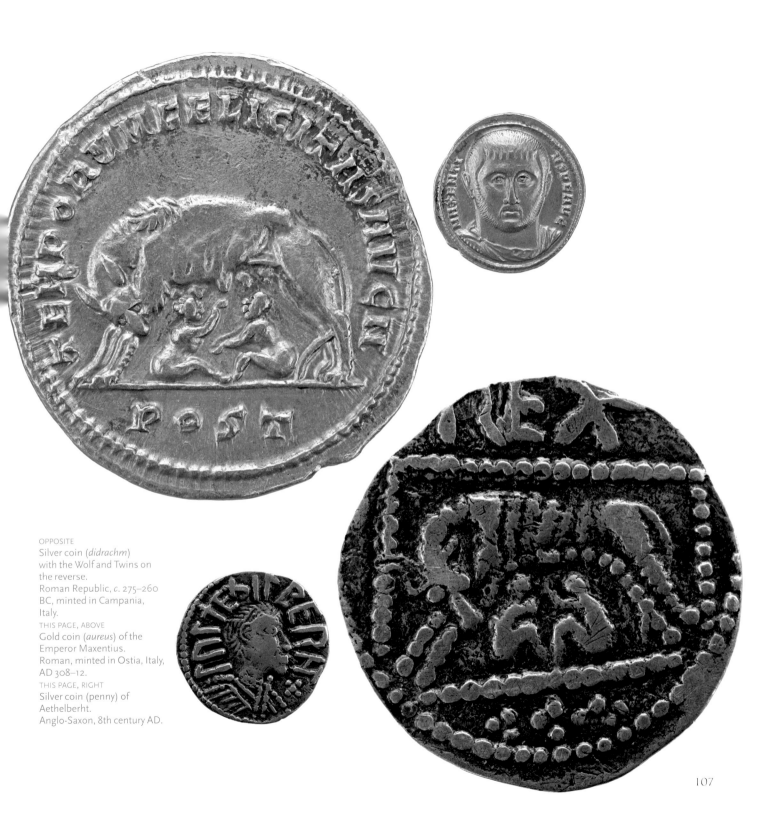

OPPOSITE
Silver coin (*didrachm*)
with the Wolf and Twins on
the reverse.
Roman Republic, *c.* 275–260
BC, minted in Campania,
Italy.

THIS PAGE, ABOVE
Gold coin (*aureus*) of the
Emperor Maxentius.
Roman, minted in Ostia, Italy,
AD 308–12.

THIS PAGE, RIGHT
Silver coin (penny) of
Aethelberht.
Anglo-Saxon, 8th century AD.

WOLVES

SCENES from mythology and legend appeared on all sorts of personal possessions and everyday functional items in the Greek and Roman world. The moulded pottery roundel, with a glossy black surface, comes from a pottery vessel made in Italy in the third century BC. It depicts the standard image of the Wolf and Twins, already a familiar symbol by that date, with two birds on a branch above. Black-slipped ware was made in an ultimately Greek tradition, based on the sophisticated ceramic techniques that lay behind black-figured and red-figured painted vases; the taste for moulded low-relief decoration was one that was to become a Roman ceramic speciality during the earlier centuries of the Roman Empire.

The panel from a Roman sword-scabbard of the first century AD shows a more elaborate vignette of the Wolf suckling the Twins. The image is enclosed by a line which may represent a cave. Flanking the scene are two trees, not the fig-tree mentioned in Plutarch's account of

OPPOSITE
Sherd of black-slipped
pottery with moulded
relief decoration of
the Wolf and Twins.
Roman (Campanian),
c.250–200 BC.
THIS PAGE
Sheet-bronze mount
from a sword-scabbard,
with relief decoration.
Roman, 1st century AD.
River Thames at
Fulham, London.

the legend, but two oaks, complete with acorns. Above, or beyond, is a stag, brought down by two hounds. These details may refer to another version of the legend, or are simply space-fillers chosen by the artist as harmonious pastoral additions to the composition. The scabbard has another elaborately decorated bronze panel with relief decoration of conventional plant scrolls and birds.

The sword itself is a *gladius*, the practical, characteristic weapon of the Roman legionaries. The complex traditions of Roman decorative art, and the legends and myths upon which so much of it was based, were introduced into even the most remote provinces of the Empire and became part of the cultural traditions of those who were natives of those countries, and had never even seen Rome itself.

FOXES

THE distinctive ancient Greek wine-cup known as a *rhyton* was ultimately based on the shape of a drinking horn. The decorated upper body was smoothly flared, but the 'point' of the vessel was shaped as an animal's head. Though various species are represented (see also page 157), the general theme often relates to hunting. The example on this page was made in Apulia (Southern Italy) in the fourth century BC, and its upper part is painted in the distinctively ornate and florid style of the region, with a winged female wearing an elaborate hairstyle and jewellery. The rest of the cup is skilfully and realistically modelled in the form of a fox's head with striking yellow eyes. Although it is finished in black, the broad skull, large, wide-set ears and short, pointed muzzle are typically vulpine. Black individuals occasionally occur in Red Fox populations, and a black fox would very likely have

THIS PAGE
Red-figure pottery drinking-vessel (*rhyton*) by the Bristol Painter. South Italian Greek (Apulian), 350–330 BC.
OPPOSITE
Carved stone smoking pipe. America/Canada, Lake Superior region, 19th century.

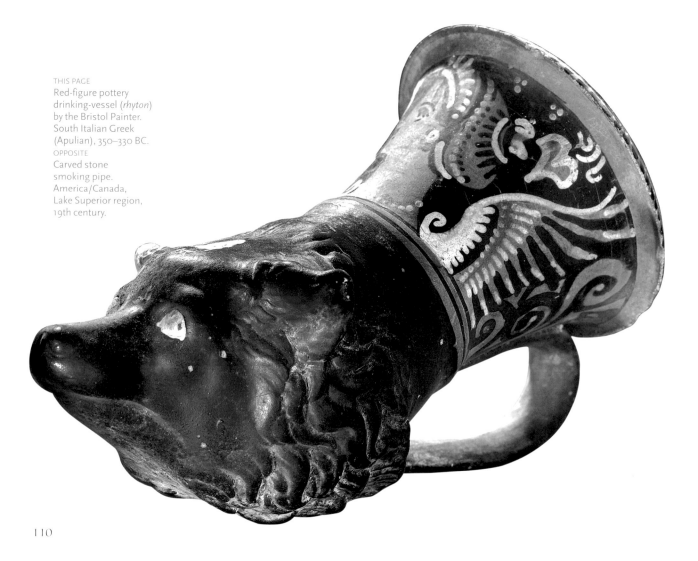

been noticed and might have been regarded as special in some way.

The other object is both a functional utensil and an item of religious equipment. It is a smoking pipe of nineteenth-century or earlier date from the western Great Lakes area of America, on the borders of Canada and the United States. The carved bowl would have had a long stem attached to it for use. The smoking of tobacco is not a simple leisure activity amongst the native peoples of North America, but an important element in certain religious rituals, and pipes were often elaborately decorated objects. This one, made of stone, is ornamented with two beavers, a bird and a fox. Foxes and beaver were among the animals hunted by people such as the Ojibwe (Chippewa), who live around Lake Superior, and may be represented here as clan totems or crests.

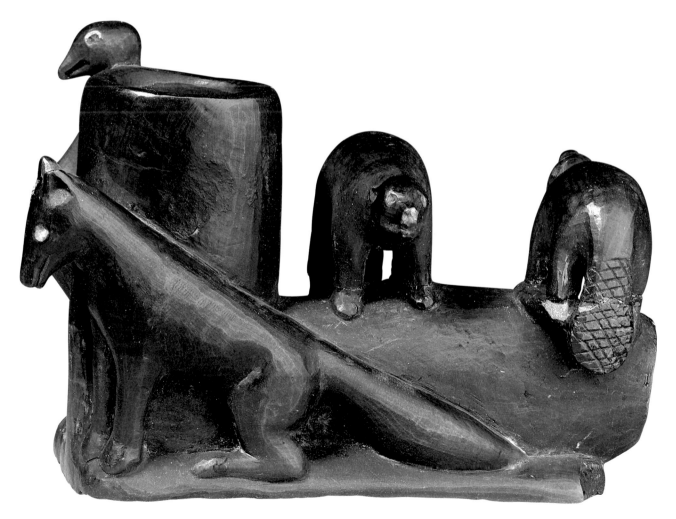

FOXES

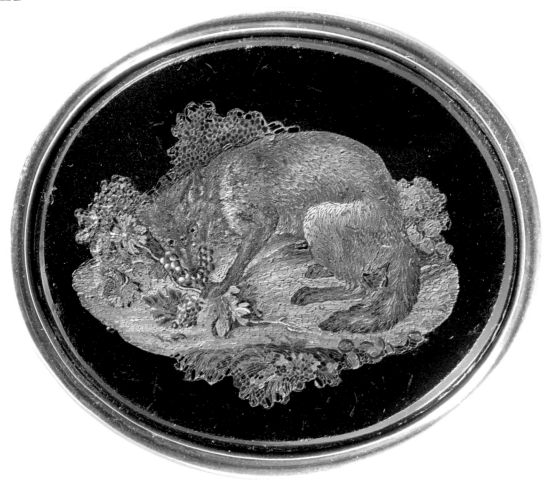

THOUGH foxes have not been domesticated, they are familiar wild animals over most of the world. They feature prominently in the folk-tales and myths of many countries from antiquity onwards, and are usually characterized as tricksters, renowned more for their cunning than their courage.

Animal fables with a moral were well established in story-telling tradition long before they were written down. The earliest examples familiar in Europe are the Greek fables of Aesop, a shadowy figure who lived in the sixth century BC. Many of the tales attributed to him are also found in other cultural traditions. In one of Aesop's best-known tales a fox, unable to reach a tempting bunch of grapes, finally saves face by declaring that they are sour anyway. The scene on the intricate glass micromosaic set in a gold brooch has been described as an illustration of that tale, but this fox, unlike Aesop's, has secured the grapes and is devouring them. The brooch was made in Italy around 1830–50.

In medieval France, Germany and the Low Countries, popular poems describing the exploits of Reynard the Fox, Isengrim the Wolf, Bruin the Bear, Baldwin the Ass and numerous other

animal characters acted as a vehicle for satirical comment on the social issues of the day: an English translation of some of these was printed by William Caxton in 1481. Though Reynard appears as an amoral, venal creature who can talk his way out of almost any situation, he effectively pricks the self-importance of other, equally undeserving characters and is thus a folk hero. The ink and wash drawing by the Dutch artist Allart van Everdingen (1621–75) is from a series of studies for etchings designed to illustrate a 1652 edition of the tales. In this scene, Isengrim and Reynard argue over a fish.

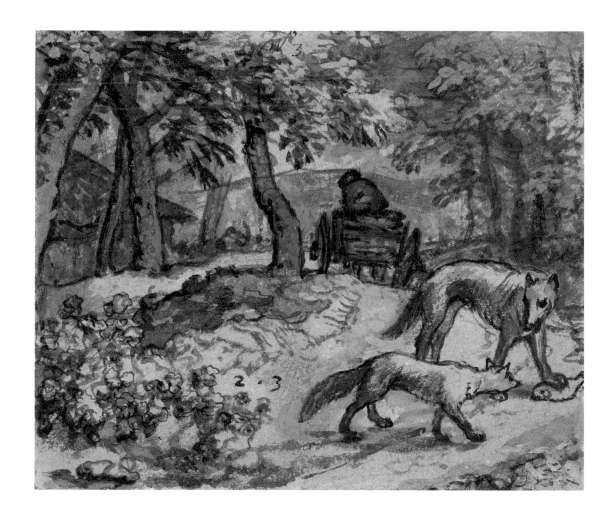

FOXES

THE jewellery and other luxury objects of Mughal India employed precious materials in a breathtakingly lavish and sumptuous manner. We tend to regard descriptions of jewels, vessels and weapons made of extravagant combinations of carved gemstones, patterned gold and vivid enamels as overstated, fairytale fantasies, but in the sixteenth and seventeenth centuries, such objects were actually made by Indian craftsmen and were proudly used and displayed by their aristocratic owners.

The steel-bladed dagger, made in the 1620s, is one such piece: the hilt and chape are fashioned of gold, delicately incised with swirling patterns and richly inlaid with flowers and animals in translucent red and green; the colourful inlay is composed of precisely cut and shaped ruby and emerald. The hilt bears hunting

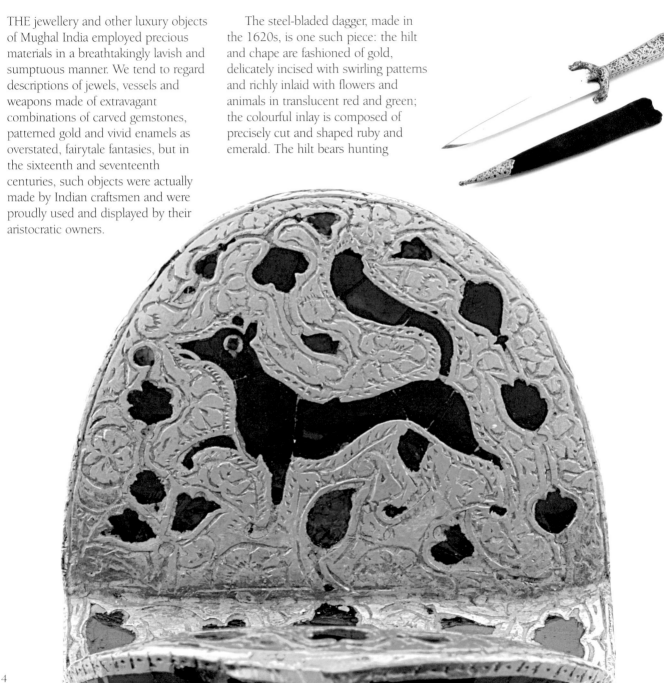

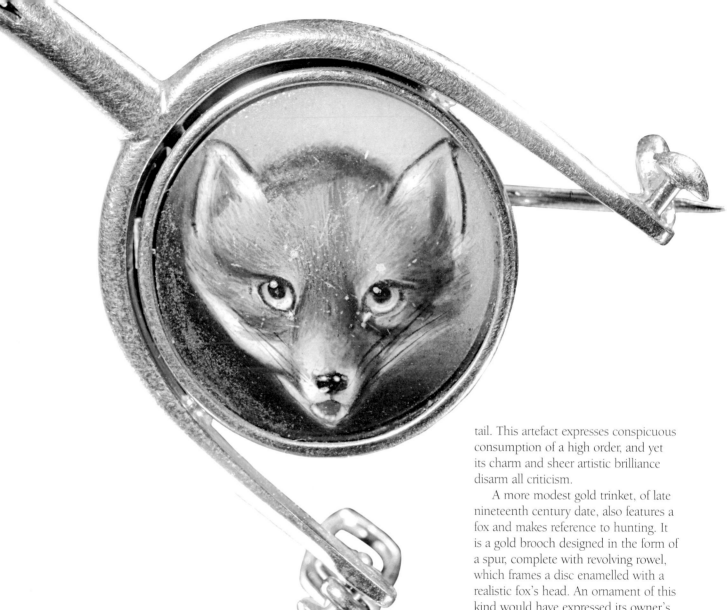

tail. This artefact expresses conspicuous consumption of a high order, and yet its charm and sheer artistic brilliance disarm all criticism.

A more modest gold trinket, of late nineteenth century date, also features a fox and makes reference to hunting. It is a gold brooch designed in the form of a spur, complete with revolving rowel, which frames a disc enamelled with a realistic fox's head. An ornament of this kind would have expressed its owner's passion for fox-hunting and the skilled horsemanship that goes with it. The wearer would have been female: she was no doubt one of those fearless Victorian ladies who, like accomplished horsewomen down the ages, galloped across country clearing hedge, fence and ditch while mounted side-saddle and clad in cumbersome skirts.

imagery: panthers, deer and a winged mythical sphinx-like creature alternate with lush flowers, while within the angled notch at the top of the hilt, a jaunty ruby fox with a knowing emerald eye trots through the foliage, waving his

FOXES

FOXES, called *kitsune* in Japanese, play an important part in the myths and folk-tales of Japan and are frequently represented in art. They are magical creatures, credited with extreme longevity and with considerable supernatural powers, including the ability to shape-shift and to possess human beings. As in many other cultures, they are characterized as tricksters, and in general as rather troublesome and malicious spirits, though there are also tales of foxes acting as helpers and protectors of humans. Their abilities are linked with their supposed longevity: at the age of 100 years, a fox is able to appear in human form, while the oldest foxes, those who have attained the age of 1,000, grow multiple tails, up to nine in all, and become white or gold in colour.

The ivory *netsuke*, a garment fastener, represents foxes as the messengers of Inari, the Shinto god of rice and the harvest, and is therefore an object of good omen, as any article must be that is worn on the body or the clothing.

The woodblock print is one from the celebrated series of *One Hundred Famous Views of Edo* by the great Japanese artist Utagawa Hiroshige (1797–1858). It represents 'fox-fires' at a legendary New Year gathering of *kitsune* around an ancient tree at the Shinto shrine at Oji. The fox spirits, lighting their way to the meeting-place with torches, will receive their orders there for the coming year. The eerily supernatural atmosphere created by the artist is extraordinary: the slender, elegant foxes seem to glow with their own ghostly luminosity against the cool, almost monochrome nocturnal landscape, while the tongues of flame from their torches appear almost as independent, living entities.

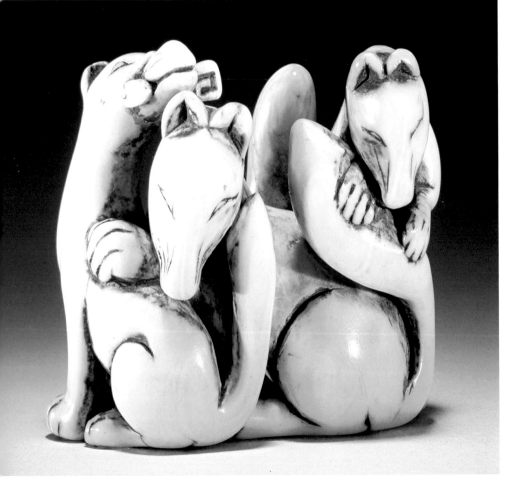

THIS PAGE
Ivory *netsuke*.
Japanese, 18th–19th century.
OPPOSITE
Utagawa Hiroshige
(1797–1858): *Fox-fires on New Year's Eve at Shozoku Enoki*, from *One Hundred Famous Views of Edo*.
Woodblock print.
Japanese, 1857.

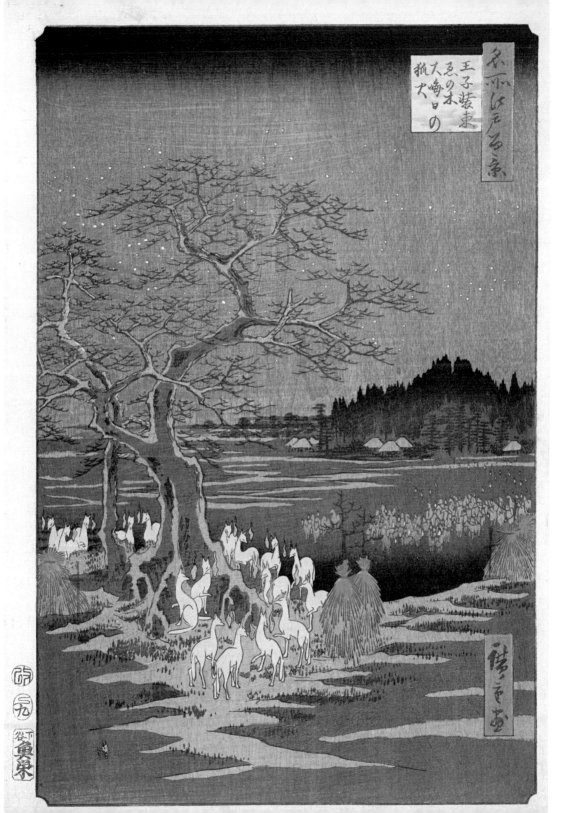

TYPES AND BREEDS

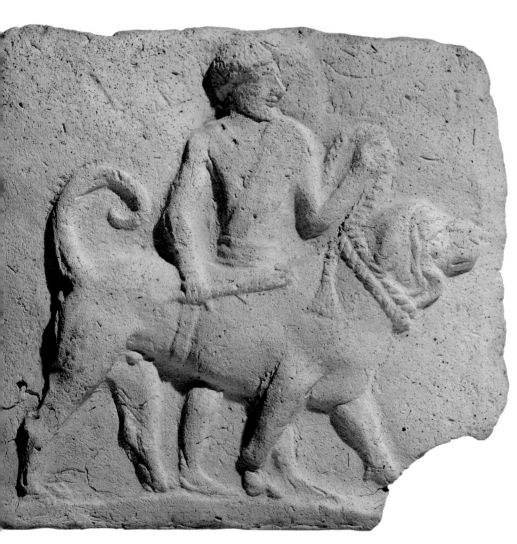

POWERFUL dogs of mastiff type were evidently highly favoured in the great civilizations of the ancient Near East. They are quite different from the dogs we see in Egyptian art of these early times.

The moulded terracotta plaque probably dates from about 1750 BC and shows what must be a very large, weighty animal, even if we should not take the respective sizes of man and dog too literally. He is a smooth-coated dog with fairly long, hanging ears and a massive head, apparently with folds of loose skin beneath the throat but not around the deep muzzle. His legs are comparatively short in relation to his body, and his tail is carried high in a loosely curled sickle shape. His handler controls him with a double collar and lead made of thick rope, and a slip (a strap around the loins); the man also holds a stick in one hand.

Many centuries later, around 645 BC, the walls of the palace of King Ashurbanipal (r. 669–631 BC) at Nineveh were adorned with wonderful carved decoration in low relief. Dogs of the type seen in this panel are

shown in other scenes taking part in the hunting of onagers (wild asses) and lions. Lion-hunting was regarded as a royal sport. The three hounds shown here are being led through a garden by their handlers. Although they have longer legs and straighter tails, they are not unlike their ancestors from a millennium earlier. The collars, clearly seen on the hound in the centre, seem to be made of a rigid material, possibly metal, and in a spiral design like a key-ring that would have enabled the leash to be slipped on and off easily, while still being secure when centred.

OPPOSITE
A mastiff and his handler: terracotta plaque with relief decoration.
Old Babylonian, *c.* 1750 BC.
Southern Iraq.
THIS PAGE
Alabaster wall-relief depicting three hounds and their handlers.
Neo-Assyrian, *c.* 645 BC.
Nineveh, Iraq.

TYPES AND BREEDS

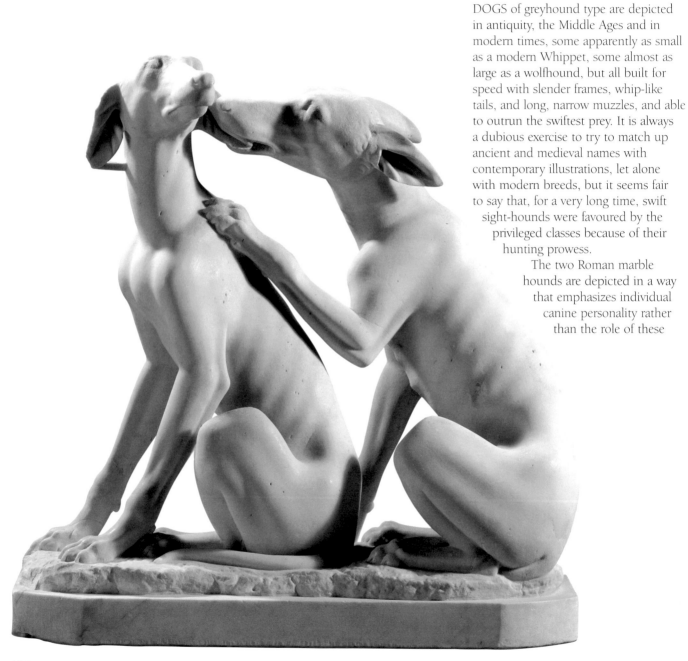

DOGS of greyhound type are depicted in antiquity, the Middle Ages and in modern times, some apparently as small as a modern Whippet, some almost as large as a wolfhound, but all built for speed with slender frames, whip-like tails, and long, narrow muzzles, and able to outrun the swiftest prey. It is always a dubious exercise to try to match up ancient and medieval names with contemporary illustrations, let alone with modern breeds, but it seems fair to say that, for a very long time, swift sight-hounds were favoured by the privileged classes because of their hunting prowess.

The two Roman marble hounds are depicted in a way that emphasizes individual canine personality rather than the role of these

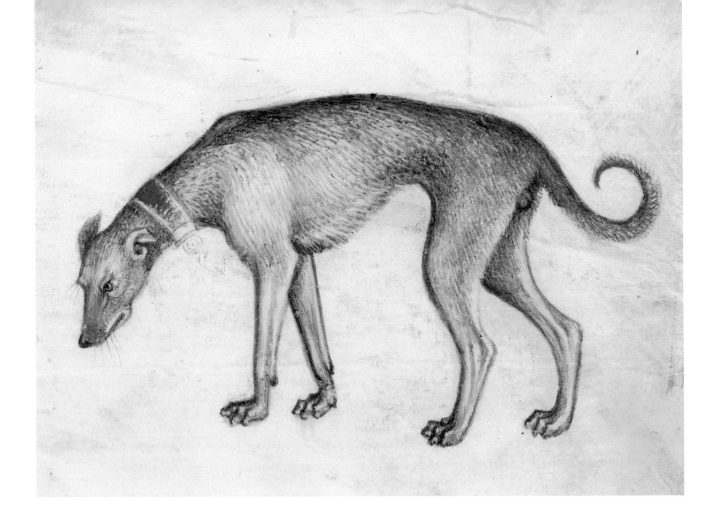

animals in society. They are off-duty hunters, a dog and a bitch sitting together with the latter nibbling her companion's ear in a friendly fashion. Though there is no reason to suppose that the work is a portrait of specific animals – indeed, the fact that other statues very like it are known indicates that it was a standard type – it does indicate the awareness of dogs as individuals and as animals with a complex and well-developed social life. The statue was found in Italy in the eighteenth century and was once in the collection of the antiquary Charles Townley.

The greyhound painted on vellum in a medieval Italian sketchbook looks like a rather less contented animal than his Roman ancestors; he seems a good deal thinner than is consistent with perfect health, and has an unhappy expression. But he, too, would have been a valued possession, belonging to a person of consequence and emphasizing that person's social status. In type, he is very close indeed to a modern greyhound.

OPPOSITE
The Townley Greyhounds.
Marble.
Roman, 1st–2nd century AD.
Lanuvio, Italy.
THIS PAGE
A greyhound.
Watercolour and bodycolour
on vellum.
Italian (Lombard), c. 1400 AD.

TYPES AND BREEDS

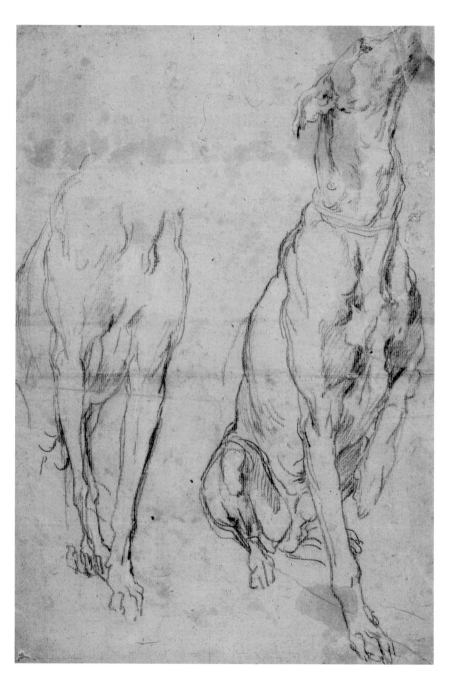

AS the hunting dogs of choice amongst the most privileged classes, greyhounds appeared from time to time in formal portraits of their owners. These two chalk studies of greyhounds have much in common. Both are drawings of dogs for inclusion in portraits of British aristocrats, and both are by artists who were not British by birth, but who became society painters of their time in England and were rewarded with high rank and honours.

Sir Anthony van Dyck (1599–1641) was the Flemish-born court painter of King Charles I of England. His lush paintings epitomize for us the extravagant luxury and taste of that period, soon to be violently swept away by the ferocity of the English Civil Wars and the extreme act of regicide. The hound in Van Dyck's delicate drawing features very prominently in his portrait of the first Duke of Richmond, now in the Metropolitan Museum of Art, in

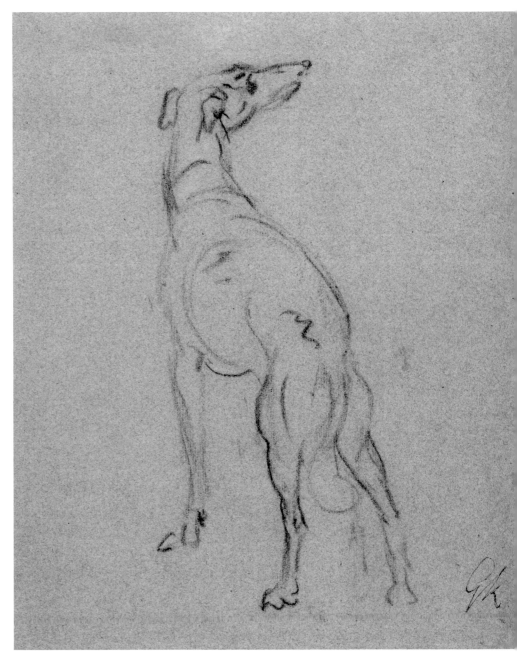

New York. The dog is no mere decorative accessory in the composition as he gazes up devotedly at his master; rather, he is the joint subject, with the duke. It is said that this animal had once saved his master's life, presumably during a hunt.

Sir Godfrey Kneller (1646–1723), who was born in Lübeck in Germany, became the leading portraitist of the English court through several reigns, from Charles II to George I: his hand recorded for us not only the lords and ladies of his time but also some of the great scholars, such as Sir Isaac Newton. Kneller's greyhound study, drawn from a difficult, foreshortened angle, was made around 1700 for a portrait of Richard Boyle, later Lord Burlington, as a child with three of his sisters. Children and animals often seem to go naturally together in art, but the greyhound also indicated the high social status of his human family.

TYPES AND BREEDS

WHEN sitting for a portrait, people are often prepared to hold a pose for an uncomfortably long period of time. Few dogs are as patient and biddable, especially since the honour of being immortalized on paper or canvas does not particularly impress them. This is probably why there are so many studies of sleeping or resting dogs in post-medieval Western art: artists hoping to observe and capture the subtleties of canine anatomy are able to do so at leisure when the dog is dozing.

The two examples shown here both depict reclining greyhounds, with their long, elegant heads stretched out before them. The chalk study by the Dutch artist Adriaen van der Velde (1636–72) is clearly drawn from life. This artist was one of several seventeenth-century painters named Van der Velde: he painted the landscapes and genre scenes with animals that were so popular at the time, and was also known for collaborating with colleagues by adding the figures to their landscape compositions. This greyhound drawing formed part of the collection of Sir Hans Sloane (1660–1753), and is thus one of many examples of art depicting dogs and other animals in the founding collection of the British Museum.

The woodcut, made around 1930, is the work of Alfons Purtscher (1885–1962), an Austrian-born artist who lived and worked in Britain from the late 1930s and was known chiefly for his sporting subjects and animal studies. Though drawn from a different, more frontal, viewpoint, it shows a similar hound reclining in exactly the same position as Van der Velde's greyhound. Greyhounds, with their slender yet powerful build, and their thin, fine coats are excellent subjects for the study of bone and muscle and, in spite of the different styles and techniques, both artists have conveyed these details vividly.

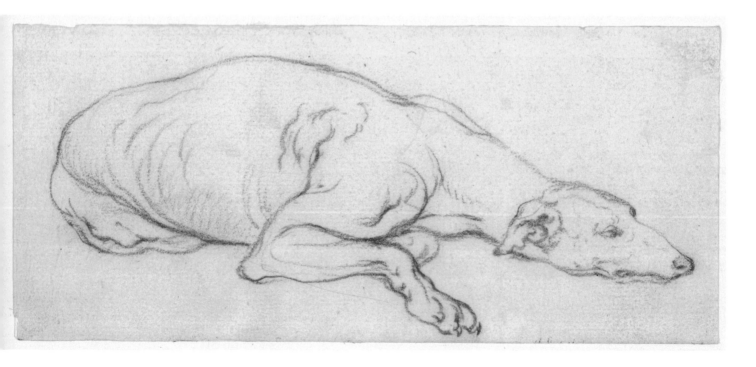

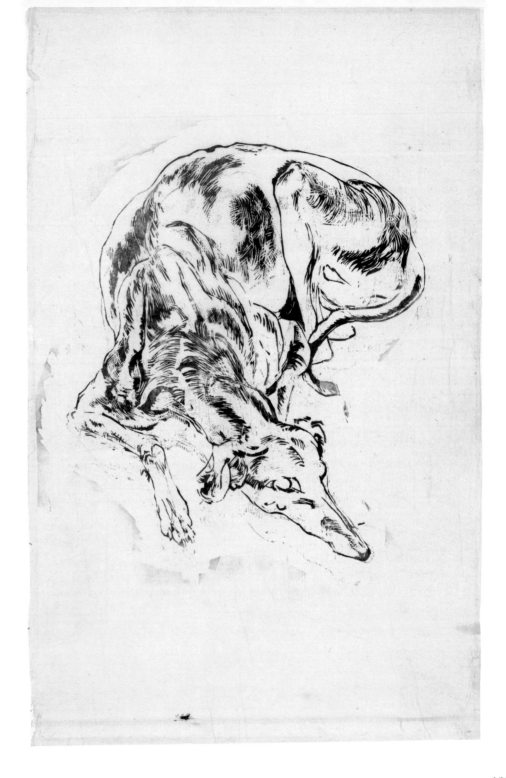

TYPES AND BREEDS

IN medieval European society, greyhounds were associated almost exclusively with royalty and the aristocracy. They were the people who owned large tracts of land, who commanded extensive and exclusive hunting rights, and for whom hunting was a major leisure activity. When represented in art, medieval greyhounds generally look almost indistinguishable from their modern descendants.

The glazed earthenware floor-tile with its leaping hound was designed and made in the thirteenth or fourteenth century. Two-colour inlaid tiles of the period were made with a wide range of intricate geometric, floral, heraldic and representational motifs, and were used for the highly decorative and durable flooring of public and private buildings of importance. While the unfired red clay tile was still soft, a stamp was used to impress it with the pattern, and the depression formed was then filled with iron-free white clay. Covered with a lead glaze, the background turns a red-brown colour when fired, and the white inlay a warm honey-yellow.

F. Barlow

The greyhound in Francis Barlow's drawing has the same slender, yet muscular, build, and the same long legs and slightly curled tail as his medieval predecessor. Barlow (?1626–1704) produced series of drawings on many aspects of natural history and hunting, many of which were engraved for publication by his distinguished contemporary, Wenceslaus Hollar (1606–77), and were apparently used as reference material by other artists. Here, he has depicted three seventeenth-century dogs. The crop-eared mastiff-like guard-dog is chained, but the graceful greyhound and the eager spaniel are both free to harass a pair of defiant cats.

TYPES AND BREEDS

VERY large hounds with rough, wiry coats and rangy build may have been present in the British Isles since the Roman period, though the evidence is far from clear. The registered breeds now known as the Scottish Deerhound and the Irish Wolfhound were established in their present forms quite recently, in the nineteenth century, but powerful rough-coated dogs of this type, which hunt chiefly by sight, not scent, were undoubtedly used for many centuries in the Middle Ages for coursing large game such as wolves and Red Deer (*Cervus elaphus*) in the rough and often wet terrain of Ireland and Britain. Statements that 'Irish Wolfhounds' were bred to hunt the ancient giant deer sometimes called the 'Irish Elk' are, however, the purest romantic fantasy and betray an exceedingly uncertain grasp of chronology. That impressive prehistoric elk, *Megaloceros giganteus*, was not confined to Ireland, and, more to the point, it became extinct nearly 8,000 years ago.

The mid-twentieth-century coinage of the Republic of Ireland featured a variety of animals on the reverse, from a domestic hen with chicks to a hare, a bull, a horse and a leaping salmon. The sixpenny piece, a white metal coin 21 millimetres in diameter (a little over three-quarters of an inch) which was worth one-fortieth of a pound, bore the image of a wolfhound, a dog closely associated with Ireland. Even at such a small scale, it can be recognized as a very large dog, with the relaxed stance typical of a confident and good-natured animal.

The chalk drawing of a dozing wolfhound belongs to the same period. It is by the English artist George Vernon Stokes (1873–1954), whose accurate, perceptive and attractive paintings of dogs, especially sporting dogs, were popular in illustrated books.

TYPES AND BREEDS

ENGLISH BULL DOG

English Bulldog, accurately represented in an etching made in 1906 by James Exley (1878-1967), evolved as a bull-baiting breed, though it is now simply a companion dog. Bulldogs early acquired strong symbolic significance in their country of origin, their physical courage and tenacity being regarded (by the English) as quintessentially English virtues. As late as the Second World War, cartoonists used the image of a bulldog as a personification both of the whole British nation and specifically of its wartime leader, Winston Churchill. Other breeds associated with bull-baiting, and with dog-fighting and competitive ratting, include the English Bull Terrier (which, unlike the Bulldog, has a long muzzle), the Staffordshire Bull Terrier, American varieties of all these breeds, the American Pit Bull Terrier, and smaller dogs such as the French Bulldog, Boston Terrier and Miniature Bull Terrier.

A group of such dogs appears on a late Victorian set of gold and enamel masculine jewellery made in London. The set comprises a tie-pin and cufflinks; the latter, shown here, bear portraits of four different dogs. A classic English Bulldog is easily recognizable: the dog with large pricked ears may be a Boston Terrier, and its companion (also portrayed on the matching tie-pin) may be a Staffordshire Bull terrier. The other animal's breed is uncertain, but all undoubtedly belong to the bulldog/ bull terrier family.

ALTHOUGH dogs will fight each other in certain circumstances, their natural social behaviour, when independent of human interference, is generally designed to settle territorial and status disputes without excessive bloodshed. But some humans have a depraved taste for watching savagery and cruelty, and have deliberately bred and trained dogs for baiting much larger animals, notably bears and bulls, and for fighting each other, sometimes to the death, as a competitive 'sport'.

The wide-bodied, snub-nosed

TYPES AND BREEDS

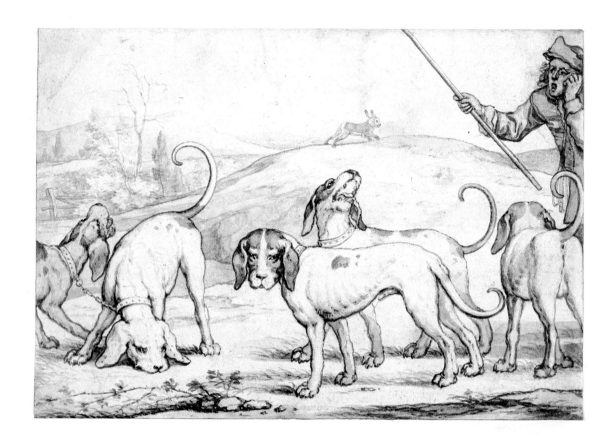

THOUGH representations of dogs from the medieval period and from antiquity include many that closely resemble modern breeds, it was not until the 18th or even the 19th century that many breeds we know today took on their modern form.

The drawing by Francis Barlow (?1626–1704) depicts a huntsman with five hounds that are obviously ancestors of English Foxhounds (though they are probably harriers, judging by the hare departing rapidly over a hillock). They are chained by their collars in pairs. Barlow was noted for animal paintings, and produced and published series of studies of animal species and types and of country sports from hawking and stag-hunting to fishing. His drawings were etched for publication by the distinguished artist Wenceslaus Hollar (1607–77). The urge to compile visual lists of animals, or of methods and styles of hunting, was both a

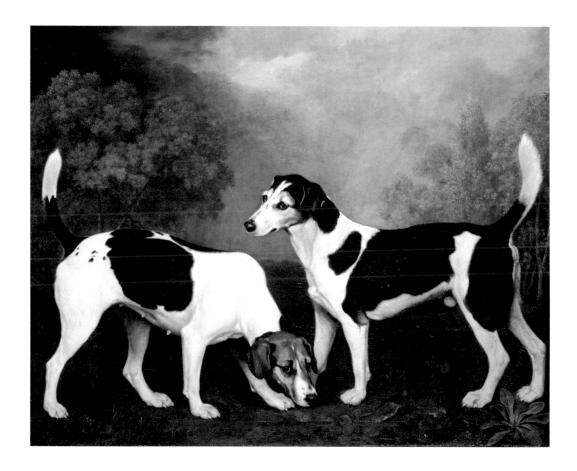

continuation of the medieval bestiaries and reference works on hunting and a foreshadowing of the more scientific methods of classification that were evolving in the seventeenth century.

Little more than a century later, in 1792, George Stubbs (1724–1806) painted a portrait of a pair of hounds that belong unmistakably to the breed we know today as the English Foxhound. The portrait may have been commissioned by a noted breeder of hounds, the Revd Thomas Vyner, and probably records two animals from the famous Brocklesbury pack of foxhounds owned by the 1st Earl of Yarborough. The hounds are placed in a pleasingly balanced, yet utterly natural, pose against a wooded landscape: the dog's fine head is at the centre of the composition, yet draws the eye to the bitch, who is sniffing at the ground. The two jaunty tails enclose the subject like a pair of quotation marks.

SPANIELS are small or medium-sized dogs with silky coats and hanging ears. That definition does not begin to encompass the numerous separate breeds of today, but before the nineteenth century, it was sufficient; the spaniel was a sporting dog that would flush out or 'spring' game, and was often also noted for its affectionate, even obsequious, temperament.

The lively and beautiful drawing by the English artist Sawrey Gilpin (1733–1807) dates from 1758. It shows an ordinary working spaniel of the eighteenth century; by today's standards it perhaps most resembles the Welsh Springer Spaniel, but modern breed standards are not relevant. Dogs of this kind have an ancient ancestry and have fulfilled a significant role in hunting and as friends for their humans for centuries. Like many artists who took a special interest in animals, Gilpin's name is little known today, but his accurate record of the animals he saw around him is invaluable, and this picture of a clear-eyed, alert and friendly animal is a delight to look at now, as it was 250 years ago.

Miniature spaniels were so popular in the court of Charles II of England (r. 1660–85) that they became known as King Charles Spaniels: in the nineteenth century, breeding practices shortened their muzzles and changed their appearance, so that in the twentieth century the Cavalier King Charles Spaniel was developed to restore the original seventeenth-century type. The small picture in micromosaic, by Luigi Moglia, was created around 1830 and features what would then have been a King Charles – and what we would now call a Cavalier King Charles – reclining in a landscape. The technique, using minuscule cut chips of glass to create a tiny picture only 6.2 centimetres long (less than 2½ in.) was an Italian speciality of the period.

OPPOSITE
Sawrey Gilpin (1733–1807): *A spaniel guarding its master's stick.* Graphite, ink and wash, 1758.
THIS PAGE
Copper panel with glass micromosaic by Luigi Moglia. Italian (Rome), *c.* 1830.

TYPES AND BREEDS

POODLES are sometimes mocked because their thick, woolly coats are often clipped into fanciful styles. During certain periods of history when Britain and France were at loggerheads, British caricaturists regularly personified the English as tough, courageous, no-nonsense bulldogs and the frivolous French as prancing poodles. Poodles' playful intelligence, high-stepping action and unusual aptitude for walking on their hind legs also made them adept circus performers in the days when dogs appeared in such shows, and contributed to the idea that they are not a 'serious' breed. In fact, like certain other breeds with dense,

THIS PAGE
Johann Adam Klein (1792–1875): *Schwalerl*. Etching, 1817.
OPPOSITE
Gold brooch in the shape of a poodle. French?, *c.* 1870.

curly coats, they evolved as hard-working sporting dogs, skilled at retrieving game from water.

The delightful etching of a poodle shown here conveys a fair and objective view of the breed. Made in 1817 by the German artist Johann Adam Klein, it portrays a dog named Schwalerl, who belonged to a Vienna wine-merchant. The subject is a handsome and obviously intelligent animal, his coat clipped in a practical everyday fashion, posing with a glove in his jaws. Klein, who was born in Nuremberg in 1792, had a keen eye for animals as individuals, observing and representing them with accuracy and affection. Even if the dog's name had not been noted on the plate, we should feel sure that this was not just 'a poodle', but a specific animal with his own distinctive personality.

The little gold brooch was probably made in France around 1870. This poodle is clipped in a style similar to the modern show 'lion-clip', with bracelets of fur around the leg joints and a pom-pom on the docked tail: Schwalerl's tail is left with a far more becoming plume. Zoomorphic (animal-shaped) jewellery has a very long history, and there was a good choice of luxury examples available in late Victorian Paris.

TYPES AND BREEDS

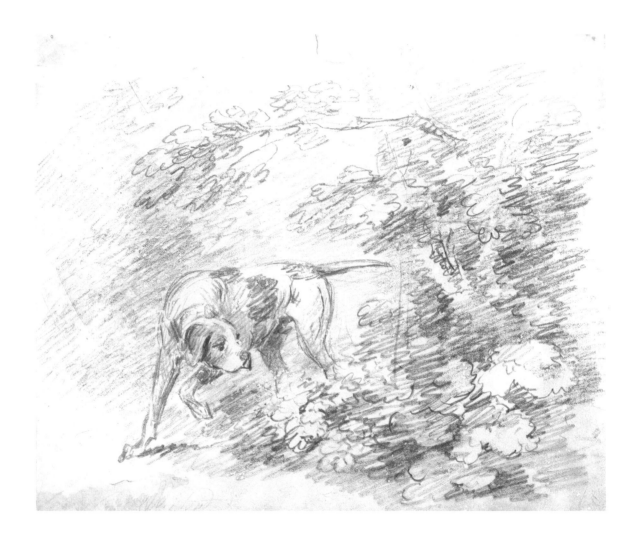

THERE have been different types of hunting hounds from the earliest times; the size and the habits of the quarry vary, and so do the ways in which the dogs give chase and interact with human huntsmen. Some dogs naturally hunt by sight, some by airborne scent, and yet others by tracking scent trails on the ground. The invention of guns led to new hunting methods, and hence to new hound breeds, known collectively as 'gundogs'.

The dog in a pencil drawing by George Morland (1763–1804) is instantly recognizable as a pointer, a gundog that locates game and 'points' to assist human hunters and other hounds. The pose, with raised paw and outstretched neck, is characteristic, and the overall appearance of this late eighteenth-century dog would be acceptable to modern admirers of the breed. Though his name is no longer well known, George Morland – who died young as a result, it is

said, of riotous living – was an extremely popular and successful artist in his time. He specialized in rural scenes, often idealized and sentimental, that appealed to the romantic taste of his time. The drawing reveals acute observation and is an accurate rendering of a breed that is still valued as a working dog and companion today.

The gold ornament, a cravat-pin made in Paris around the middle of the nineteenth century, also shows a pointer in typical pose. The owner and wearer of this pin was doubtless a keen sportsman: that is to say, he would have derived pleasure from shooting small animals and birds with the assistance of well-trained gundogs. While not all will sympathize with these activities, jewellery that refers to the lifestyle and interests of its wearers has always had a strong appeal, and hunting, in one form or another, has always been central to the lives of many humans and dogs.

OPPOSITE
George Morland (1763–1804):
Study of a pointer.
Graphite, 18th century.
THIS PAGE
Gold cravat-pin in the shape of a pointer.
French, c. 1850.

TYPES AND BREEDS

THIS PAGE
William Hogarth (1697–1764):
Self-portrait.
Engraving, 1749.
OPPOSITE
Two pugs in glazed hard-paste
porcelain.
German, made in Meissen,
c. 1740.

140

PUG dogs, with their flattened noses, wrinkled foreheads and tightly curled tails, were first bred in China and became a popular breed in Europe from the late seventeenth century onwards. The fashion for these little dogs was encouraged by royal and aristocratic patronage, and they were widely represented in art during the eighteenth and nineteenth centuries.

The most famous example is the self-portrait by William Hogarth (1697–1764), in which he includes his pet pug, Trump, in the foreground of a composition replete with symbolism. Hogarth presents himself as both artist and intellectual: the picture-within-a-picture that bears his portrait rests on volumes of Shakespeare, Swift and Milton, and his palette in the foreground is marked with the 'line of beauty' which formed part of his own theoretical analysis of art. The dog Trump may represent Nature as opposed to Art, a fundamental concept in eighteenth-century thinking, and

it is also possible that the facial similarity between the artist and his dog, and even a pun on *pug/pugnacious*, may enter into the many layers of meaning. Striking to the modern observer, however, is the fact that Trump is hardly typical of the pug breed in its present form.

The pre-eminent porcelain factory at Meissen in Saxony produced many outstanding animal figurines. The dogs shown here are scratching their ears in a natural manner: unlike Trump, they have cropped ears. Such figures may well have been connected with the *Mops-Orden*, the Order of the Pug, a secret society founded in Bavaria after Pope Clement XII banned Catholics from membership of the Freemasons in 1738. Pugs represented loyalty, steadfastness and reliability, and pug figurines were apparently used in the rituals of the society, which, unlike the Freemasons, admitted women as well as men.

TYPES AND BREEDS

THE term 'spitz' denotes a dog with a markedly wolf-like head and generally a very long, thick and fluffy coat. Most have curled tails carried over the back. Though imprecise, the German term (meaning 'sharp' or 'pointed') is a useful one to refer to a general canine type rather than a specific breed. Such dogs have existed since antiquity, and the great Sothic dog as represented in Ptolemaic and Roman Egypt was a spitz. Today there are numerous breeds, large, medium, small and tiny, that answer that general description, from the Japanese Akita Inu to the minuscule Pomeranian, the smallest of several German spitz dogs.

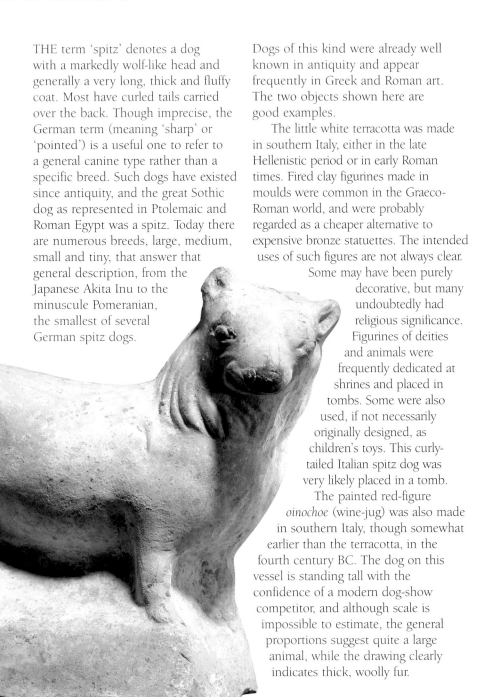

Dogs of this kind were already well known in antiquity and appear frequently in Greek and Roman art. The two objects shown here are good examples.

The little white terracotta was made in southern Italy, either in the late Hellenistic period or in early Roman times. Fired clay figurines made in moulds were common in the Graeco-Roman world, and were probably regarded as a cheaper alternative to expensive bronze statuettes. The intended uses of such figures are not always clear. Some may have been purely decorative, but many undoubtedly had religious significance. Figurines of deities and animals were frequently dedicated at shrines and placed in tombs. Some were also used, if not necessarily originally designed, as children's toys. This curly-tailed Italian spitz dog was very likely placed in a tomb. The painted red-figure *oinochoe* (wine-jug) was also made in southern Italy, though somewhat earlier than the terracotta, in the fourth century BC. The dog on this vessel is standing tall with the confidence of a modern dog-show competitor, and although scale is impossible to estimate, the general proportions suggest quite a large animal, while the drawing clearly indicates thick, woolly fur.

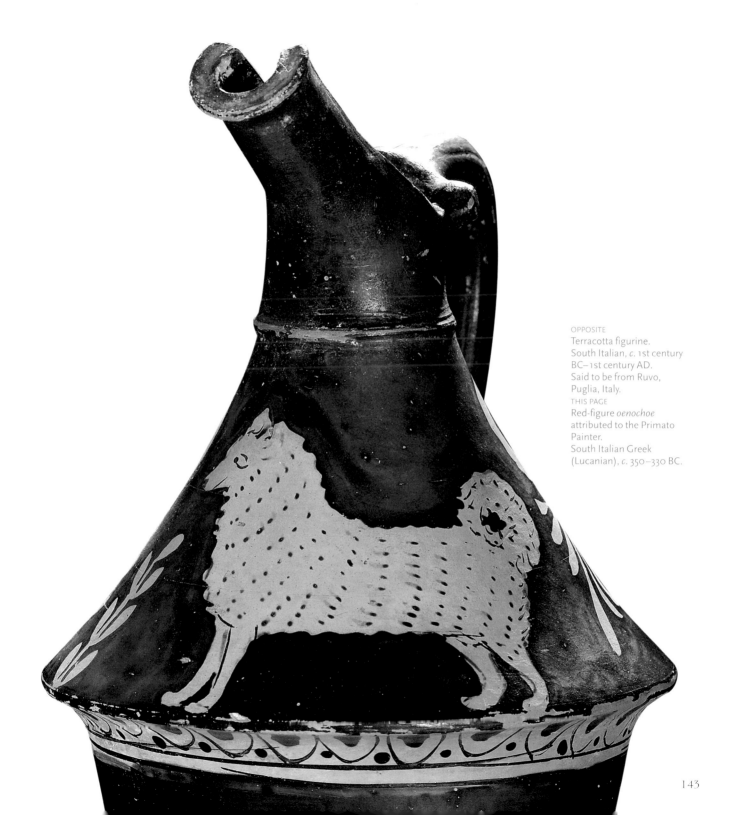

OPPOSITE
Terracotta figurine.
South Italian, *c.* 1st century
BC–1st century AD.
Said to be from Ruvo,
Puglia, Italy.
THIS PAGE
Red-figure *oenochoe*
attributed to the Primato
Painter.
South Italian Greek
(Lucanian), *c.* 350–330 BC.

TYPES AND BREEDS

THESE two depictions of small spitz-type dogs are chronologically separated by almost two millennia, but they show dogs of very similar type. The unknown artist from ancient Turkey and the celebrated eighteenth-century Englishman have both conveyed not only physical appearance but also canine spirit and playfulness.

The tiny terracotta figurine, only 4 centimetres (about 1½ in.) long, was probably made in the first century BC and comes from Turkey. It is flat-backed, so was intended to be attached to some object as a decoration in relief. The white surface slip has now worn away over much of the clay, but

it would originally have been a pure white dog; it may be a distant ancestor of a miniature breed like today's Volpino Italiano. The pose appears often in Classical art, showing the small pet dog jumping up eagerly in greeting, or as a human friend holds out some object to tease and interest it.

Nearly 2,000 years later, in 1775, George Stubbs (1724–1806) painted a 'Spanish dog' belonging to a friend,

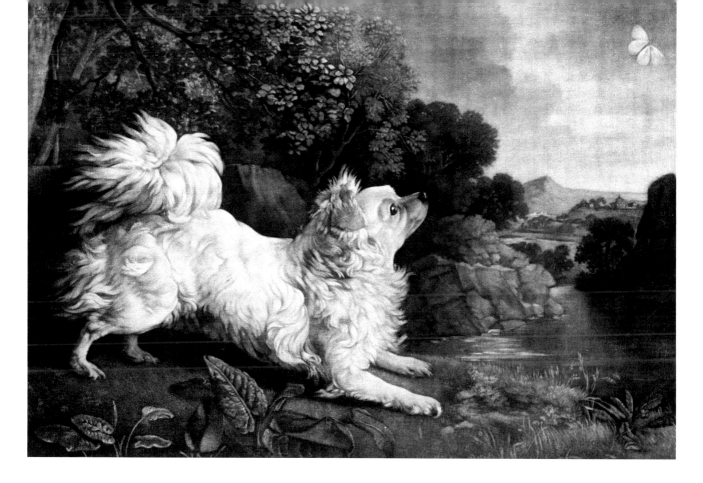

the artist Richard Cosway. The dog is in the play-bow pose, intent on the fluttering butterfly that we see in the corner of the composition. White spitz-type dogs were very popular in eighteenth-century England, though they were normally larger than the toy variety that became known as the Pomeranian in the Victorian period. From the proportions of his head, Mr Cosway's dog was probably quite small, but not tiny. In the print, published in 1782, the dog is no longer Spanish but 'A French fox dog', and though the butterfly may be intended to evoke the word *papillon*, the breed now known by that name is closer to a miniature spaniel with very large pricked ears. Like all Stubbs's animal portraits, the picture conveys the subject's nature and personality.

OPPOSITE
Moulded terracotta relief.
Hellenistic Greek, *c.* 1st century BC.
Smyrna, Turkey.
THIS PAGE
Edward Fisher, after a painting
by George Stubbs (1724–1806):
A French fox dog.
Mezzotint, 1782.

TYPES AND BREEDS

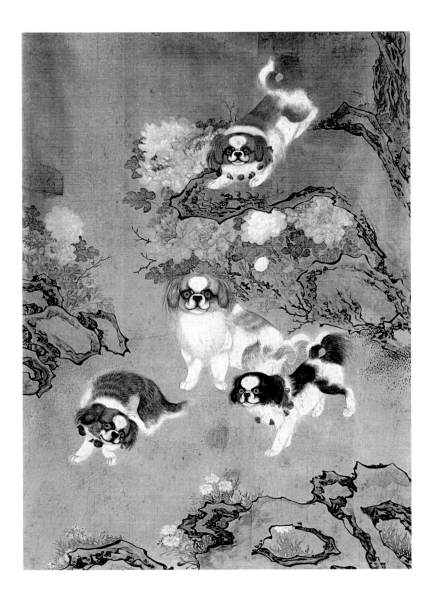

THE Pekinese, with its bow legs, luxuriant coat, flattened snout and protuberant eyes, is unmistakable. Chinese legends about its origins claim not only great antiquity but also leonine ancestry, for the faces of these little dogs are reminiscent of the fiercely frowning mythical Lion Dogs. The effect on the skull and jaw of the breed is extreme: it looks so different from the skull of any wolf-like dog that one would scarcely take them for the same species.

Pekes first became known in Europe only after the middle of the nineteenth century: following the sack of the Summer Palace in Peking (Beijing) by English and French troops in 1860, five of these dogs were taken back to England. One, named Looty (perhaps with unconscious irony), was presented to that great dog-lover, Queen Victoria, in 1861. Photographs of many of her dogs survive, including one of Looty. Perhaps the lack of representations of Pekinese in Chinese art of early dynasties merely reflects their rarity and exclusivity, or it may be that they did not evolve in their present form until comparatively recent times, even in their land of origin.

The Chinese painted scroll showing four dogs frolicking amongst trees, rocks and flowers is of nineteenth-century date, and the delightful animals are

THIS PAGE
Pekineses.
Hanging scroll, ink on paper.
China, Qing Dynasty, 19th century.
OPPOSITE
Painted silk hanging scroll, painted by Shen Quan (1682–1762). China, Qing Dynasty, 18th century.

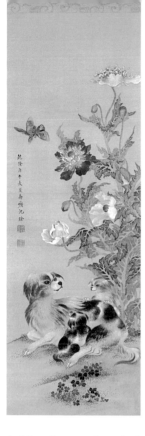

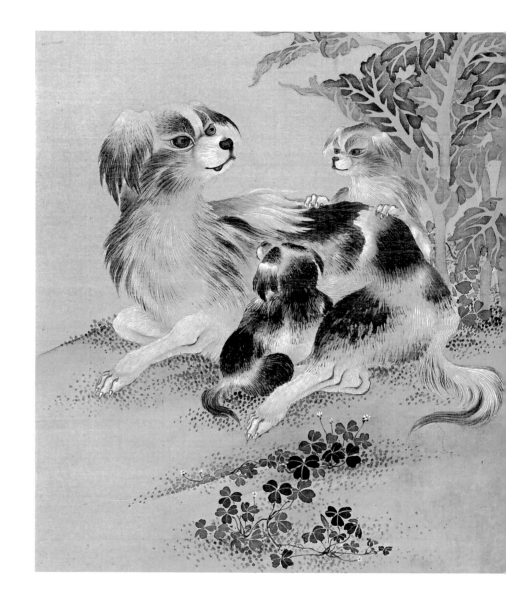

unmistakably Pekinese, though their legs are longer and straighter, and their silky coats shorter, than those of contemporary specimens of the breed. Whether the other painting, a silk scroll painted by the artist Shen Quan in the eighteenth century, is intended to represent dogs of Pekinese type is uncertain. The bitch and her two puppies are of a spaniel type similar to many European dogs of that period. They are placed against a decorative background with peonies and butterflies, motifs full of auspicious symbolism in Chinese art.

TYPES AND BREEDS

SOME noteworthy dog breeds originated in China, but while Pugs were already immensely popular in Europe by the seventeenth century, and the irrepressible Pekinese made its presence felt abroad from the nineteenth, the Chow Chow did not become widely known and admired until the twentieth century. In its native country, this strong, serious-minded dog with its extremely luxuriant coat and disconcerting blue-black tongue was valued not only as a guard and companion, but also as a draught animal and as a source of both fur and meat.

The engaging pair of eighteenth-century white porcelain dogs would not readily meet modern Chow breed-standards – their muzzles are too long, their ears too bent and their coats too flat for even the rare short-coated variety – but the bear-like impression is still strongly evocative of this aloof and dignified breed. The fine glazed white porcelain made

at Dehua, Fujian province, and known in the west as *blanc de Chine* included a variety of decorative figures, modelled and fired with meticulous skill.

The Japanese woodblock print includes another large oriental dog, one that has much in common with the breed known today as the Akita Inu, a very handsome spitz with large upstanding ears and a curled tail. The print is by Utagawa Toyokuni I (1769-1825; several later artists took the same name). The scene is of a woman standing by a lamp in the falling snow. Behind her is a large, curly-tailed yellow dog, looking up at her with his pale eyes and picking his feet up uncomfortably from the cold, snow-covered ground. The composition, with its bold, flat areas of colour and precisely judged balance of form, demonstrates the appeal of the Japanese prints which came to influence some Western artists very strongly in the later nineteenth century.

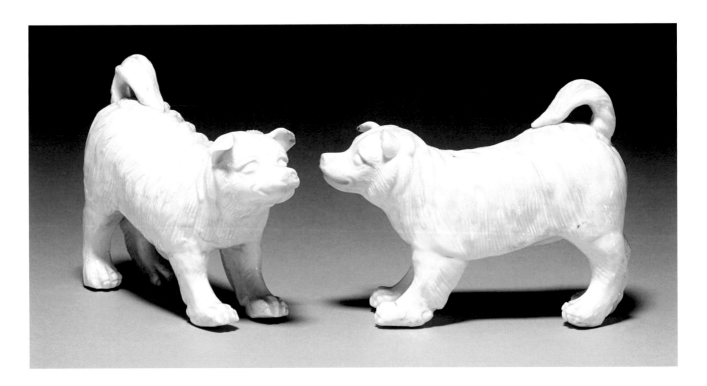

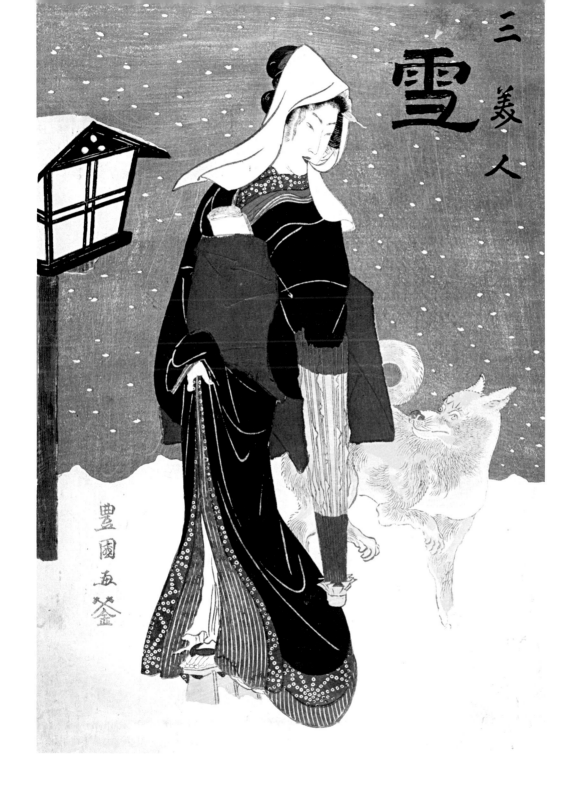

三美人
雪

豊國画

OPPOSITE
A pair of Chows in *blanc de Chine* glazed porcelain. China, Qing Dynasty, 18th century. Dehua, Fujian province, China.
THIS PAGE
Utagawa Toyokuni I (1769–1825); *Yuki*. Woodblock print. Japanese, 18th–19th century.

149

TYPES AND BREEDS

INDIVIDUALS with short limbs occur spontaneously, and for a variety of genetic reasons, in many mammalian species, and their peculiarity will not necessarily disadvantage them in life. Short-legged dogs have been around for millennia, and have often been favoured because for certain tasks, such as hunting burrowing animals, their long, low shape assists them.

An ancient Egyptian example is the delightful little carved ivory dog made around 1350 BC. His pose, with lowered forehand and rump in the air, is the classic one of a dog at play, inviting a response from another dog or a person. As well as his short legs, he has floppy ears and a full, bushy tail curled tightly over his back. In his mouth he holds a forked object made of bronze; it looks like the tail of a fish,

but could even be a large fly that this lively little creature has caught. Around his neck is a collar that was once embellished with gilding. Only 6.4 centimetres (2½ in.) long, this miniature work of art vividly evokes the affectionate perception of dogs in New Kingdom Egypt and demonstrates how little some things have changed.

Perhaps the best known of many short-legged breeds today is the Dachshund ('badger-dog'), originally valued as an active working hound with a strong propensity for digging and burrowing. The etching of a seated dachshund was made in 1815 by the German artist Johann Adam Klein, and is shown here greatly enlarged. He captures the animal's robust and unexaggerated physique and his thoughtful, intelligent expression to perfection. Though the dog's name is not recorded, the etching is undoubtedly an individual portrait, and it gives us a charming picture of the breed as it was nearly two centuries ago.

THIS PAGE
Figurine of a dog in ivory and bronze.
Egyptian, New Kingdom, *c.* 1350.
OPPOSITE
Johann Adam Klein (1792–1875):
Seated dachshund.
Etching, 1815.

J.A: Klein. fec.
Nürnberg 1815

151

ART AND ARTEFACTS

BOTH images here are the work of Dutch artists of the seventeenth century, though one is hardly a household name today, while the other is one of the most famous names in the history of Western art.

The series of chalk drawings of a sleeping dog is by Paulus Potter (1625–54). His career was short, since he died of tuberculosis at the age of 28, but he was a prolific painter and had a fine reputation as a painter of animals and landscape. He often featured individual horses, cattle and dogs as the primary subjects of his pictures. The dog that he observed so closely and accurately in this sheet of drawings is of no particular breed, and was probably an all-purpose watchdog or herding dog with his short, smooth coat, long-docked tail and folded ears.

The small print was made around the same time (1640) by Rembrandt (1606–69), and also depicts a sleeping dog. The animal seems to coalesce slowly out of a tenebrous blur of short, curved and criss-crossed lines, an initially confusing pattern of light and shade. He emerges as a puppy tightly curled up against a background of deep shadow, his eyes fast shut, his tail tucked down and his nose almost touching his hock. The little dog is probably no more than a footnote in Rembrandt's oeuvre, but has still been realized with the utmost skill and care. The technique is a combination of etching and drypoint, in which lines are drawn directly on the metal plate with a sharp point, without the use of acid.

OPPOSITE
Paulus Potter (1625–54):
Six studies of a dog.
Black chalk, c. 1640–54.
THIS PAGE
Rembrandt van Rijn (1606–69):
Sleeping puppy.
Etching and drypoint, c.1640.

ART AND ARTEFACTS

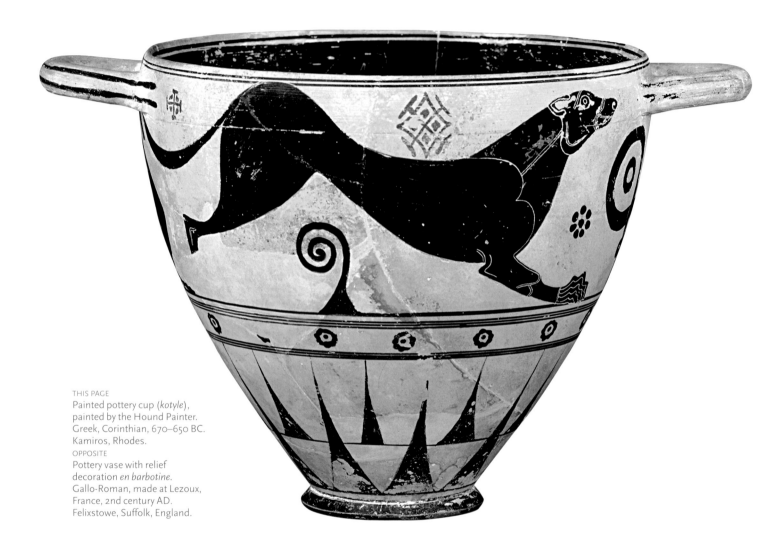

EVER since humans learned to make useful containers from fired clay, pottery has been an expression of both art and craft, ornament and function. Two ceramic vessels from the Classical world illustrate just a few of the sophisticated and highly developed skills of the potters of antiquity, their eye for form and balance, and their striking use of representational imagery.

The painted Greek vessel is a large drinking-cup made in Corinth, Greece, around the middle of the seventh century BC. The vessel is the work of a master potter and painter, with its shapely, tapering form and the graceful decorative counterpoint of the bold, powerful running hound and the delicate abstract ornament. Incised lines as well as additional colour – yellow and a purplish red – are

used to pick out the details of the animal's head and neck.

Many centuries later, in Roman France, a craftsman employed in a major pottery industry made a large jar in the robust, glossy red ware archaeologists now call samian ware. This pottery was so practical, decorative and popular during the first and second centuries AD that it was exported far afield to other Roman provinces. Though most relief-decorated samian ware was made in moulds in a virtually industrial process, a vase like this one is more individual. Like the Greek craftsman centuries before him, the Gallo-Roman potter has chosen a running hound as his decorative focal point. His technique required great skill and experience; the leaves are individual mould-made details attached to the pot with slip, but the dog himself, his mouth open and baying eagerly as he chases his prey, and the swirling stems of foliage have all been piped freehand onto the surface of the dry, unfired pot using a piping-bag, a nozzle and thick, but fluid, clay.

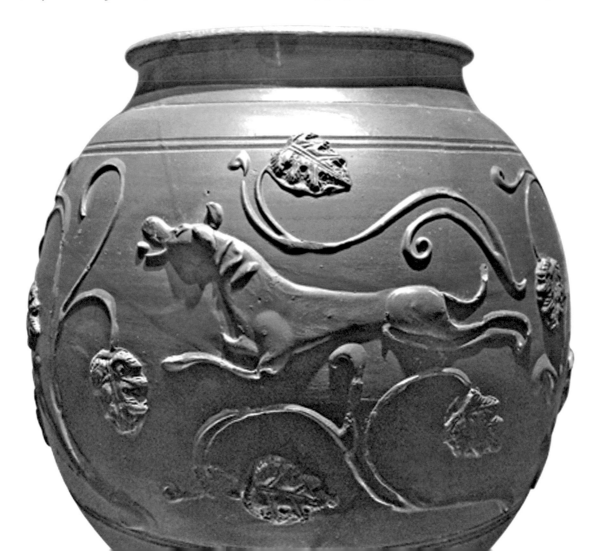

ART AND ARTEFACTS

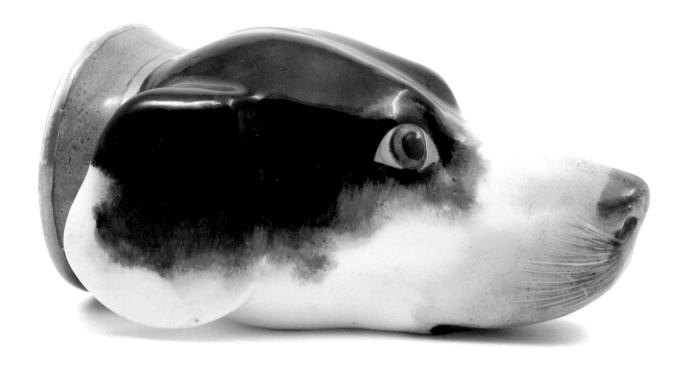

A STIRRUP-CUP was so called because the drinker was on horseback, downing a warming and invigorating draught of hot punch, ale or wine while the riders and the hounds milled about at the meet, before the hunt departed in pursuit of a fox on a crisp winter morning. Such cups were made in metal or ceramic, and as they did not need to be set down on a flat surface, the body of the vessel could be modelled or moulded in an appropriate decorative form, often the head of a fox or, as in this example, a foxhound. The stirrup-cup illustrated here is made of Staffordshire bone china and was manufactured around 1830. The breed characteristics of the English foxhound were well established by that date, and the head is a vivid and accurate representation of a nineteenth-century working hound.

But drinking-cups designed in the form of animal heads were nothing new. An ancient Greek *rhyton* was also a vessel shaped as a head, or even the whole head and forequarters, of an animal. The other cup, larger than the English stirrup-cup, was made more than 2,000 years earlier in Italy, in the red-figure technique of painted Greek pottery. Around the flaring rim it has a painted scene of the god Eros with decorative plants, flowers and grapes, while the lower part of the container is in the form of a most elegant hound's head, a prick-eared, long-muzzled creature who may represent one of the prized 'Laconian' hounds that were used for hunting hares and other swift game. Though we have many breed or type names from antiquity, and many pictorial representations, we do not have any detailed verbal descriptions that enable us to match them up closely.

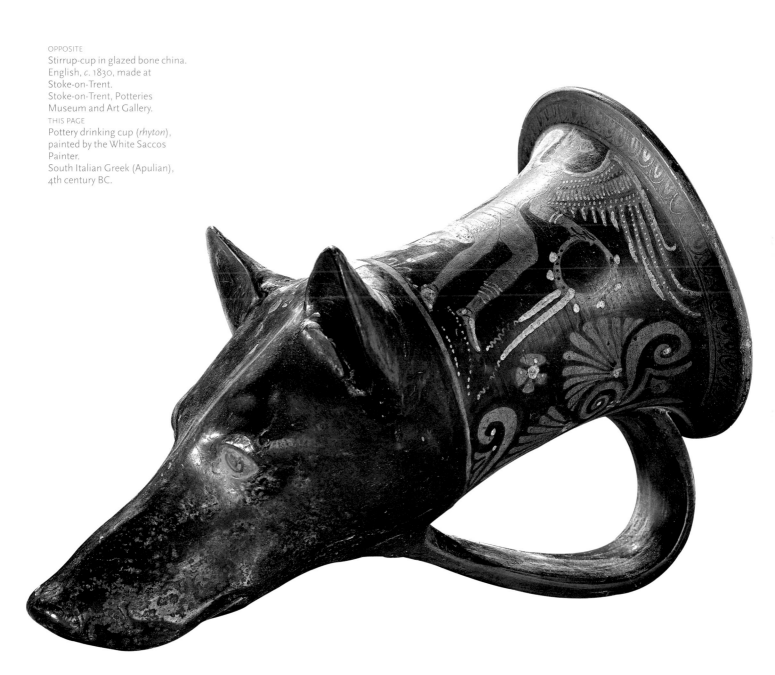

ART AND ARTEFACTS

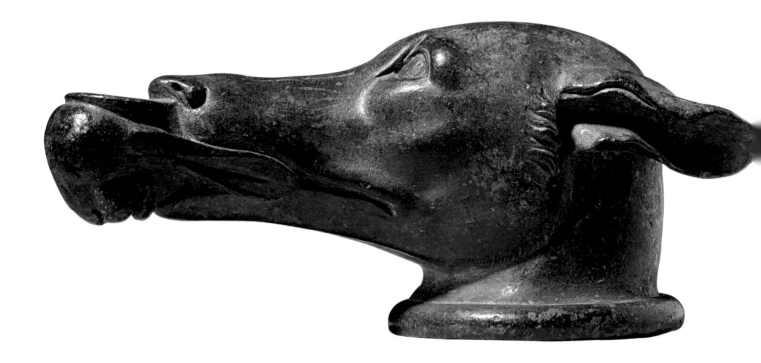

THIS PAGE
Cast bronze oil-lamp with
silver inlay.
Roman, 1st century AD.
Italy.
OPPOSITE
Silver watch-case and steel
and brass watch (hand lost),
made by Jaques Joly.
Swiss, Geneva, 1655–65.

FUNCTIONAL objects made in representational forms, so
that they double or masquerade as pure decoration, can range
from the stylish, witty and amusing to vulgar and tasteless.
Both the examples shown here have considerable charm.

Ancient oil-lamps were made both in metals and ceramics
and were often highly decorative objects. The bronze lamp
of the early Roman period (first century AD) was cast in
the shape of a hound's head, holding in its mouth the head
of an unfortunate hare – a standard part of the ubiquitous
hunting iconography of the Greek and Roman world. The
filling-hole, where the fuel – olive oil – would have been
poured into the lamp, is in the back of the hound's head,
and the wick would emerge from the nozzle at the front.

The hare's head is somewhat hidden when the lamp stands on a table. The modelling is beautiful: this is the universal, aristocratic greyhound, with his long muzzle, expressive eyes (heightened with silver inlay) and little folded ears.

The silver pendant in the form of a reclining dog is more naive in execution than the stylish Roman lamp: a stocky little beast, wearing a broad collar with a ring, he has long,

hanging ears, a fairly short muzzle and a solemn expression. His coat is indicated with short, chased lines. Only 4.1 centimetres long (*c.* 2¹/₂ in.), he was clearly intended to be suspended from a chain or ribbon as a personal ornament. But this silver dog, made in Switzerland around 1655–65, hides a surprising secret: the base of the model is hinged, and opens to reveal a watch. The watch is signed by Jaques Joly, a Swiss watchmaker working in Geneva.

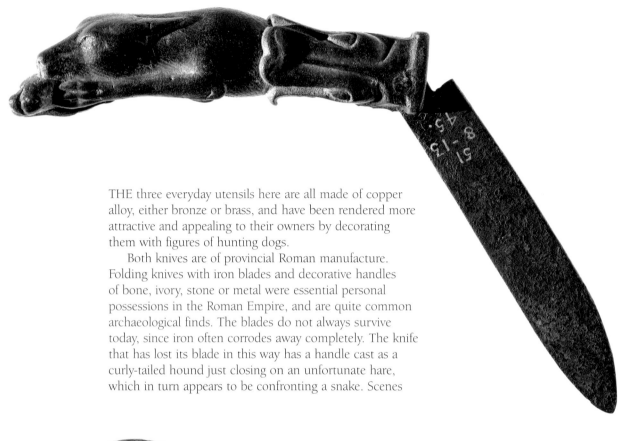

THE three everyday utensils here are all made of copper alloy, either bronze or brass, and have been rendered more attractive and appealing to their owners by decorating them with figures of hunting dogs.

Both knives are of provincial Roman manufacture. Folding knives with iron blades and decorative handles of bone, ivory, stone or metal were essential personal possessions in the Roman Empire, and are quite common archaeological finds. The blades do not always survive today, since iron often corrodes away completely. The knife that has lost its blade in this way has a handle cast as a curly-tailed hound just closing on an unfortunate hare, which in turn appears to be confronting a snake. Scenes

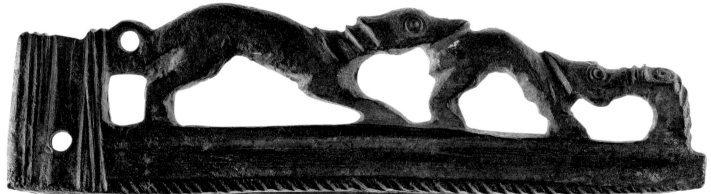

like this were probably the most popular design for
knife-handles, and many examples are known. The other
knife has its iron blade still in good condition, and can be
fully opened out. Its handle is more unusual, modelled
as the front half of a hound with the hare's head already
between its paws, like the lamp illustrated on page 158.
Both objects are from France, and were made between the
first and third centuries AD.

The function of the other implement is not quite as
obvious at first sight. It is a medieval brass nutcracker of
fifteenth-century date. The degree of decorative detail is
considerable for an essentially mundane artefact. The ends
of the handles are cast as human heads, one male and one
female, and lions' heads are engraved on the nippers that
crush the nutshell. But the most obvious decoration is the
pair of lively little dogs near the hinge, each apparently
about to catch the bird in front of him.

OPPOSITE, TOP
Folding knife with iron blade
and cast bronze handle.
Gallo-Roman,
c. 1st–3rd century AD.
France.
OPPOSITE, BOTTOM
Folding knife with iron blade
andcast bronze handle.
Gallo-Roman,
c. 1st–4th century AD.
Vaison (Vaucluse), France.
THIS PAGE
Brass nutcracker.
English, 15th century.

ART AND ARTEFACTS

IMAGES of dogs have been used to decorate both everyday objects and luxury trinkets intended more for display than for use.

Inexpensive mould-made terracotta oil-lamps, burning olive oil, were used all over the Roman world. They were mass-produced in vast numbers, and were often decorated with scenes ranging from the mythological to the mundane. Academic study of these lamps over many generations has made it possible to date them quite closely, and to recognize where individual examples were made. The lamp illustrated here was found at Ephesus in Turkey, and was manufactured there towards the end of the first century AD or the beginning of the second. The decoration features a fluffy, prick-eared dog with a curly tail, lying on a couch. It is clearly a motif that would appeal to a pet-owner.

The snuff-box with a picture of a dog on the lid is, by contrast, an extremely valuable and luxurious article. It was made around the turn of the eighteenth and nineteenth centuries. The picture of a seated white hound with red ears, set against a dark blue background, is a micromosaic, composed of minute,

carefully shaped glass tesserae. It is of Italian workmanship, and the design, which is not unique, was clearly inspired by larger mosaics of the Roman period. A border of patterned *millefiori* glass tesserae surrounds the mosaic picture, and the whole is set within a gold frame, chased with leafy scroll ornament in relief. The tortoiseshell box itself is of Austrian manufacture. The owner of an object such as this would have displayed it as a demonstration of his or her wealth and taste, and the choice of subject would surely have appealed only to a dog-lover.

OPPOSITE
Mould-made
terracotta lamp.
Roman, made at Ephesus,
late 1st –early 2nd century AD.
Ephesus, Turkey.
THIS PAGE
Lidded tortoiseshell
snuff-box with glass
micromosaic and gold
mount.
Italian and Austrian,
made in Rome,
18th or 19th century.

ART AND ARTEFACTS

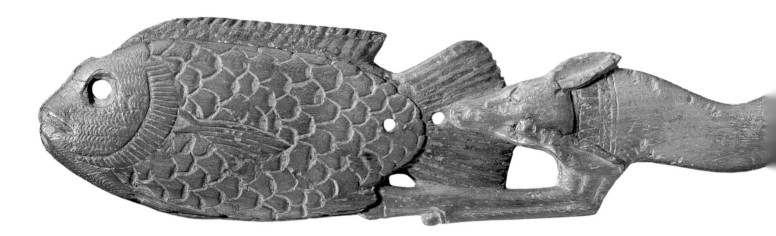

DECORATED functional objects incorporating animal imagery may be found in all cultures. It is often difficult to say whether the choice of a particular animal or other motif was made simply because it was visually appealing, or because it had some symbolic significance to the original owner of the artefact.

The dog seizing a fish by the tail is an ancient Egyptian 'cosmetic-spoon'; the precise use of these lidded boxes with long handles is not certain, but they were often made in ingenious and highly decorative forms, incorporating figures of animals and people. This one, just over 26 centimetres (over 10 in.) long, is finely carved in wood, and still has traces of blue paint remaining on the hound's wide collar and the scales of the fish. The fish is a *Tilapia nilotica*, or *bolty* fish, an important, large food-fish that was frequently represented in Egyptian art. The stretched and half-twisted pose of the dog is noteworthy, and may be intended to indicate that he is swimming and catching his prey in the water, rather than leaping upon a landed fish. With his long ears, slender and sinuous body and thick, straight tail, the dog forms a graceful,

elongated handle. This decorative
utensil was made during the
New Kingdom, perhaps around
1300 BC.

The horn comb in the shape of
a seated dog is modern, made in the
late twentieth century in Mexico.
The teeth of the comb are cut along
the animal's back, while the details
of eyes, ears, paws and tail are picked
out in painted brown lines. The
amusing painted flower is a purely
decorative accent. Though this object
is far simpler and more naive than
the fish-hunting hound from distant
antiquity, it has great wit and charm.

ART AND ARTEFACTS

THE choice of a particular animal motif on a functional object may have symbolic meanings, or it may be based on nothing more than a liking for the animal in question or even a playful association of ideas.

The American smoking pipe is carefully carved in a fine-grained stone and polished to a smooth, dark surface. Like other examples of Native American pipes illustrated in this book, it would have been used at specific ritual gatherings, and the choice of animal to decorate it will certainly not have been random. He may be a wolf, though the shape of the head is more suggestive of a domestic dog. Although the date and provenance of the pipe are not known for certain, it is thought to be Mohawk and to have been made in the seventeenth or eighteenth century AD. The Mohawk nation occupies a region in what is now the north-eastern United States and south-eastern Canada.

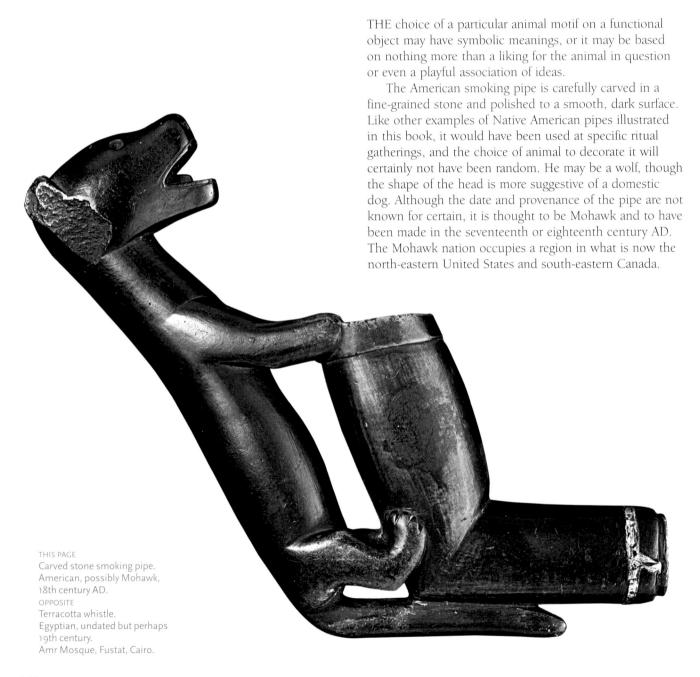

THIS PAGE
Carved stone smoking pipe.
American, possibly Mohawk,
18th century AD.
OPPOSITE
Terracotta whistle.
Egyptian, undated but perhaps
19th century.
Amr Mosque, Fustat, Cairo.

The other object is of even more uncertain date, and was acquired in the 1870s by the Revd Greville Chester, an intrepid Victorian traveller who acquired many small antiquities during his frequent visits to the Middle East and became a regular benefactor of the British Museum. The roughly formed little pottery dog is also a functional object – a whistle – and is said to have come from the medieval Amr Mosque at Fustat, which is now part of Cairo. It may be of nineteenth-century date or earlier, and it belongs to a very widespread tradition of pottery whistles formed in the shapes of birds and other animals. Although modelled in an extremely simplified way, we have no difficulty in perceiving this little creature as a dog, raising its head and emitting, not a canine bark or howl, but a shrill whistle.

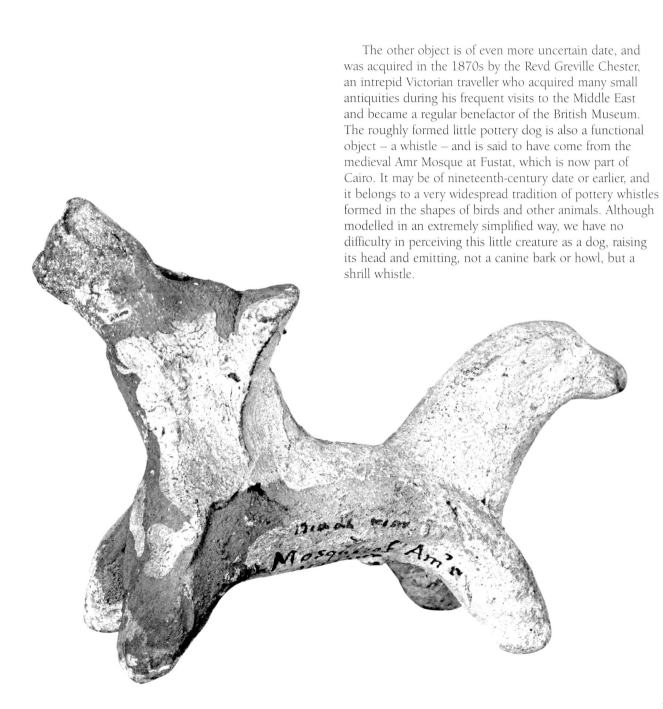

ART AND ARTEFACTS

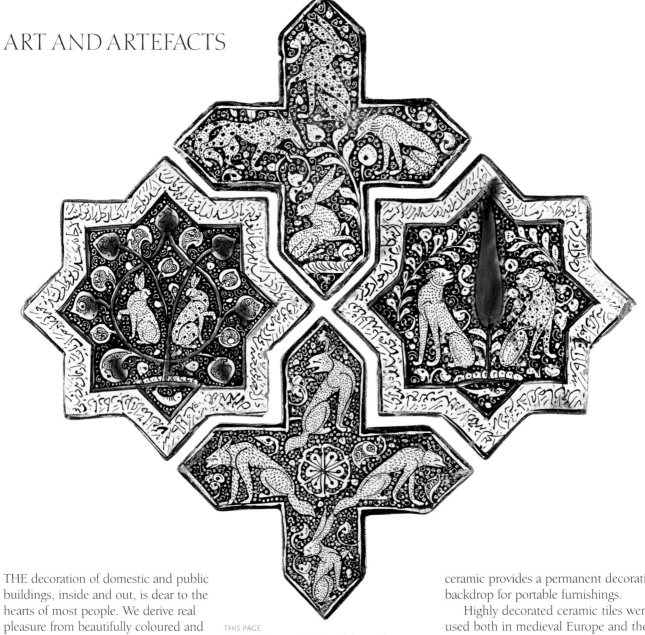

THE decoration of domestic and public buildings, inside and out, is dear to the hearts of most people. We derive real pleasure from beautifully coloured and embellished walls, floors and ceilings, and the rather dry term 'architectural ornament' includes many objects of great artistic merit. The surfacing of internal walls and floors with pictures and patterns in durable stone or

THIS PAGE
Interlocking ceramic tiles with lustre glaze.
Persian, AD 1260–70.
Kashan, Iran.
OPPOSITE
Earthenware floor-tile, inlaid and glazed.
English, 14th century, made at Penn,
Buckinghamshire.
Notley Abbey, Buckinghamshire, England.

ceramic provides a permanent decorative backdrop for portable furnishings.

Highly decorated ceramic tiles were used both in medieval Europe and the contemporary Islamic world. The gorgeous Persian tiles in an interlocking pattern of star and cross shapes were made in the thirteenth century AD. In cream with brown lustre glaze and touches of strong blue-green, they depict

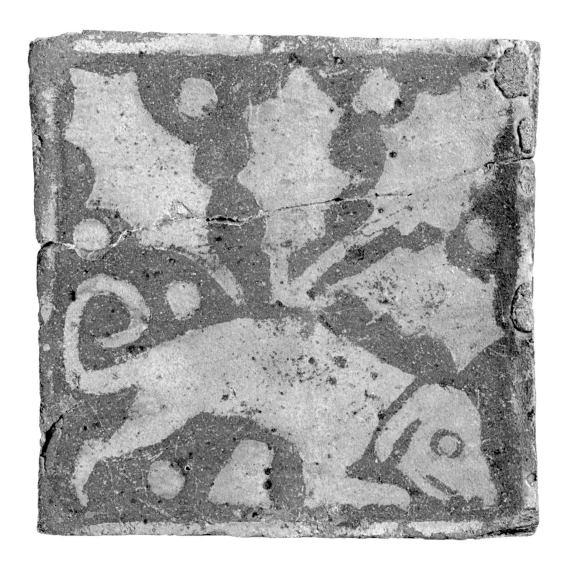

a rich array of plants, flowers and animals. Cheetahs, hares and wolves are placed carefully amongst the vegetation in formal, heraldic poses. They are depicted in an elegantly mannered and balanced style, their elongated bodies and limbs and gracefully turning heads fitting their spaces perfectly, and their coats are delicately patterned.

The small square tile looks almost childishly plain by comparison with the intricate detail of its Islamic counterparts. Made in southern England in the fourteenth century, it was once part of the flooring of an abbey. But this design has its own charm and impact, the effectiveness of a bold simplicity which is very far from naive. The eye can instantly take in the picture of the busily tracking hound, his curly tail held high and his nose close to the ground, hurrying past a small holly tree. The dog's eager concentration is palpable, even though he is depicted in simple blocks of two bold colours; the inlaid white clay, tinted to the colour of honey by the lead glaze, stands out clearly against the red-brown background.

ART AND ARTEFACTS

DECORATIVE hardstones have been skilfully engraved with minuscule scenes and figures for millennia, and have served three main purposes, sometimes simultaneously. They have been worn or carried as amulets, to help focus divine protection on the owner; they have been used as sealstones, to make impressions on clay, wax and other materials as proofs of identity, ownership and security; and they have also been worn quite simply as personal adornment, since they are often exquisitely beautiful miniature works of art.

The pierced gem in opaque red jasper, a type of quartz, is an example of the art of Minoan Crete, shaped and carved in the sixteenth or fifteenth century BC. It probably served all three of the purposes mentioned above, as a personal sealstone, a protective charm, and an attractive item of jewellery. Only 2.2 centimetres long

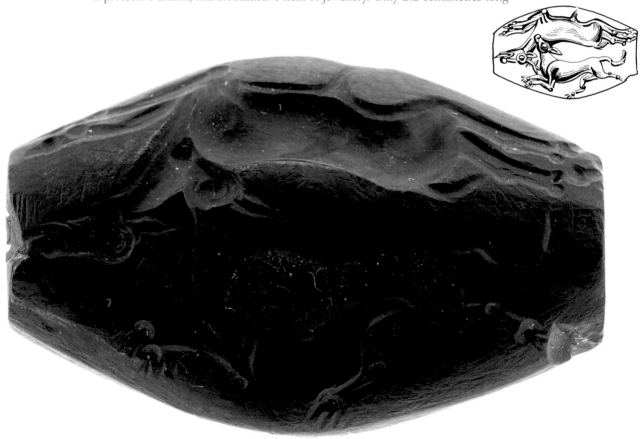

(less than an inch) it is engraved with an image of a hound bringing down a stag. The scene has been ingeniously fitted into the tiny area, and the style of engraving is bold and assured. The animals' eyes are deliberately emphasized, but their bodies and limbs are acutely observed and realistically proportioned.

The other gemstone was made more than 1500 years later, in the early Roman period, and was intended solely as a decorative jewel. It is cut in relief, as a cameo. The stone is agate, a type of microcrystalline quartz attractively banded in different colours. The gemcutter has made use of these colour variations and contrasts in the stone to emphasize the characteristics of the subject, a resting dog. With his rough, shaggy blue-grey coat, the animal looks a little like a modern wolfhound.

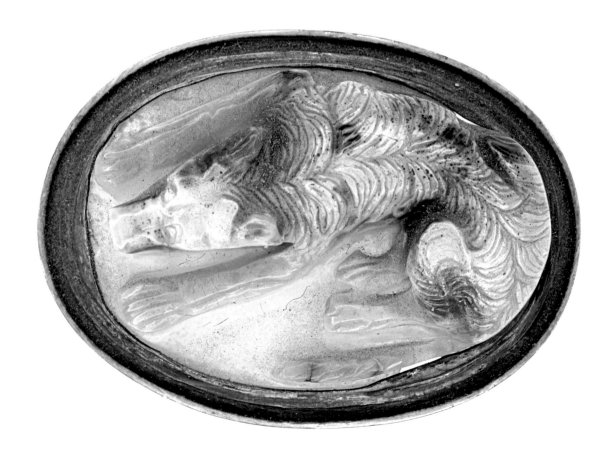

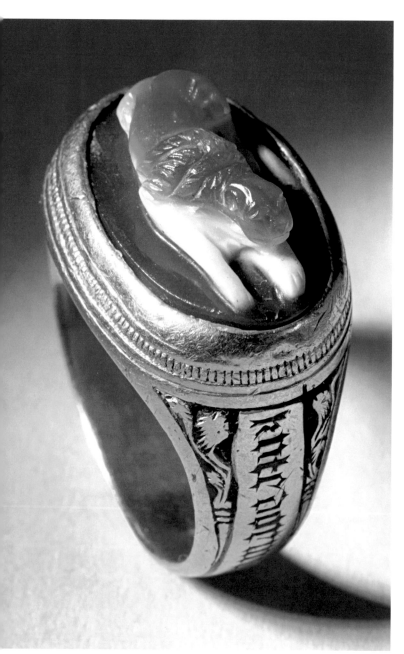

THE gold ring with a brown, white and amber sardonyx carved in cameo with a recumbent dog was made in Italy in the fifteenth century AD. The cameo is very similar to the Roman example illustrated on the previous page, though less skilfully cut: it may be a Renaissance copy, but might be Roman, re-used in a new setting at a period when Classical art was much admired. The gold hoop of the ring is handsomely decorated with leafy patterns and an inscription picked out in niello (black metal sulphide). The motto, in debased Latin, reads *kute dormio, tute vigilo, victis parco, nullam fugio*, translated as 'alert I sleep, safely I watch, I spare the vanquished, I flee from none'. This suggests a reliable watchdog, and it has been observed that it might have been a motto favoured by a soldier. If so, he was a soldier with a taste for very valuable and flamboyant jewellery.

The other ring also shows the influence of Classical antiquity. The large stone, a hessonite garnet, is very deeply cut in intaglio with the head of a heavy-jowled hound. It represents Sirius, the dog-star, and is signed in Greek letters by the artist, Johann Lorenz Natter (1705–63), just as its ancient prototype (now in the Boston Museum of Fine Arts) was signed by the gemcutter Gnaios in the first century BC. Natter published an important treatise on gem-engraving in 1754, in which he discussed and illustrated the Gnaios gem, then in a private collection, and described his attempts to match it. The collecting of Classical antiquities, including engraved gems, was at its height, and the influence of Classical taste was to be seen in art and architecture all over Europe. The finest gemcutters of the eighteenth century aspired to, and often achieved, the standards of their ancient predecessors.

THIS PAGE
Gold finger-ring with sardonyx cameo setting (quartz) and niello inlay.
Italian, 15th century.
OPPOSITE
Gold finger-ring, set with a hessonite garnet intaglio cut by Johann Lorenz Natter (1705–63).
German/English, 18th century, before 1754.

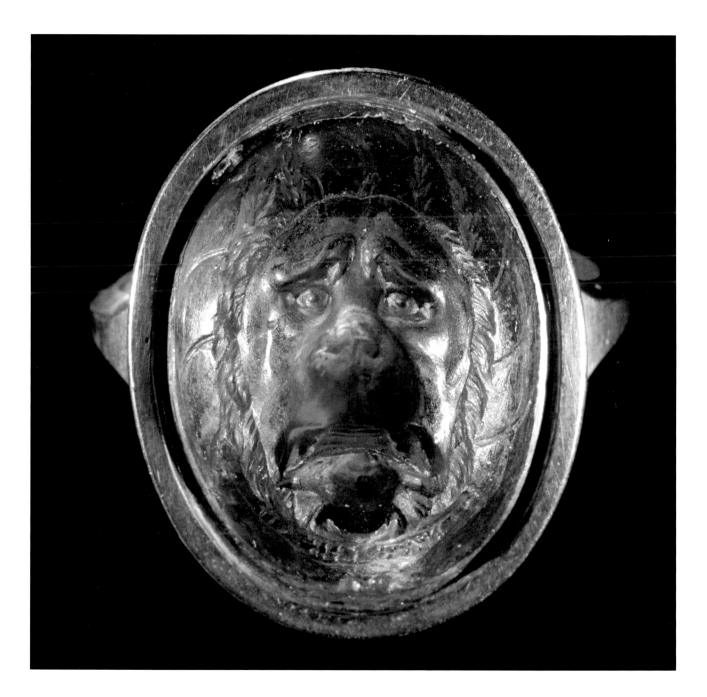

173

ART AND ARTEFACTS

JEWELLERY featuring animals has a very long history indeed, and can range from the most modest and inexpensive trinkets to valuable possessions that convey complex messages of wealth and social status.

The little dog-shaped bronze brooch with coloured enamel spots was made in Gaul (France) in the Roman period. When new, the bronze would have had a bright, golden shine, and the enamelled spots would have been brilliant in red and blue. We do not know whether the dog had any special meaning: other zoomorphic (animal-shaped) brooches in the same style include horses, lions and panthers, while many animals such as wild boar, hares and birds were also popular as brooches in Roman Britain and Gaul. We cannot always tell which

of these had symbolic meaning and which were favoured simply for their decorative qualities. Dogs were associated with several deities of hunting and healing, but perhaps this charming little ornament was simply chosen by somebody who liked dogs.

The other piece is also a brooch, a precious relic of Anglo-Saxon England, and undoubtedly once the possession of a person of great wealth and influence. It is a large silver disc, with intricate inlays of gold, black niello (silver sulphide) and glass, and both technically and artistically it is a masterpiece of ninth-century metalwork. The assured use of metallic colour – gold, silver and black – produces a balanced design that

can be read simply as a pleasing pattern, but closer scrutiny reveals that at least some of the many strange creatures that form a repeating motif are dogs: seated dogs, wearing collars, and looking back with upraised tails. Again, we do not know whether there was a special symbolic meaning in the presence of dogs, but the artist who made this remarkable object depicted them vividly.

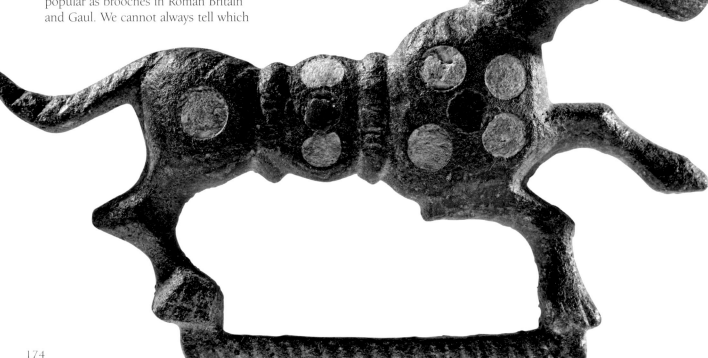

OPPOSITE
Enamelled cast bronze
brooch.
Gallo-Roman,
c. 1st–2nd century AD.
THIS PAGE
The Strickland Brooch:
silver disc-brooch
with gold, niello and
blue glass.
Anglo-Saxon, mid-9th
century AD.

ART AND ARTEFACTS

PERSONAL ornament regularly includes pictorial imagery depicting gods and saints, but human beings dear to the wearer have also frequently been represented in jewellery. In some antique pieces we find outstanding miniature portraits painted on ivory by noted artists, set in gold and adorned with gems, but the concept still exists today, usually in the humbler form of a modest silver locket enclosing a tiny photograph. It is natural to take pleasure in a small image of a loved one worn on the person. Jewellery decorated with domestic animals, including many different breeds of dog, is also still available today, but it is rarely obtainable in the quality seen in these two handsome late Victorian cravat-pins.

Whether these pins with dogs' heads painted in enamels come into the category of specific 'family portraits', or are merely generic illustrations of a favoured breed,

THIS PAGE
Enamelled gold cravat-pin, painted by William Bishop Ford.
English, 1882.
OPPOSITE
Enamelled gold cravat-pin, painted by William Bishop Ford.
English, 1876.

is uncertain, but in either case they are very fine miniatures, painted with knowledge and care. They are the work of William Bishop Ford (1832–1922), and were made and set in their elegantly simple gold mounts in 1876 and 1882. At a little under an inch (2.25 and 2.5 cm) in diameter, they show impressive subtlety and fine detail. The little Pug has the characteristically worried, wrinkled frown and large eyes of his kind, while the other animal, with his solemn expression and pale amber stare is a large hound of some kind. Although to modern eyes the breed that comes most readily to mind is perhaps the Weimaraner, he may well be a late Victorian Great Dane, his ears allowed to grow naturally rather than being cut.

It is all too easy to dismiss such work as sentimental, but the feelings expressed in such jewels are sincere, and the technical expertise displayed is admirable by any standards.

ART AND ARTEFACTS

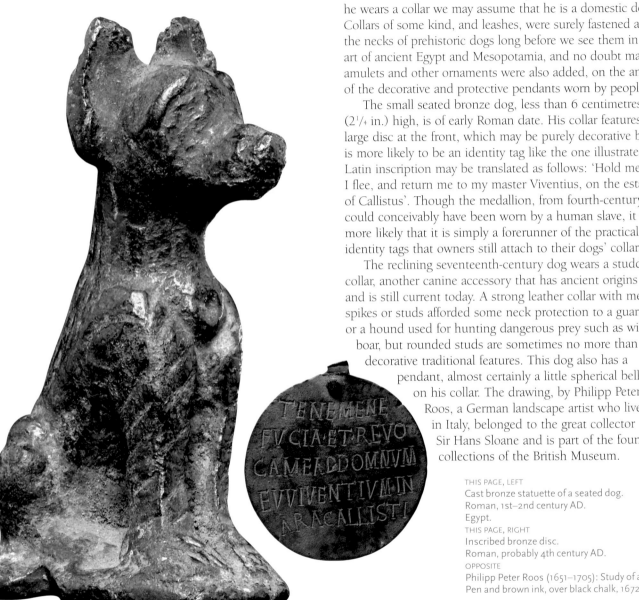

HOWEVER wolf-like an animal may look in a work of art, if he wears a collar we may assume that he is a domestic dog. Collars of some kind, and leashes, were surely fastened around the necks of prehistoric dogs long before we see them in the art of ancient Egypt and Mesopotamia, and no doubt magic amulets and other ornaments were also added, on the analogy of the decorative and protective pendants worn by people.

The small seated bronze dog, less than 6 centimetres (2¼ in.) high, is of early Roman date. His collar features a large disc at the front, which may be purely decorative but is more likely to be an identity tag like the one illustrated. Its Latin inscription may be translated as follows: 'Hold me, lest I flee, and return me to my master Viventius, on the estate of Callistus'. Though the medallion, from fourth-century Italy, could conceivably have been worn by a human slave, it is more likely that it is simply a forerunner of the practical identity tags that owners still attach to their dogs' collars.

The reclining seventeenth-century dog wears a studded collar, another canine accessory that has ancient origins and is still current today. A strong leather collar with metal spikes or studs afforded some neck protection to a guard-dog or a hound used for hunting dangerous prey such as wild boar, but rounded studs are sometimes no more than decorative traditional features. This dog also has a pendant, almost certainly a little spherical bell, on his collar. The drawing, by Philipp Peter Roos, a German landscape artist who lived in Italy, belonged to the great collector Sir Hans Sloane and is part of the founding collections of the British Museum.

THIS PAGE, LEFT
Cast bronze statuette of a seated dog.
Roman, 1st–2nd century AD.
Egypt.
THIS PAGE, RIGHT
Inscribed bronze disc.
Roman, probably 4th century AD.
OPPOSITE
Philipp Peter Roos (1651–1705): Study of a dog.
Pen and brown ink, over black chalk, 1672–1705.

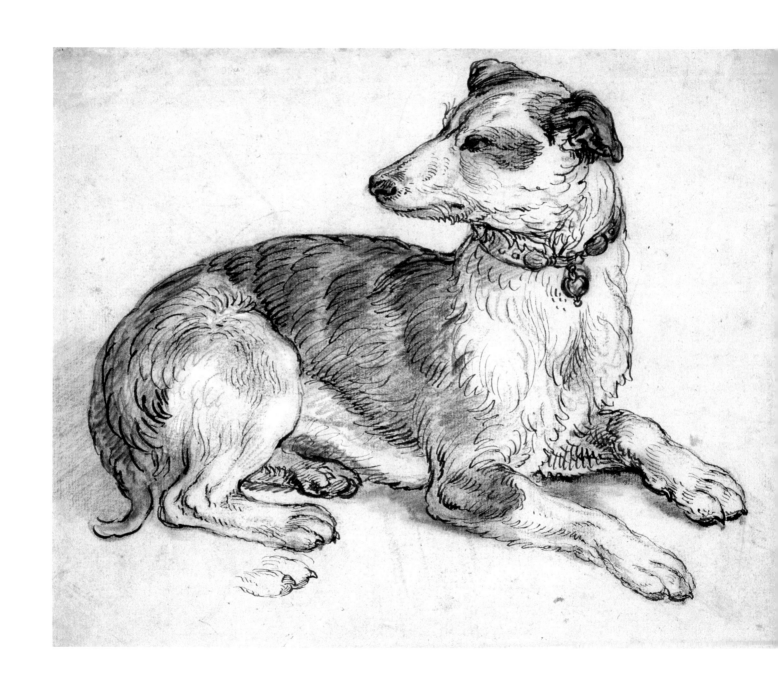

ART AND ARTEFACTS

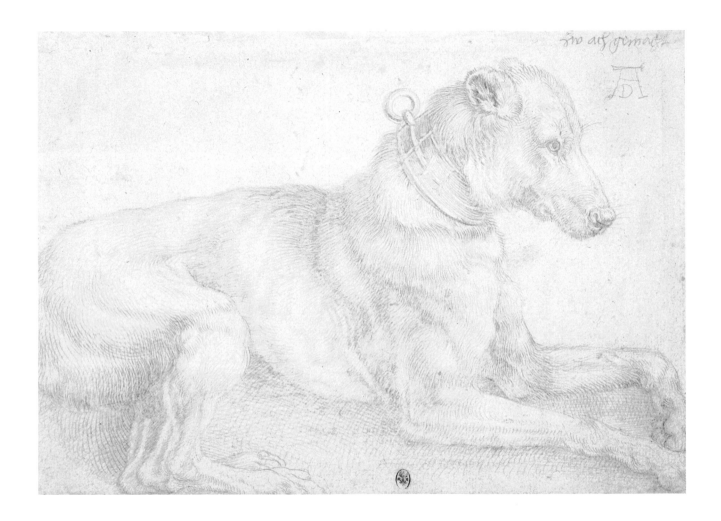

WE flinch at accounts of the medieval 'lawing' or *expeditation* of mastiffs and other large dogs to prevent unauthorized animals from chasing the king's deer: it entailed the permanent laming of the victims by brutally amputating three digits of their forefeet, using a block of wood and a chisel. Our reasons for de-sexing many of our domestic animals are, in general, humane, though they are based on our needs and convenience rather than those of the animals, but the custom of surgically changing details of a dog's appearance on purely aesthetic grounds is much harder to justify.

Ear-cropping has a long history.

Wild canids all have upstanding ears, but many domestic dogs already had pendant ear-flaps thousands of years ago. The first impetus to remove them may have arisen from a desire to forestall painful fighting or hunting injuries in which dogs' ears were seized and torn; but whatever the original justifications, in those countries where ear-cropping remains legal, it is now performed simply to 'improve' the dog's appearance.

Albrecht Dürer recorded a fine early example in a delicate silverpoint drawing made in Aachen in 1520. He portrayed a large, bony, long-legged dog wearing a broad collar with a ring. The animal's ear appears to have had almost the whole external flap excised.

A similarly severe degree of cropping, to produce a 'pricked' ear, is seen in a luxury piece of jewellery made in Paris around 1890. The brooch is of gold, silver, enamel and glass, and depicts the head of a dog encircled by a collar and lead. The back of the ornament incorporates a glazed compartment for a lock of hair. Such a jewel, both valuable and sentimental, would certainly have been purchased only by somebody who loved dogs, yet the handsome canine head, beautifully modelled and enamelled, is marred by shockingly mutilated ears.

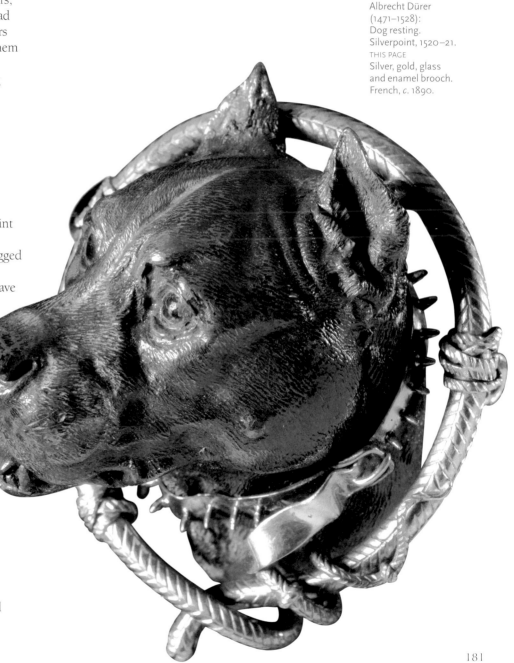

OPPOSITE
Albrecht Dürer
(1471–1528):
Dog resting.
Silverpoint, 1520–21.
THIS PAGE
Silver, gold, glass
and enamel brooch.
French, c. 1890.

FRIENDS AND COMPANIONS

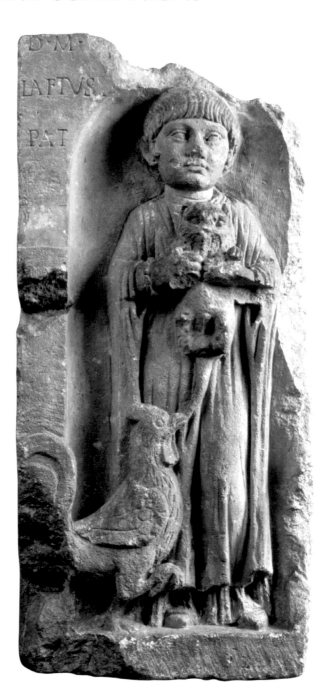

THIS PAGE
Limestone tombstone.
Gallo-Roman,
2nd century AD.
Bordeaux, France.
Musée d'Aquitaine,
Bordeaux.
OPPOSITE
Paul Sandby
(?1730–1809):
A girl with a pet dog
on her knee.
Brush drawing in grey
wash, over graphite,
18th century.

MOST children are attracted to dogs, especially to small dogs and puppies, and children may well have contributed to the acceptance of dogs as members of human families in prehistory.

The beautiful Roman tombstone probably dates from the second century AD and was found in Bordeaux, an important Gallo-Roman city. The inscription is incomplete, so we do not know the name and age of the little girl whose short life it commemorates, but her father's name, Laetus, survives. The daughter of Laetus holds an animal which was long misidentified as a cat, but which is certainly a small, male dog. Although the dog and the cockerel may well have symbolic meanings in relation to death and the afterlife, it also possible that they were simply this child's pets, and that her grieving parents wished to record her as she had been in life, playing with her favourite animals.

In more recent art, pictures of children with pets all too often descend into mawkishness, but this pencil and wash drawing by Paul Sandby (?1730-1809) has charm without undue sentimentality. It depicts a plainly dressed young girl, sitting and petting the small, smooth-coated terrier that stands on her lap. Sandby was one of the founding members of the Royal Academy and a distinguished landscape painter; he was also a member of the pioneering team of military cartographers, led by William Roy, that surveyed and mapped the Scottish Highlands after the Jacobite revolt of 1745, recording not only natural features and contemporary structures, but also the traces of the past that survive in the landscape. This work ultimately led to the establishment of the British Ordnance Survey, which produced highly detailed and accurate maps of Britain and countries under British influence for two centuries before the advent of satellite photography.

FRIENDS AND COMPANIONS

THE relationship between dogs and people includes the human responsibility of caring for their canine companions and providing them with food, shelter and other comforts. The painting of a fair-haired boy and his dog is a domestic scene typical of many Dutch interiors of its era, the seventeenth century. The artist, Gerard ter Borch (1617–81), was a fine portrait and genre painter, whose subjects ranged from the great and the good, dressed in their rich silks and velvets, to humble everyday scenes like this one. Here, the dark and sparsely furnished interior provides a simple backdrop for the figure of the plainly dressed boy, who is seated with his red-and-white spaniel lying patiently across his lap. The youth's gaze is focused with intense concentration on the dog's coat, and the position of his hands is that of one who has located a flea, and is about to crush it.

In fact, this atmospheric picture is not the original 1660s oil painting by ter Borch himself (which is now in Munich), but a very careful and highly finished watercolour copy of it made

in the eighteenth century. It belonged to the antiquarian Richard Payne Knight, who bequeathed his collection to the British Museum. It is interesting that hand-painted copies of this picture, as well as printed reproductions, are still available for sale today.

Another youth with his dog, this time a little rough-coated terrier of some kind, appears in the delightful drawing by the English artist Paul Sandby. His figure studies, as epitomized by this drawing and the one of a young girl with her dog on page 183, are sensitive and expressive.

on page 183

OPPOSITE
After Gerard ter Borch (1617–81):
A boy cleaning his dog's coat.
Watercolour.
British, 18th century.
THIS PAGE
Paul Sandby (?1730–1809):
A boy sitting on the ground with a dog.
Red chalk and graphite, 18th century.

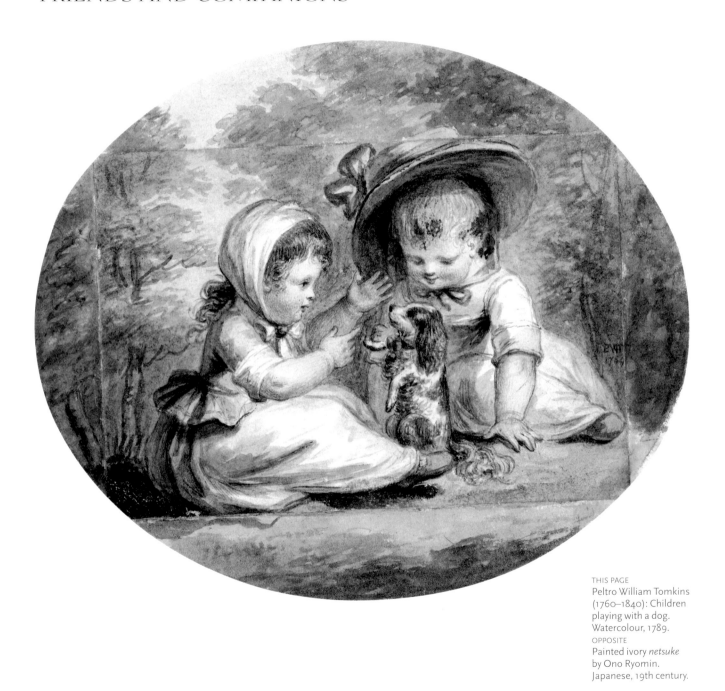

THESE two scenes of children playing with a puppy are not very far apart in date, but are from opposite sides of the world. The small oval watercolour by an English artist, Peltro William Tomkins, presents the sweetly sentimental view of childhood that we associate particularly with the Victorian period, although this picture dates from about 1789, anticipating Victoria's reign by half a century. The two small children, a boy and a girl, are shown playing with a red-and-white dog, apparently encouraging it to sit up and beg. The dog wears a red ribbon and bow around his neck, and is not very realistically depicted, since his diminutive size in relation to the children would make him a young puppy, but he has the proportions of an adult. He is intended to represent a small spaniel of the type that still exists in two modern breeds, the King Charles Spaniel and the Cavalier King Charles. Dogs of this type have been immensely popular purely as pets, rather than working dogs, for centuries, and have undoubtedly been the good friends and companions of many children for generations.

The two little boys in the painted ivory Japanese *netsuke* are also accompanied by a puppy, but the tiny black-and-white dog is not the focus of their attention, since they have plenty of other playthings – a flute, which one child is playing, a hobby-horse, and a *shishi* (lion-dog) costume, whose snarling head is visible beneath the boy riding the hobby-horse. Puppies are represented quite frequently in Japanese art, and are always clearly distinguishable from adult dogs, with realistically rotund bodies and short muzzles.

FRIENDS AND COMPANIONS

PUPPIES are not represented very often in Classical art, so the large terracotta figurine is unusual. Made in Greece around 400 BC, it represents a young man dressed only in a cloak and an extraordinarily elaborate headdress, carrying a small puppy in his left arm and followed by a dog, presumably the pup's mother. The headdress is of a type worn at religious festivals, so the figure has some religious or symbolic meaning. Although the quality of the modelling is high, no attempt has been made to depict the proportions of a very young dog realistically: the puppy's shape closely echoes that of the adult bitch.

By contrast, the two charming *netsuke* have been designed to convey precisely and accurately the appearance and behaviour of very young dogs. Both are carved in ivory and date from the nineteenth century. The pup scratching himself is by the maker Tomochika. Only 3 centimetres high (less than 1¼ in.), the little dog has the large head, short muzzle, little floppy ears and rounded contours of the infant canine. His legs are short and his paws clumsily large, and he instantly communicates the characteristic appeal of the very young.

Another artist, Okamoto, carved the other *netsuke*, and he has chosen to depict the playfulness and curiosity of young dogs. This small creature is playing with an awabi (abalone) shell. A cord is threaded through the first of the row of natural holes along the edge of the shell, and the pup is pulling at this. With the skill and virtuosity typical of the artists who made these highly decorative costume accessories, details such as the paw-pads of the dogs and the knot of the cord on the interior of the shell have been represented with the utmost care.

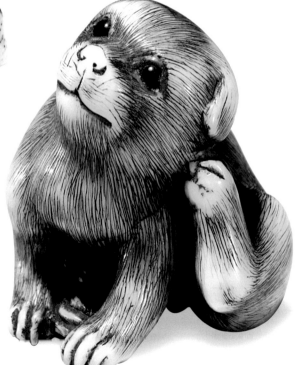

OPPOSITE
Painted terracotta
statuette.
Greek (Boeotian),
c. 400 BC.
THIS PAGE, RIGHT
Ivory *netsuke* by
Tomochika.
Japanese, 19th century.
THIS PAGE, ABOVE
Ivory *netsuke* by Okatomo.
Japanese, 19th century.

FRIENDS AND COMPANIONS

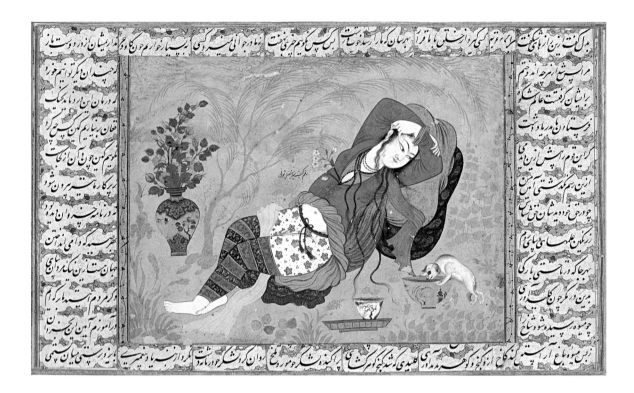

THE stereotype of the wealthy and luxury-loving woman who keeps a vastly over-indulged little pet dog is a very ancient and widespread one, and has been used to censure and criticize influential and independent women, from prioresses and aristocrats to expensive courtesans, over the centuries.

These pictures illustrate aspects of that stereotype. The seventeenth-century Persian painting by the artist 'Mir Afzal Tuni is of a reclining woman, in a marked state of dishabille, languidly looking on while her tiny white dog laps wine from an elegant porcelain bowl. The deliberately erotic pose and the woman's seductively loosened hair and clothing imply that she is a cultured lady of easy virtue rather than a respectable female. Persian paintings of this period include genre scenes showing leisure activities, entertainments and the luxurious life of courtiers. The little dog is of uncertain breed, but he was certainly bred to be a pampered pet, for he has no connection with the hunting hounds of his time.

The graceful and gorgeously dressed nineteenth-century Japanese lady painted on a silk scroll by Mihata Joryu

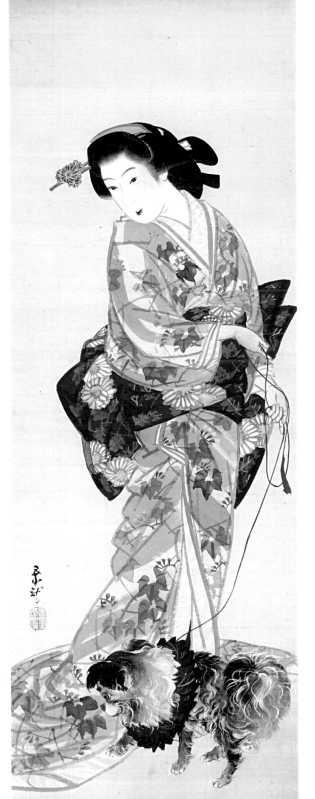

is, by contrast, simply a wealthy woman. Her dog is quite a small spaniel of some type, with a longer muzzle than the modern Japanese Chin breed, and while he is not perhaps small enough to be described as a lapdog, he is clearly a valued and cherished companion. His luxuriant misty blue-grey coat is well groomed, and he is wearing a most ornamental red collar. Stepping daintily onto the hem of his owner's clothing, he focuses attention on its subtle and pleasing pattern of soft green leaves, as well as providing a visual balance for the curved pose of the standing woman.

OPPOSITE
'Mir Afzal Tuni, A lady watching her dog drink from a bowl. Watercolour, ink and gold on paper. Persian, *c*. 1640. Isfahan, Iran.
THIS PAGE
Painted silk hanging scroll by Mihata Joryu. Japanese, *c*. 1830–40.

191

FRIENDS AND COMPANIONS

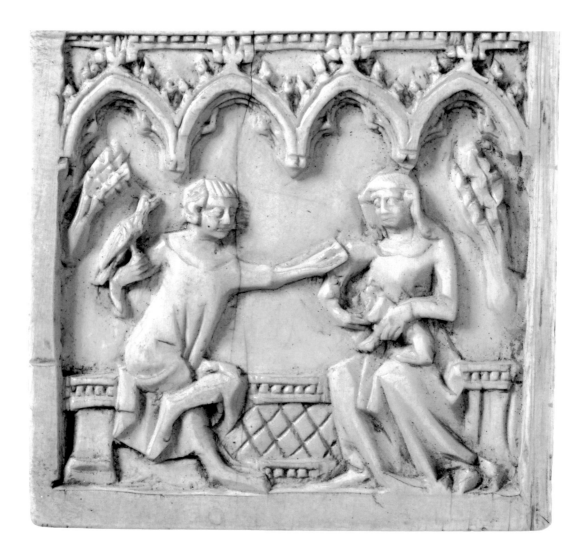

'LAPDOG' is a word that has derogatory connotations in both literal and metaphorical use. Little dogs whose main function in life was to entertain and be pampered by their owners, usually women who lived lives of luxury and privilege, were a focus of much self-righteous disapproval from the Middle Ages onwards, yet it was hardly the fault of the dogs if their owners were unduly indulgent and sentimental.

In medieval art, a woman's aristocratic status is sometimes indicated by the presence of a little pet dog, while the noble male will often be shown with his hunting hound and falcon. The mannered scene from the intricately decorated back of an ivory writing-tablet, half of a pair, made in France in the fourteenth century,

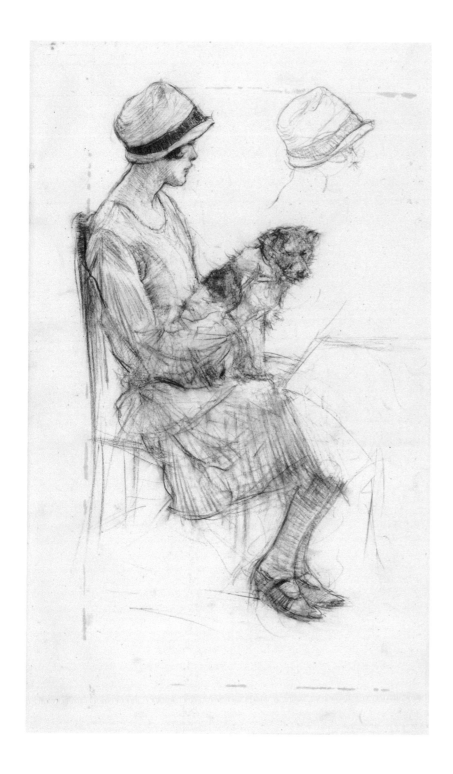

features a young man carrying a hawk and speaking to a lady with a small dog on her lap. The other scenes carved on the pair of writing-tablets likewise depict men and women living a life of leisure, hunting or playing a board-game.

But lapdogs need not be tiny and fluffy; many large dogs vainly aspire to the role. Nor do their owners have to be sheltered flowers of the nobility. The English artist Ernest Borough Johnson (1866–1949), known chiefly as a book illustrator, captured in his chalk drawing a typical vignette from the late 1920s, when women were becoming ever more independent. A young woman sits at a café table; her bobbed hair is almost hidden by a cloche hat, and her short pleated skirt and long, straight, jumper exemplify the comfortable and practical fashions of the time. On her knees sits a wire-haired fox terrier. The fox terrier, very popular in the earlier twentieth century, is a strong-willed and often stubborn working breed; it has never been stigmatized as a lapdog.

FRIENDS AND COMPANIONS

DOGS shown in certain contexts, such as sitting on a person's lap or sleeping on his bed, are quite obviously pets and companions, even if their names are not recorded. Taking your dog to a party would seem to come under that heading. The red-figure amphora shows a music-making reveller of the fifth century BC, playing the double pipes, with his lyre slung over his shoulder and a dog at his feet. This is no hunting hound, but a small, fluffy pet who presumably accompanied his master everywhere.

We have to draw inferences about the ancient Greek dog, but in the case of the dog Muff, the information is clearly set out for us on a small, precious piece of jewellery. The gold brooch was made in England in 1862, and it is set with a polished rock crystal cut in reverse intaglio and painted with the head of a dark-eyed white German Spitz, a breed that was very popular in Victorian England.

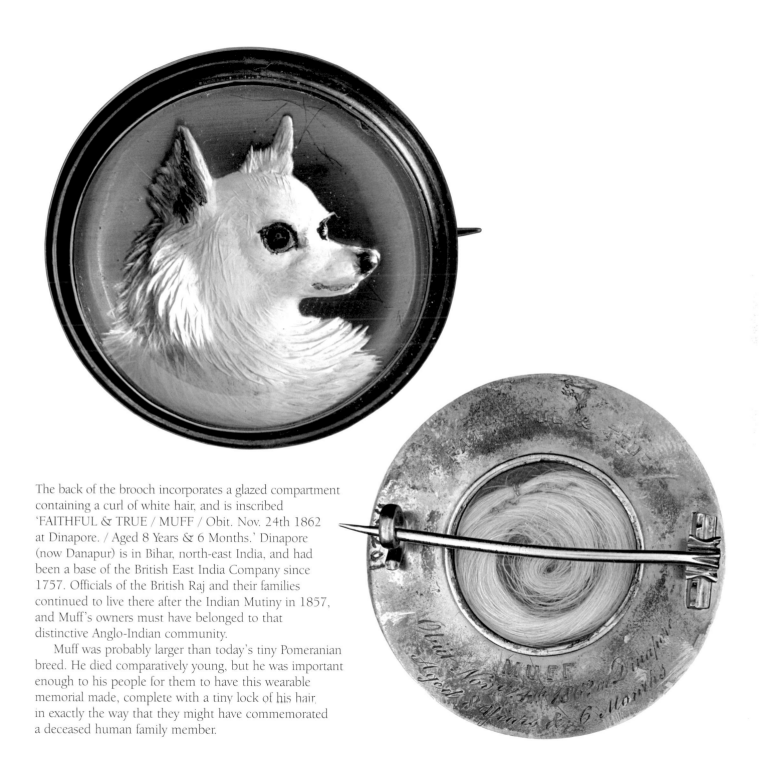

The back of the brooch incorporates a glazed compartment containing a curl of white hair, and is inscribed 'FAITHFUL & TRUE / MUFF / Obit. Nov. 24th 1862 at Dinapore. / Aged 8 Years & 6 Months.' Dinapore (now Danapur) is in Bihar, north-east India, and had been a base of the British East India Company since 1757. Officials of the British Raj and their families continued to live there after the Indian Mutiny in 1857, and Muff's owners must have belonged to that distinctive Anglo-Indian community.

Muff was probably larger than today's tiny Pomeranian breed. He died comparatively young, but he was important enough to his people for them to have this wearable memorial made, complete with a tiny lock of his hair, in exactly the way that they might have commemorated a deceased human family member.

FRIENDS AND COMPANIONS

IT is a fairly common misconception that dogs have been regarded as valued friends and family members only in quite modern times, and that in the past they were generally regarded as working livestock without individual personalities. There are many ancient records that dispel that idea, amongst them the representations of Ankhu and Debtet, two Egyptian dogs who lived some 3800 years ago.

Ankhu ('Lively') was the dog of Djehutyhotep, a *nomarch* (provincial governor) in Middle Egypt during the 12th Dynasty and a man of high social status and importance. Djehutyhotep's splendidly decorated tomb at Deir-el-Bersha is carved and painted with scenes that include processions of seal-bearers, officials and servants and a famous, though badly damaged, scene of teams of men moving a colossal statue. Amongst them is the image of the dog Ankhu, carefully depicted at a very large scale that suggests he held a special place in the affections of his master. Ankhu, whose name is inscribed above his picture, was a very short-legged,

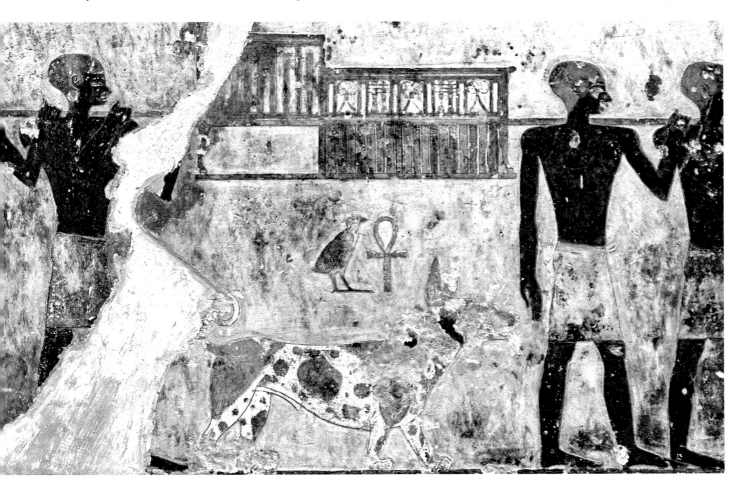

smooth-coated dog with large pricked ears and a curled tail. His coat seems to have been white, black and tan, in a distinctive and unusual pattern of patches and spots.

A dog of very similar type, short-legged and curly-tailed, appears on another funerary monument of about the same period, this time the carved limestone stela of a man named User.

Here the dog is shown at a small scale, to fit into a limited space near the feet of his deceased owner, who is seated before a table of offerings. As in the image of Ankhu, the dog's name is inscribed above him: Debtet. Although the exact meaning of the name is uncertain, the fact that the dog is portrayed with his name gives him a unique personhood.

OPPOSITE
Painted limestone relief wall decoration from the tomb of Djehutyhotep.
Egyptian, 12th Dynasty, c. 1850 BC.
Deir-el-Bersha, Egypt.
THIS PAGE
Carved limestone stela.
Egyptian, 12th Dynasty, c. 1800 BC.

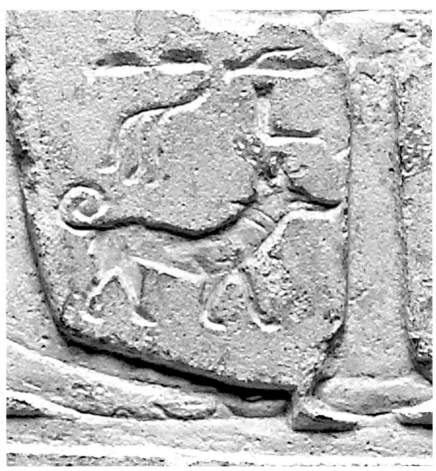

FRIENDS AND COMPANIONS

NEARLY two thousand years ago, during the first or second century AD, a couple living in Rome buried their white hound, Margarita ('Pearl'). She was so dear to them that they ordered a gravestone for her in fine white marble, just as they would have done for any deceased member of the family, and had it elegantly engraved with a thirteen-line epitaph describing the dog's life and character as though in her own words:

> Gaul was my birthplace. The oyster from the rich water's waves gave me a name suited to my beauty. I learned to run boldly through treacherous woods and to pursue shaggy beasts in the hills. Heavy chains never restrained me, nor did my snow-white body ever suffer any blows. I used to lie in my master's and mistress's soft laps, and curl up on their bed when I was tired. I used to talk more than I should, with my dog's dumb mouth, though no-one feared my barking. But alas, misfortune befell me when whelping, and now this little marble slab marks where the earth enfolds me.*

Margarita was of Gaulish (French) breed, probably carefully chosen and imported into Italy because of her outstanding hunting lineage and her training, but, like so many dogs over the centuries and millennia, she became not only a working hound, but also a much-loved and fondly indulged companion. We can all too easily imagine the distress of her owners when their hope of breeding pups that would inherit her skills, her beauty and her temperament ended in the premature death of their canine friend. Margarita and her people have been gone for a very long time, but their voices still speak to us down the centuries.

* Based on the translation by R.C.A Carey

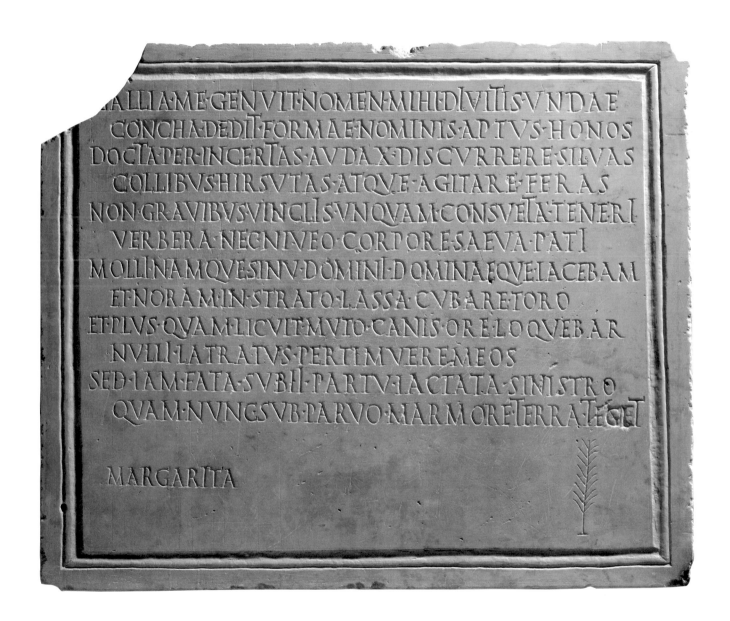

[G]ALLIA ME GENVIT NOMEN MIHI DIVITIS VNDAE
CONCHA DEDIT FORMAE NOMINIS APTVS HONOS
DOCTA PER INCERTAS AVDAX DISCVRRERE SILVAS
COLLIBVS HIRSVTAS ATQVE AGITARE FERAS
NON GRAVIBVS VINCLIS VNQVAM CONSVETA TENERI
VERBERA NEC NIVEO CORPORE SAEVA PATI
MOLLI NAMQVE SINV DOMINI DOMINAEQVE IACEBAM
ET NORAM IN STRATO LASSA CVBARE TORO
ET PLVS QVAM LICVIT MVTO CANIS ORE LOQVEBAR
NVLLI LATRATVS PERTIMVERE MEOS
SED IAM FATA SVBII PARTV IACTATA SINISTRO
QVAM NVNC SVB PARVO MARMORE TERRA TEGIT

MARGARITA

Inscribed marble tombstone
of Margarita.
Roman, 2nd century AD.
Rome.

FURTHER READING

I have not noted any of the countless illustrated books on modern dog breeds that are readily available, though I have made use of some of them, nor have I attempted to list even a basic selection of works on the many cultures represented in this book. The following suggestions for further reading focus on the domestication, genetics, ancient history and behaviour of dogs. These are all fields of study that are rapidly progressing and changing, but classic older publications continue to be valuable sources of information.

Douglas Brewer, Terence Clark and Adrian Phillips, *Dogs in Antiquity: From Anubis to Cerberus, the origins of the domestic dog*, Warminster 2001

Stephen Budiansky, *The Truth about Dogs: The ancestry, social conventions, mental habits and moral fibre of Canis familiaris*, London 2001

Juliet Clutton-Brock, *A Natural History of Domesticated Animals*, Cambridge and London 1987

Stanley Coren, *How Dogs Think: Understanding the canine mind*, London 2005

Stanley Coren, *How to Speak Dog: The art of dog-human communication*, London 2005

Richard and Alice Fiennes, *The Natural History of the Dog*, London 1968

R.H.A. Merlen, *De Canibus: Dog and hound in antiquity*, London 1971

John Paul Scott and John L. Fuller, *Genetics and the Social Behaviour of the Dog*, Chicago 1965

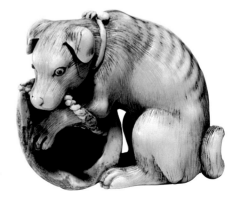

Ivory *netsuke* of a dog playing with an awabi shell, by Tomotada. Japanese, 19th century.

ILLUSTRATION REFERENCES

All photographs are British Museum copyright unless otherwise stated. References are British Museum registration numbers. Photography of British Museum objects by British Museum Photography and Imaging.

97　PD 1866,0210.207
98　PE 1929,0511.1
99　AOA Am1949,22.80
100　GR 2001,0501.1
101　PE 1939,1010.2.a–i. Presented by
　　Mrs Edith M. Pretty
102　PE 1856,0701.27
103　AOA Am1939,11.3. Presented by
　　P.I. Beeman
104　GR 1772,0302.134
105　PE 1856,0701.31
106　CM 1867,0701.31
107 (top)　CM R.243
107 (bottom)　CM BA1,83,2
108　GR 1873,0820.449
109　PE 1883,0407.1. Presented by
　　Thomas Layton
110　GR 1859,0216.103.
　　Auldjo Collection
111　AOA Am,DC.29
112　PE 1978,1002.511. Hull Grundy
　　Collection
113　PD 1836,0811.189
114　ME 2001,0521.35. Anonymous gift
115　PE 1978,1002.290. Hull Grundy
　　Collection
116　Asia 1945,1017.521. Bequeathed
　　by Oscar Charles Raphael
117　Asia 1906,1220,0.694
118　ME 1850,0630.1. Presented by
　　Albert, Prince Consort
119　ME 1856,0909.24
120　GR 1805,0703.8
121　PD 1895,1214.95
122　PD 1874,0808.141
123　PD 1888,0719.73
124　PD SL,5214.175. Bequeathed by
　　Sir Hans Sloane
125　PD 1930,0111.50
126　PE 1947,0505.499
127　PD 1875,0612.559
128　CM 1940,0708.4
129　PD 1969,0123.4
130　PD 1916,0107.6
131　PE 1978,1002.136
132　PD 1875,0612.560. Presented by
　　Miss Cynthia M. Harnett
133　© Tate Britain

134　PD 2002,0323.8. Presented through
　　the National Art Collections Fund
　　by Professor Luke Herrmann
　　(from the Bruce Ingram collection)
135　PE 1991,1107.1
136　PD 1849,1031.274
137　PE 1978,1002.190. Hull Grundy
　　Collection
138　PD 1886,1013.1966
139　PE 1978,1002.558. Presented by
　　John Dettett Francis
140　PD 1860,0728.60
141　PE 1923,0314.81. Presented by
　　Harold Lee–Dillon,
　　17th Viscount Dillon
142　GR 1856,1226.380.
　　Temple Collection
143　GR 1836,0224.235
144　GR 1914,0516.4
145　PD 2001,0729.29
146　Asia 1910,0212,0.561.a
147　Asia 1881,1210,0.46
148　Asia Franks.79.+. Franks Collection
149　Asia 1907,0531,0.484
150　EA 13596
151　PD 1849,1031.263
152　PD Oo,10.215. Bequeathed by
　　Richard Payne Knight
153　PD 1843,0513.258
154　GR 1860,0404.18
155　Photo © Author
156　© The Potteries Museum & Art
　　Gallery, Stoke on Trent
157　GR 1772,0320.172
158　GR 1865,0712.10
159　PE 1889,1201.206. Octavius
　　Morgan Bequest
160 (top)　GR 1851,0813.45
160 (bottom)　GR 1904,0204.358
161　PE 1889,1216.6. Octavius Morgan
　　Bequest
162　GR 1867,1122.207
163　PE 1978,1002.770. Octavius
　　Morgan Bequest
164　EA 5945
165　AOA Am1978,15.920
166　AOA Am.Db.2
167　AOA Af.7410. Christy Collection

168　ME G.232. Godman Collection
169　PE 1947,0505.1710
170　GR 1921,0711.3
171　GR 1865,0712.76
172　PE AF.1039. Franks Bequest
173　PE 1978,1002.1069. Hull Grundy
　　Collection
174　GR 1904,0602.3. Presented by
　　Sir Charles Hercules Read
175　PE 1949,0702.1
176　PE 1978,1002.623. Hull Grundy
　　Collection
177　PE 1978,1002.623. Hull Grundy
　　Collection
178 (left)　GR 2001,0314.1. Donated by
　　Anna Jones
178 (right)　GR 1975,0902.6
179　PD SL,5214.181. Bequeathed by
　　Sir Hans Sloane
180　PD 1848,1125.3
181　PE 1978,1002.742. Hull Grundy
　　Collection
182　Museé d'Aquitaine, Bordeaux
　　(60.1.268)
183　PD 1872,1012.3416
184　PD Oo,10.231. Bequeathed by
　　Richard Payne Knight
185　PD 1872,1012.3418
186　PD 1879,0712.7
187　Asia HG.23. Hull Grundy
　　Collection
188　GR 1907,1023.1
189 (top)　Asia HG.442. Hull Grundy
　　Collection
189 (bottom)　Asia HG.56. Hull Grundy Collection
190　ME 1930,0412,0.2
191　Asia 1986,1112,0.1
192　PE 1856,0623.96
193　PD 1950,0311.3. Presented by
　　Mrs Ernest Borough Johnson
194　GR 1772,0320.275
195　PE 1978,1002.201
196　EA 1147. Presented by the
　　Egypt Exploration Fund
197　EA 237
199　GR 1756,0101.1126
201　Asia HG.445. Hull Grundy
　　Collection

INDEX